U0056434

New Waves of
European Graphic Design

·歐洲平面設計新浪潮·

gaatii光体

編 著

瑞昇文化

目 錄

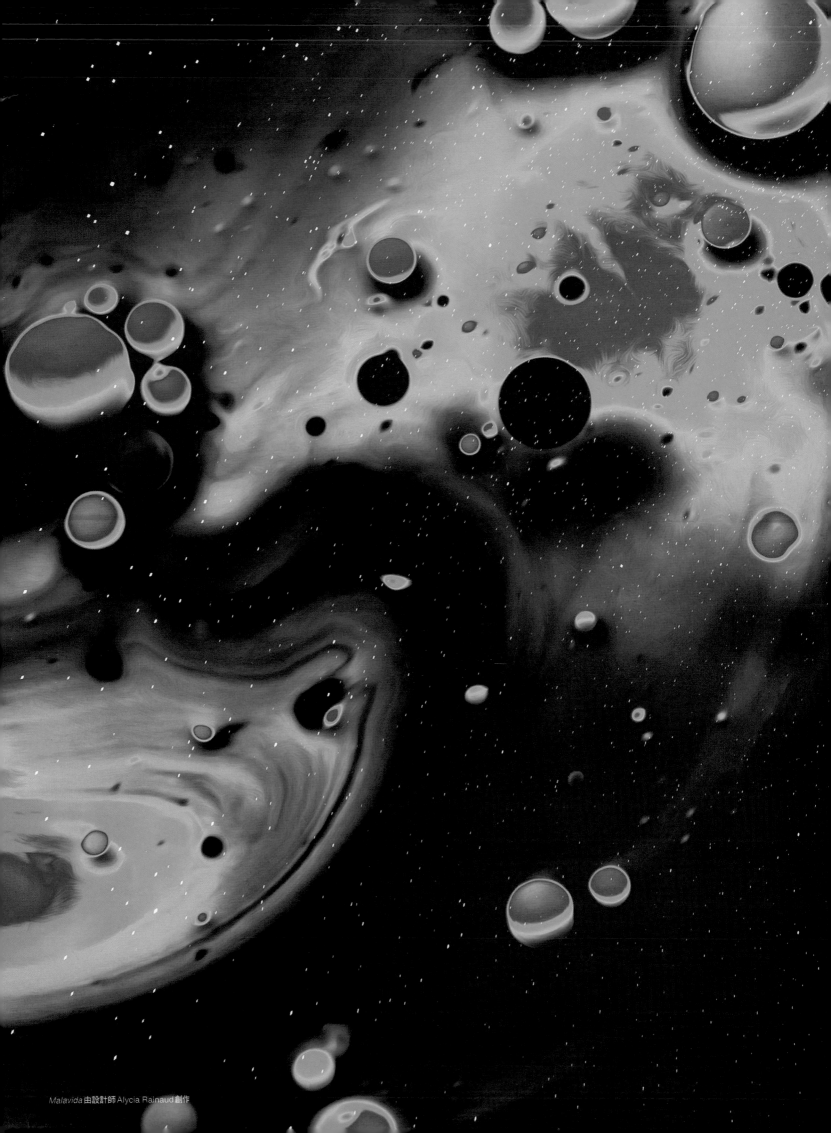

Malavida 由設計師 Alycia Rainaud 創作

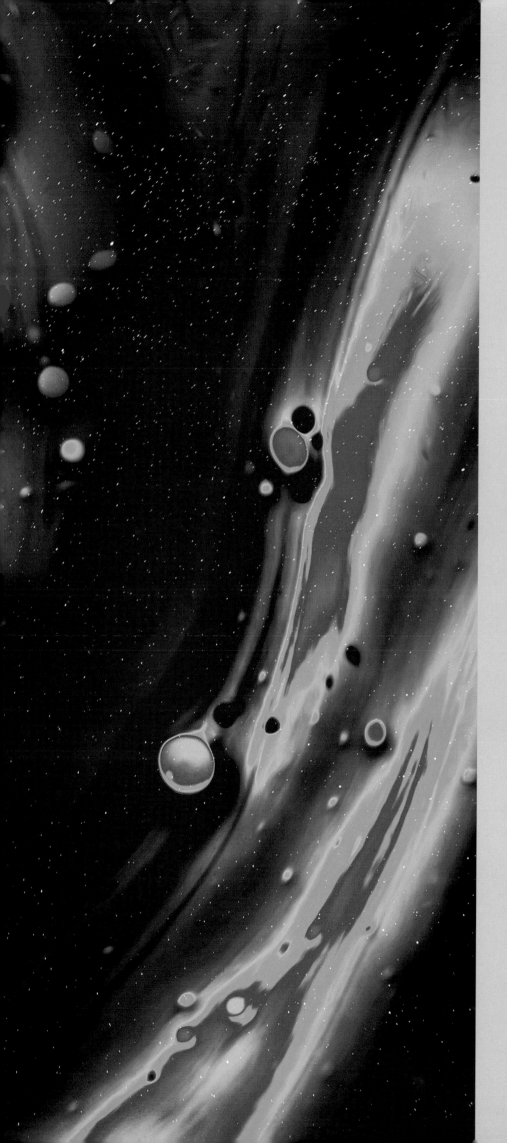

- 引言

歐洲是現代平面設計的起點，又是後現代主義設計的發端，在每一個設計時代交迭更替之際，它都是破舊迎新的中心與前沿陣地。

近年來歐洲湧現的各種新風格浪潮，乍看之下讓人眼花繚亂，但其實在超強的視覺衝擊力和大膽而又富有靈性的風格背後，包含著年輕設計師們顛覆設計規則，繼承並重塑設計文化的創意和野心。

他們有的為平面添加3D藝術；有的故意打破設計規則，顛覆視覺習慣；有的玩起復古；有的進行像素解構和故障處理……總之，無一不是從各方面對現代極簡主義發起挑戰和衝擊。

「如果人們連看都不想看一眼，還怎麼傳遞訊息？」環顧四周把我們重重包裹著的訊息媒介，已經讓人感到視覺疲勞且審美麻木。如何從千篇一律的設計中跳脫出來，吸引大眾的目光，成為有效傳達訊息的重要思考。

本書中入選的作品，充滿個性，表達情緒，還帶有一股感性的藝術實驗氣息。但他們天馬行空的風格創意，能為年輕的設計師以及學生們啟發靈感，拓寬視野，使他們能夠將這些新興的藝術設計風格靈活運用到自己的作品中。

設計本身就不該被局限，它需要不斷被打破、被審視、被解構、被重組。

abcdefghi
jklmnopqr
stuvwxyz

ABC → AB C

ABC → A B C

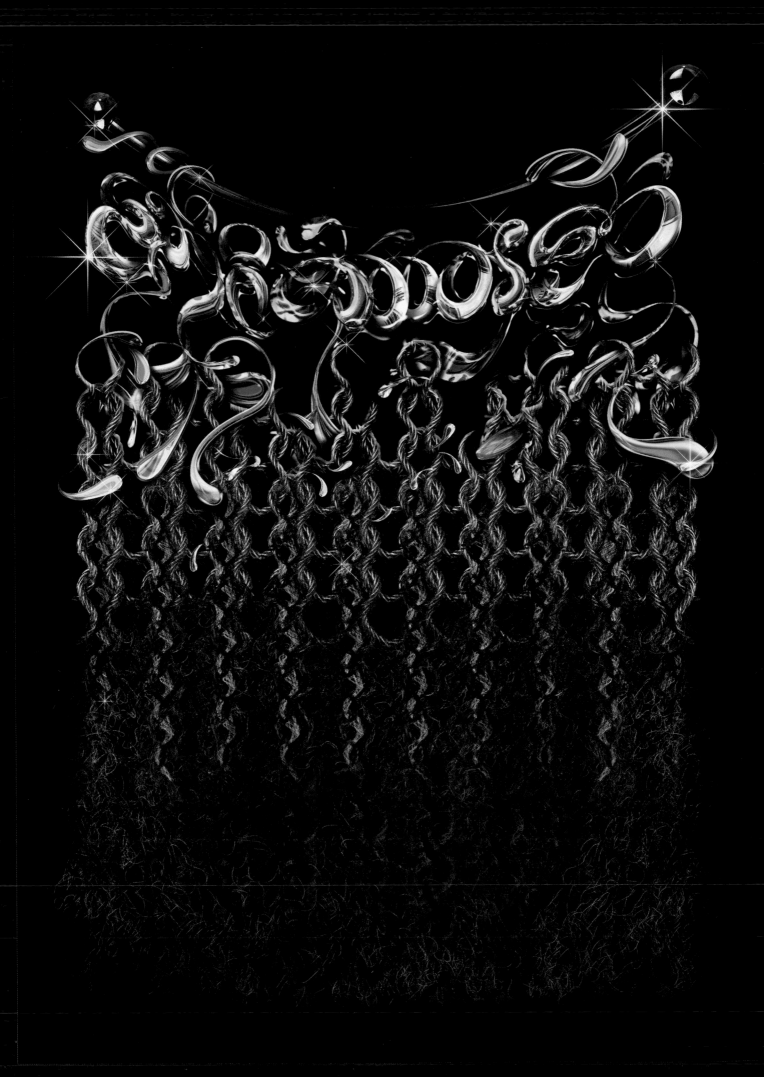

> 如何製作液態金屬字體
ENTANGLED 液態金屬字體設計

創意總監：Maria Nowicka
設計師：Maria Nowicka
國家：波蘭

ENTANGLED這個作品是我對2D和3D混合技術的探索。我使用的是類似織物的3D元素和紋理，然後將圖案無縫地融合到藝術字體中。我這裡的主要練習目標是從2D到3D的過渡。

Part 1：字體設計

01 - 02

首先繪製字體的草圖，確定基本字型。然後進入Illustrator，將字體向量化，並用深淺不一的4種紅色區分字體的正反轉折面。

03

字體部分設計最終效果。

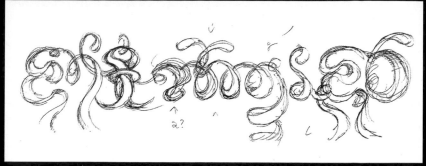

01

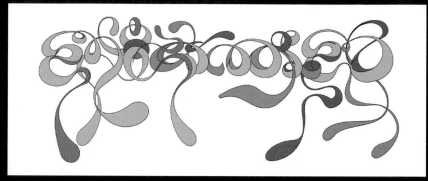

02

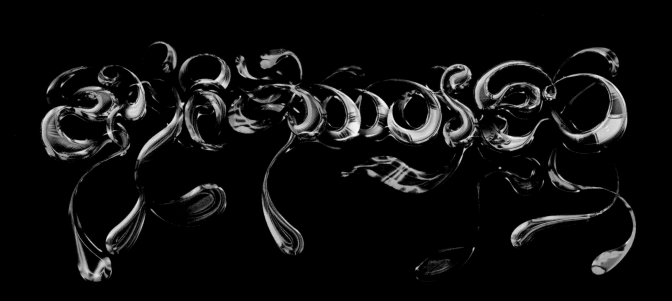

創意總監：Maria Nowicka
設計師：Maria Nowicka
國家：波蘭

03

a

b

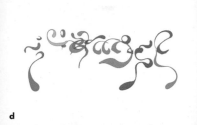

c

d

e

f

g

04

06

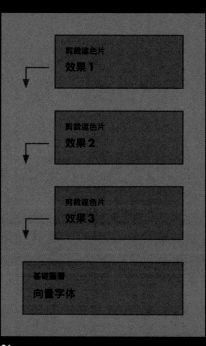

04

將製好的向量文字導入Photoshop，將字體按照之前劃分好的紅色或圖層疊壓的前後關係拆分為7個基礎圖層。

05 - 06

為達到最終的效果，我創建了20多種不同的風格，分別在每組中添加4～5種。重要的是，針對每種新樣式，我都會創建一個全新的圖層（不同的顏色、效果等），並以剪裁遮色片的方式逐層疊加。這是因為最終實現的效果複雜，無法一步到位。在將它們全部合併之前，我總是創建一個備份版本以確保後期仍可以修改。

07 - 09

我主要通過Photoshop中的圖層樣式「斜面和浮雕」和「光澤（緞面）」來實現效果。有趣外觀的關鍵，就在於重疊的效果，我一般使用多個圖層來調節不透明度、混合模式、關閉不同的RGB色版等。

值得注意的是，每完成一種樣式的調整，就需要蓋印並創建新圖層（Ctrl / Command + Shift + Alt / Option + E），再在此基礎上添加新樣式，這樣才能實現逐層疊加的效果。當然，如果您想統一使用基礎圖層來疊加圖層樣式，也可以通過複製基礎圖層，並將圖層的「填充」改為0％，來達到相同的效果。

07「斜面和浮雕」參數

樣式：浮雕效果；方法（技術）：平滑
深度：43%；方向：下
大小：29 像素；軟化（柔化）：2 像素
角度：119 度；高度：37 度
高光模式（亮部模式）：#f3dcdc、正常、100%
陰影模式：#331e1e、正常、21%

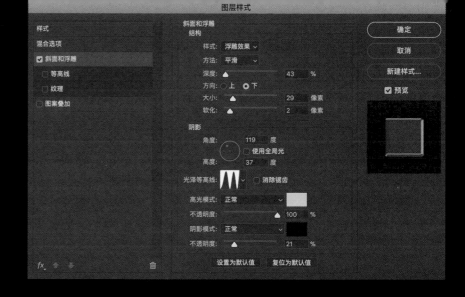

08「斜面和浮雕 + 描邊（筆畫）+ 光澤（緞面）」參數

- 斜面和浮雕：
樣式：內斜面；方法（技術）：平滑
深度：32%；方向：下
大小：62 像素；軟化（柔化）：0 像素
角度：119 度；高度：37 度
高光模式（亮部模式）：#9f7e80、正常、76%
陰影模式：#f5e3e3、正常、64%

- 描邊（筆畫）：
大小：3 像素；位置：內部
混合模式：正常；不透明度：100%
填充類型：顏色、#98524f

- 光澤（緞面）：
混合模式：正片疊底（色彩增值）、#c5d6e0
不透明度：69%；角度：-154 度
距離：168 像素；大小：13 像素
勾選「消除鋸齒」與「反相（負片效果）」

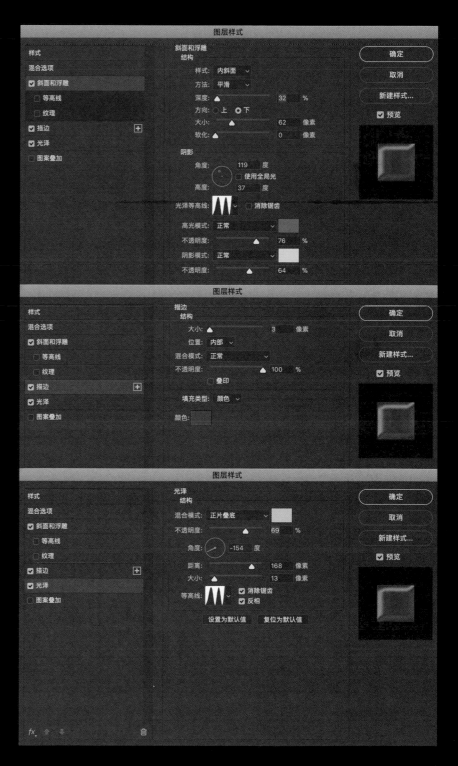

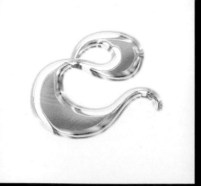

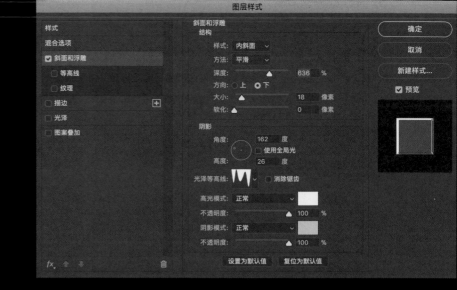

09「斜面和浮雕」參數

樣式：內斜面；方法（技術）：平滑

深度：636%；方向：下

大小：18 像素；軟化（柔化）：0 像素

角度：162 度；高度：26 度

高光模式（亮部模式）：正常、100%、#ffffff

陰影模式：正常、100%、#dedff1

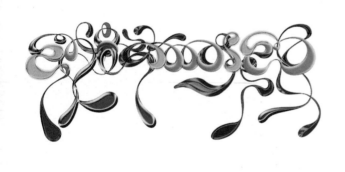

a

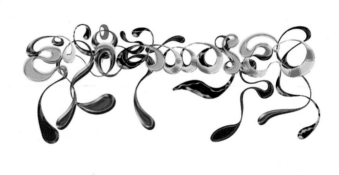

b

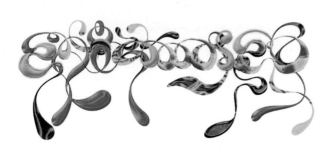

c

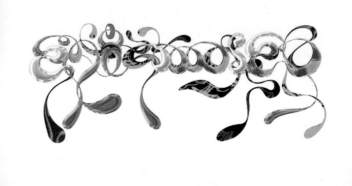

d

10 - 11

利用剪裁遮色片逐層疊加圖層樣式的過程，
a-d 從扁平的向量圖逐步向具有金屬質感的
效果圖轉變。

為了讓字體看起來更立體，我手動添加了陰
影。在製作過程中，我需要不停切換黑 / 白
背景色，以確保最終效果，步驟 **e**、**f** 展示
了添加陰影前後的變化。

12

在完成前面步驟並備份後，我合併了圖層，
然後繼續進行顏色校正、對比度、飽和度等
調整。我對文字進行了扭曲，添加了炫光，
並開始把字母和其他設計元素連接起來。

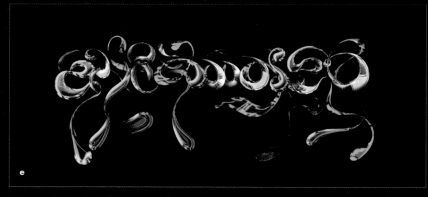

e

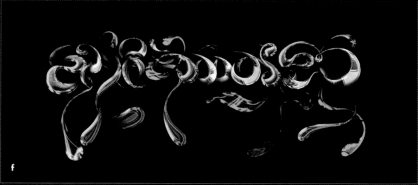

f

11

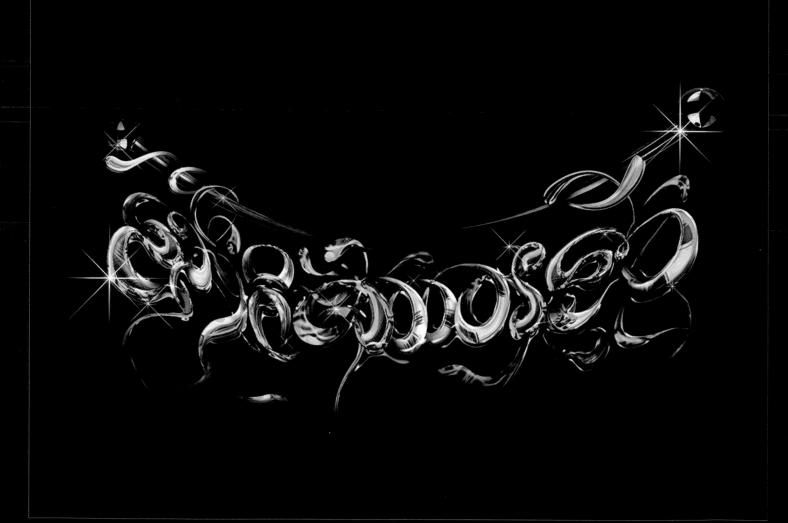

12

Part 2：毛髮和後期製作

13 - 14

我使用Cinema 4 D來創建毛髮，通過對毛髮材料進行多次實驗，我最終繪製了幾個不同的版本，然後導入Photoshop中進行混合。

15

我還用C 4 D製作了兩根編織用的針——因為海報的概念是縫紉和編織。我渲染了幾個不同鏡頭角度的版本，並在Photoshop中進行處理。

16

基於最初草稿的構圖，我把所有的設計部分結合在一起，並將字體彎曲。我添加了白色的星光點，並試著調整所有部件的色調以保持一致。我把三種不同的毛髮混合在一起，最細碎鬆散的在最下面，最整齊的在上面。簡單地擦除部分設計，直到它們看起來像無縫連接為止。

17

最後一步，我創建了小的淚痕般的藍色元素，使字體和繩髮之間的過渡更加自然。類似的方法我也用在了金屬編織針上，之所以能這樣做，是因為我之前把所有的圖層樣式保存為單獨的備份文件。

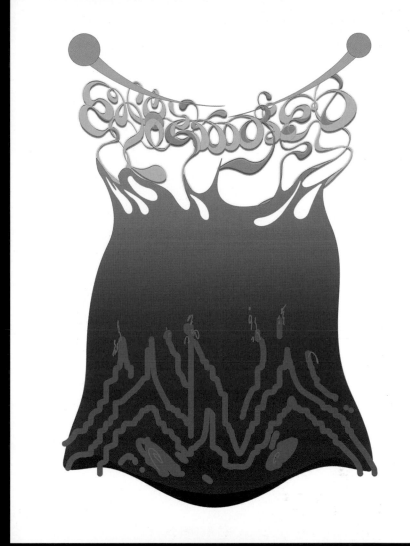

16

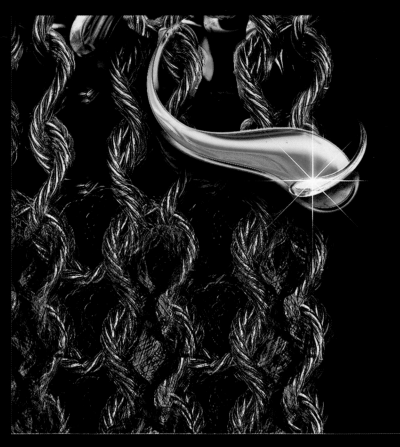

17

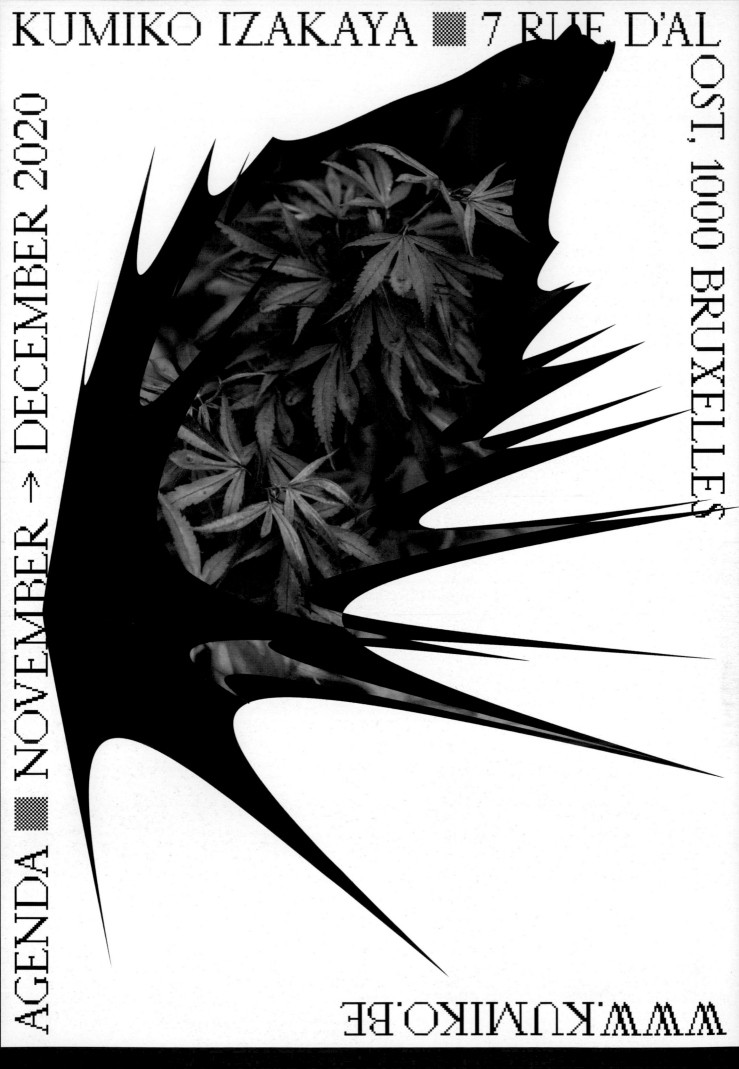

KUMIKO IZAKAYA ▨ 7 RUE D'AL OST, 1000 BRUXELLES

AGENDA ▨ NOVEMBER ▮ DECEMBER 2020

WWW.KUMIKO.BE

> 如何用抽象圖形製作新醜風海報
Kumiko - 居酒屋音樂賞

設計機構：Alliage
創意總監：Lucile Martin and Julien Pik
設計師：Lucile Martin and Julien Pik
國家：比利時
客戶：Kumiko Izakaya

Kumiko 是一家位於布魯塞爾的日本居酒
屋。每週有兩三次的音樂活動。我們被邀約
來設計這些音樂節目的宣傳物料。

我們的主要目的是在餐廳的美食和音樂之間
建立聯繫。為此，我們將抽象形狀和日本典
型圖像相結合，以創造對比並獲得令人驚訝
的效果。

Part 1：海報／傳單設計

海報／傳單的製作使用了「剪裁遮色片」的
技法，其原理是通過讓圖片嵌入目標形狀之
中，從而令圖片按照目標形狀的輪廓顯示。
在 Photoshop 和 Illustrator 兩款軟體中均可
實現這項技法，但操作上有些許不同。

01

在 Photoshop 中，將圖片層置於圖層順序
的上方，目標形狀（剪切層）居於圖層順序
的下方，然後在選中圖片層的情況下點擊右
鍵，單擊「建立剪裁遮色片」，即可實現該
效果。圖片層還可以在剪切層的範圍內任意
移動、縮放，以達到最佳的顯示效果。

02

在 Illustrator 中，圖層順序則與 Photoshop
相反，應將剪切層（剪切層需為向量圖形，
不能使用點陣圖）放置於圖層順序的上方，
圖片層居於下方，然後選中兩個圖層，單擊
右鍵，「建立剪裁遮色片」，即可實現該效
果。

值得注意的是，如果您使用的剪切圖形過於
複雜，則可能出現圖 02 的警示框，並如白
色圖片一樣，只出現輪廓而沒有剪切效果。

03

解決該問題僅需多一步操作，在頂部導航欄
選擇「對象 - 複合路徑 - 建立（快捷鍵 Ctrl
/ Command + 8）」。在執行操作後，軟體
可能仍出現圖 02 的警示框，但點擊確認後
即可實現剪切效果。

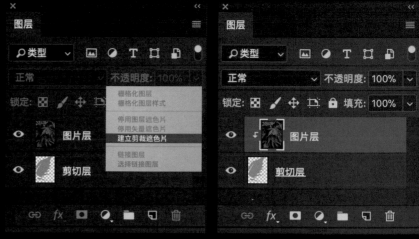

01

02

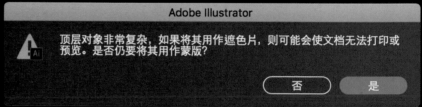

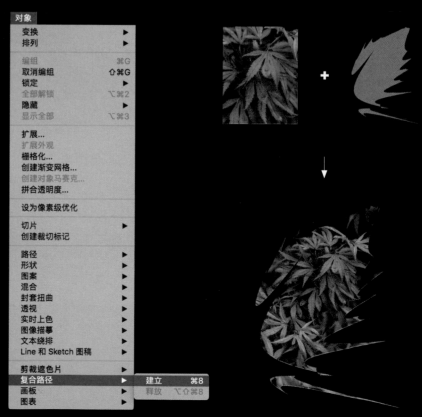

03

KUMIKO IZAKAYA ▨ AALSTSTRAAT, 1000 BRUSSELS

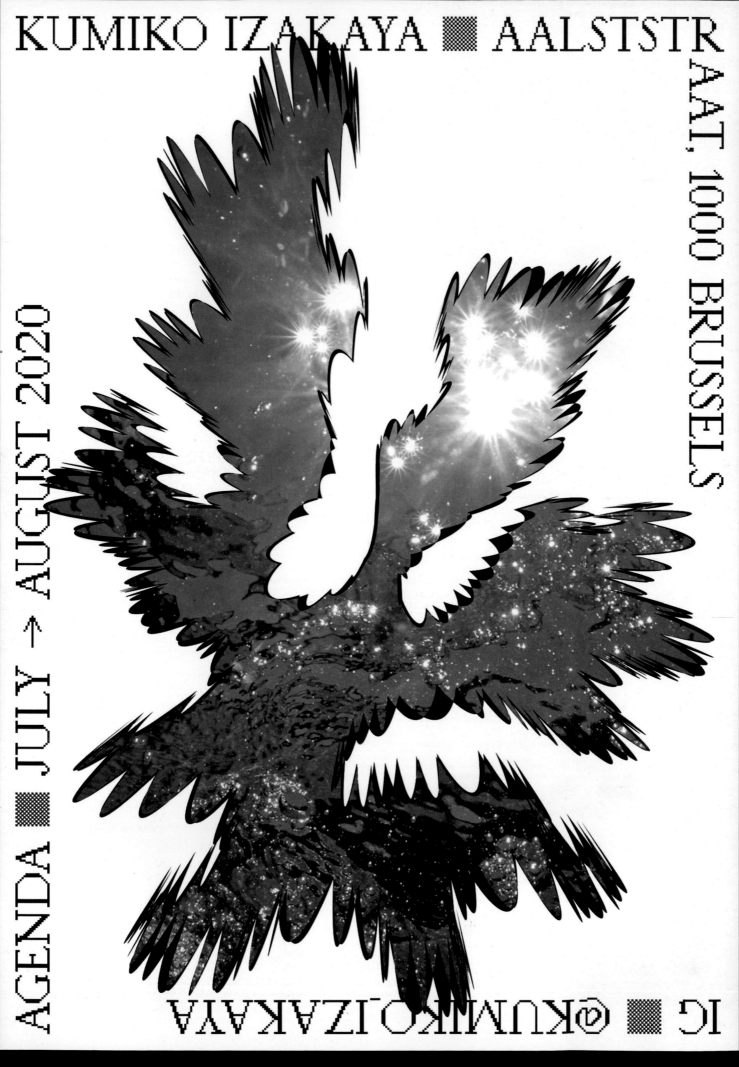

AGENDA ▨ JULY → AUGUST 2020

@KUMIKO.IZAKAYA ▨ G

每張傳單包含兩個月的節目安排，我們會選用一張日本當季的自然元素照片，與這個時段對應（例如：盛開的櫻花對應春季的節目單）。清晰的布局、抽象的元素和高清晰度的照片相結合，使畫面跳脫出來，營造出詩意、幽默、輕鬆和讓人印象深刻的形象。

04 - 09

以下是每2個月的視覺元素的變換列表：

圖04：1、2月
嚴寒 - 大雪

圖05：3、4月
初春暖陽 - 櫻花綻放

圖06：5、6月
雨季 - 森林

圖07：7、8月
晴天 - 水生植物

圖08：9、10月
柔軟潮濕 - 蘑菇

圖09：11、12月
充滿活力的秋 - 紅楓和銀杏葉

04

05

06

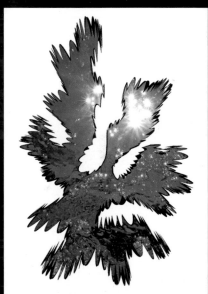

07

08

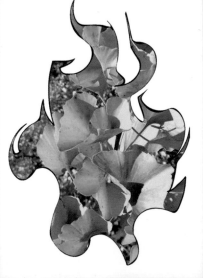

09

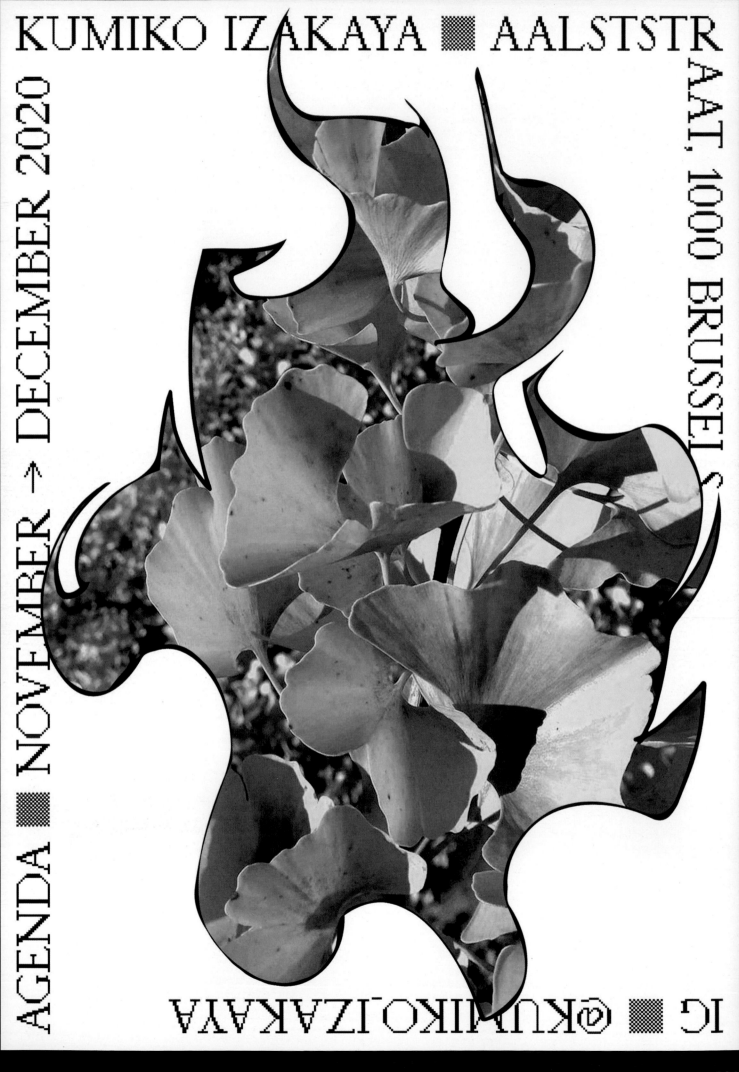

KUMIKO IZAKAYA ▓ AALSTSTRAAT, 1000 BRUSSEL

AGENDA ▓ NOVEMBER → DECEMBER 2020

@KUMIKO.IZAKAYA ▓ IG

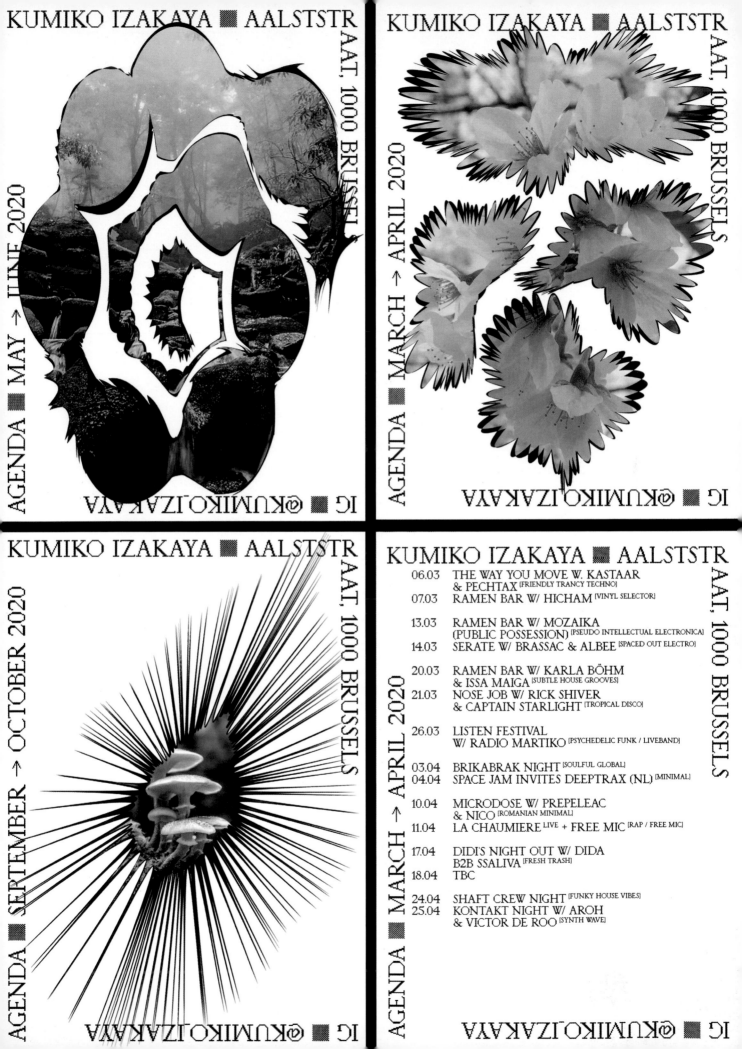

KUMIKO IZAKAYA ■ AALSTSTRAAT, 1000 BRUSSELS

AGENDA ■ MAY → JUNE 2020

@KUMIKO_IZAKAYA ■ IG

KUMIKO IZAKAYA ■ AALSTSTRAAT, 1000 BRUSSELS

AGENDA ■ MARCH → APRIL 2020

@KUMIKO_IZAKAYA ■ IG

KUMIKO IZAKAYA ■ AALSTSTRAAT, 1000 BRUSSELS

AGENDA ■ SEPTEMBER → OCTOBER 2020

@KUMIKO_IZAKAYA ■ IG

KUMIKO IZAKAYA ■ AALSTSTRAAT, 1000 BRUSSELS

AGENDA ■ MARCH → APRIL 2020

06.03	THE WAY YOU MOVE W. KASTAAR & PECHTAX [FRIENDLY TRANCY TECHNO]
07.03	RAMEN BAR W/ HICHAM [VINYL SELECTOR]
13.03	RAMEN BAR W/ MOZAIKA (PUBLIC POSSESSION) [PSEUDO INTELLECTUAL ELECTRONICA]
14.03	SERATE W/ BRASSAC & ALBEE [SPACED OUT ELECTRO]
20.03	RAMEN BAR W/ KARLA BÖHM & ISSA MAIGA [SUBTLE HOUSE GROOVES]
21.03	NOSE JOB W/ RICK SHIVER & CAPTAIN STARLIGHT [TROPICAL DISCO]
26.03	LISTEN FESTIVAL W/ RADIO MARTIKO [PSYCHEDELIC FUNK / LIVEBAND]
03.04	BRIKABRAK NIGHT [SOULFUL GLOBAL]
04.04	SPACE JAM INVITES DEEPTRAX (NL) [MINIMAL]
10.04	MICRODOSE W/ PREPELEAC & NICO [ROMANIAN MINIMAL]
11.04	LA CHAUMIERE LIVE + FREE MIC [RAP / FREE MIC]
17.04	DIDI'S NIGHT OUT W/ DIDA B2B SSALIVA [FRESH TRASH]
18.04	TBC
24.04	SHAFT CREW NIGHT [FUNKY HOUSE VIBES]
25.04	KONTAKT NIGHT W/ AROH & VICTOR DE ROO [SYNTH WAVE]

@KUMIKO_IZAKAYA ■ IG

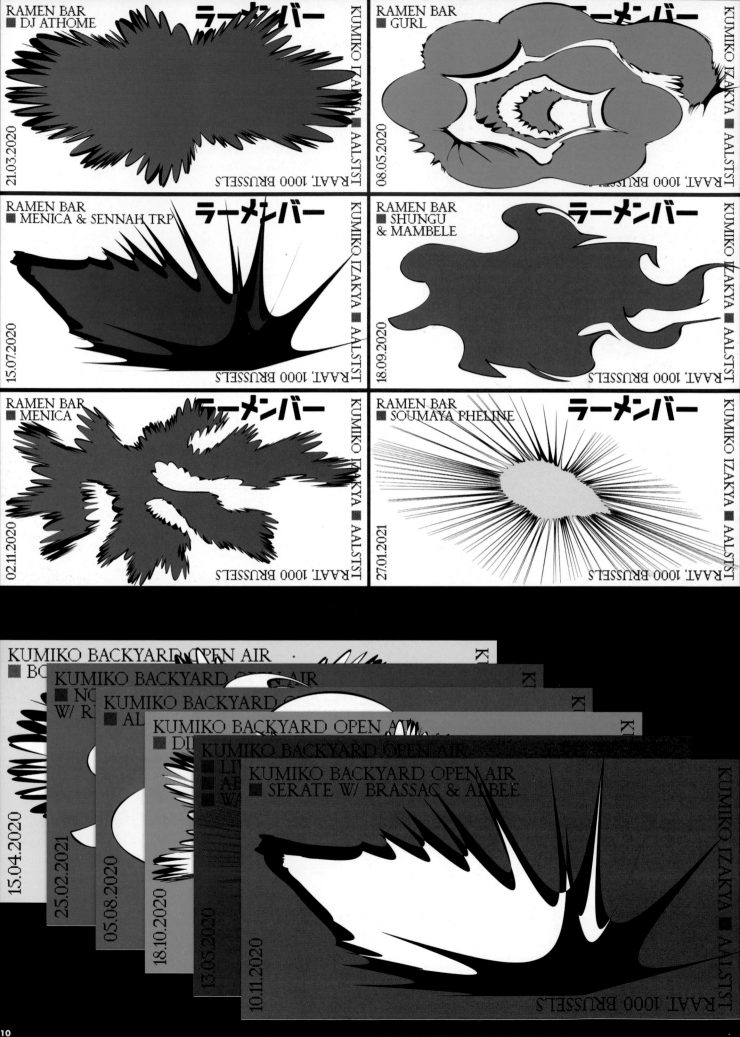

RAMEN BAR
■ DJ ATHOME
ラーメンバー
KUMIKO IZAKYA ■ AALST ST
RAAT, 1000 BRUSSELS
21.03.2020

RAMEN BAR
■ GURL
ラーメンバー
KUMIKO IZAKYA ■ AALST ST
RAAT, 1000 BRUSSELS
08.05.2020

RAMEN BAR
■ MENICA & SENNAH TRP
ラーメンバー
KUMIKO IZAKYA ■ AALST ST
RAAT, 1000 BRUSSELS
15.07.2020

RAMEN BAR
■ SHUNGU
& MAMBELE
ラーメンバー
KUMIKO IZAKYA ■ AALST ST
RAAT, 1000 BRUSSELS
18.09.2020

RAMEN BAR
■ MENICA
ラーメンバー
KUMIKO IZAKYA ■ AALST ST
RAAT, 1000 BRUSSELS
02.11.2020

RAMEN BAR
■ SOUMAYA PHELINE
ラーメンバー
KUMIKO IZAKYA ■ AALST ST
RAAT, 1000 BRUSSELS
27.01.2021

KUMIKO BACKYARD OPEN AIR
■ BO
KUMIKO BACKYARD OPEN AIR
■ NO
KUMIKO BACKYARD OPEN AIR
W/ R.
■ AL
KUMIKO BACKYARD OPEN AIR
■ DI
KUMIKO BACKYARD OPEN AIR
■ LI
KUMIKO BACKYARD OPEN AIR
■ SERATE W/ BRASSAC & ALBEE
AB
W
KUMIKO IZAKYA
RAAT, 1000 BRUSSELS

15.04.2020
25.02.2021
05.08.2020
18.10.2020
13.05.2020
10.11.2020

10

#eb1d21
C8 M95 Y91 K0

#ff2d00
C0 M91 Y94 K0

#fdff00
C11 M0 Y83 K0

#01e625
C66 M0 Y98 K0

#016ffe
C83 M56 Y0 K0

#934ffe
C68 M71 Y0 K0

Banner 使用的顏色

THE ACIDOCTOR

> 如何顛覆、重塑經典圖形元素
Ignorance 1 作品合集

設計師：Ignorance1（Luigi Brusciano）
國家：義大利

來自義大利的設計師、藝術家 Ignorance1
圍繞 20 世紀八九十年代的銳舞音樂（Rave
Music）和與其相關視覺元素來進行創作。將
現代圖形與經典元素相結合，使作品保持復
古的情緒，同時得到獨特的當代扭曲效果。

———

項目 1：賽車 Logo 重塑

這個項目的想法是從「acid（酸）」的視角重
新審視賽車、摩托車以及整個機械行業，並
重塑它們的品牌 logo。在創作上，我採用了
實物拍攝 + Photoshop 後期處理的方法。在
這個項目中，所有構成畫面的視覺元素都很
重要，他們共同創造了一個別有味道的「假」
賽車品牌。

01

銳舞（Rave）一詞源於 20 世紀 60 年代居住
在倫敦的加勒比海裔居民稱呼派對的俚語。
提及「銳舞派對」就不得不提到 Acid House
（酸浩室）。電子樂的發展與技術的出現密不可
分，正是因為 TB-303 合成器的誕生，才催
生出了 Acid House 這樣一種音樂風格。Acid
House 是起源於 20 世紀 80 年代的一種迷幻
電子樂，創作者通過旋轉合成器的旋鈕，產生
千變萬化的音色，並以此來製作音樂。

在 Acid House 出現之前，不同社會階層的人
只會參加屬於自己圈子的派對，而這種情況
在 Acid House 流行之後發生改變；無論你是
什麼階層、什麼種族，只要你想加入派對，
就會受到歡迎，因為 Acid House 的精神內核
是平等。

第一張 Acid House 唱片誕生於芝加哥，這種
在當時十分新潮、獨特的曲風很快便風靡美
國。隨著 Acid House 影響力的持續擴散，
這種獨特的音樂和派對傳到英國，並在英國
本土發展、流行並演變成了銳舞文化。銳舞
文化也有其精神內核 —— Peace（和平）、
Love（愛）、Unity（一致）、Respect（尊
敬）。

02

日本 Roland 公司發明的 TB-303 合成器。

03

「黃色笑臉」是 Acid House 的象徵，與之
主題相關的設計作品會頻繁出現這個元素。

04

通過對原 Logo 添加適當的元素，讓新圖像
「酸化」，呈現趣味、復古的氣質。

01

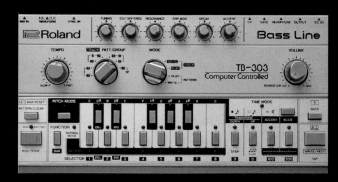

02

03

04

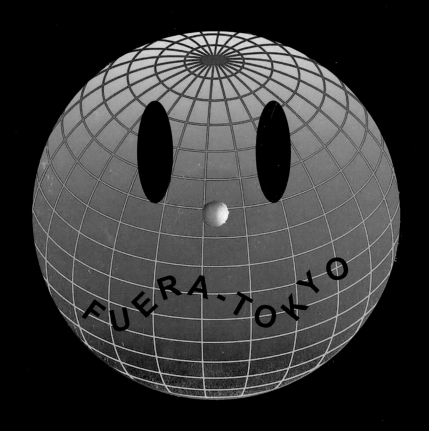

項目2：Fuera 單曲封面

我一直在策劃電子說唱組合 Fuera 的品牌形象，他們的音樂與我的「圖形風格」完美契合。我總是在和 Fuera 長時間的頭腦風暴後，創造出單曲作品的視覺效果，我們總是能得到一個有趣的結果。這個項目採用 Photoshop + 定制手寫字體的創作方式。

01

我們以 Fuera - Tokyo 的圖形為例，講解其製作過程。

02

首先是地球的經緯線部分，除了下載相關素材直接使用，您還可以使用 Illustrator 實現此效果。操作的方法是利用軟體的 3D 功能，將製作的圖案進行 3D 貼圖，從而形成帶有立體感的經緯線。

第一步先繪製兩條等長的直線，採用 0.75 pt 的黑色筆畫，然後利用「對象 - 混合 - 混合選項」設定指定步數。

圖中顯示經線（豎線）共有 24 條，因為後續 3D 貼圖的區域為長方形，如果貼圖圖案為正方形，則後期會因為拉伸而不準確，因此我們最終要製作兩個正方形圖案進行拼合，所以此處只需製作 12 條直線，除去首尾的兩條，步數即為 10 步。

在設定完混合選項後，單擊軟體左側工具欄裏的「漸變工具」，再依次點擊起點線和終點線，即可完成等距離分布。

03

與 02 步驟相同，製作 18 條緯線（橫線）。

04

將製作完成的經線和緯線水平、垂直對齊並群組（Ctrl / Command + G），然後複製多一份，將兩份拼合為圖 04 的樣子。

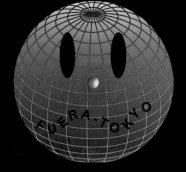

01

02

03

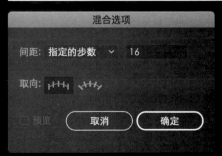

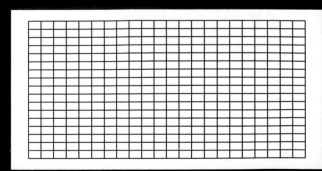

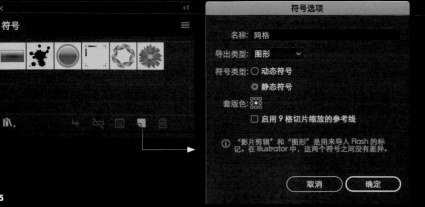

選中圖04的圖形，在「符號」面板點擊新建按鈕，在彈出來的「符號選項」中進行圖中設定。

06

繪製一個黑色的圖形，用直接選取工具（A）點擊圖形一側的錨點，刪除則獲得一個半圓。

07

選中半圓，執行「效果 - 3D - 迴轉」，先勾選「預覽」以方便查看實時變化。根據作品圖效果，將位置設置為「-35°、0°、0°」；角度為360°，自「左邊」開始迴轉。

表面選擇「擴散底紋（漫射效果）」，光源強度與環境光為0％；點擊「更多選項」，「底紋顏色」選擇自定，設置為白色（注：執行3D命令前的半圓形顏色不能為白色）。

然後點擊左下角的「貼圖（對應線條圖）」，在左上角「符號」處選擇剛剛新建的圖案「網格」。點擊左下角的「縮放以適合」讓圖案覆蓋整個貼圖範圍，然後點擊確定。在獲得圖形後，我們還需針對圖形進行相應操作，以方便我們進一步對素材進行編輯。

運用3D貼圖的方法，只需通過調整貼圖素材的樣式，即可靈活實現多種效果，上圖的兩個球體也是運用這種方法製作的。

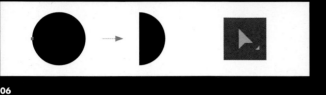

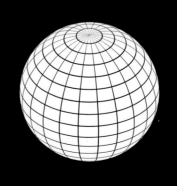

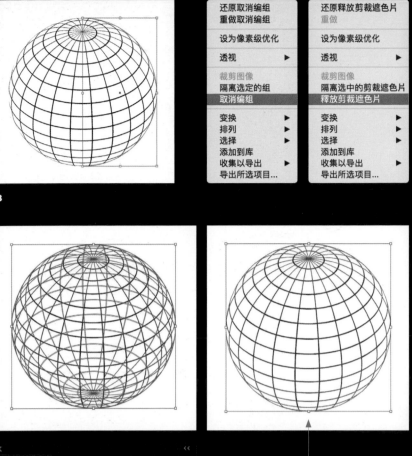

还原取消编组	还原释放剪裁遮色片
重做取消编组	重做
设为像素级优化	设为像素级优化
透视　▶	透视　▶
裁剪图像	裁剪图像
隔离选定的组	隔离选中的剪裁遮色片
取消编组	释放剪裁遮色片
变换　▶	变换　▶
排列　▶	排列　▶
选择　▶	选择　▶
添加到库	添加到库
收集以导出　▶	收集以导出　▶
导出所选项目...	导出所选项目...

08

執行完3D迴轉後點擊圖形會發現，圖形仍然以半圓的編輯區顯示且無法編輯。此時，我們首先需要執行「物件 - 擴充外觀」。

擴充外觀後需要對圖形執行兩次取消群組（Ctrl / Command + Shift + G），再右擊執行「釋放剪裁遮色片」。

09

在釋放剪裁遮色片後，會得到圖09的狀態。通過觀察，會發現軟體通過白色剪裁遮色片蓋住球體背後的透視線，因此，我們需要在「路徑查找器（路徑管理員）」中執行「合併」命令，這樣便可以把多餘的曲線刪除，之後再執行「取消群組」的命令。

10

使用魔術棒工具（Y）選中黑色部分，在魔術棒選中後剪切，將底下多餘的白色色塊刪除，然後原地貼上（Ctrl / Command + F）；再選中所有黑色的線條，在「路徑管理員」中執行「聯集」，這樣，便獲得了一個可編輯的經緯線球體。

08

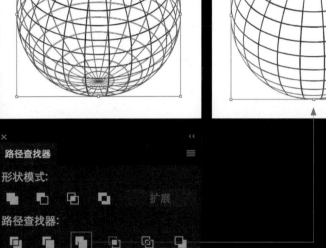

路径查找器

形状模式:

扩展

路径查找器:

09

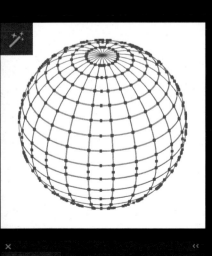

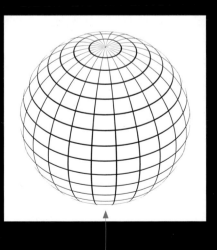

路径查找器

形状模式:

扩展

路径查找器:

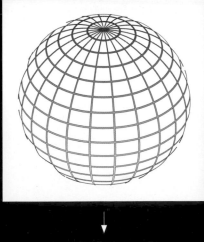

11

仔細觀察原圖，會發現原圖的經緯線帶有紫色筆畫的效果。因此，在圖10的基礎上，選中圖形並添加0.25pt的筆畫，在「視窗-筆畫」面板，「對齊筆畫」處選擇第三個按鈕「使筆畫外側對齊」。

接著，我們為經緯線添加顏色，筆畫為紫色，筆畫內的色彩為漸變色，具體色號如下：

筆畫色彩：

#553d89	
C78 M85 Y13 K0	

經緯線漸變色彩：

#553d89	#ed745e
C78 M85 Y13 K0	C0 M67 Y56 K0

#fff100	
C0 M0 Y100 K0	

12

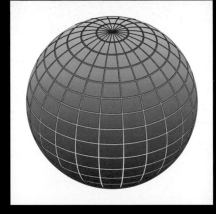

12

製作完經緯線的效果後，開始為球體添加底色，通過觀察，底色是由黃綠色向青色、藍色、墨綠色漸層而來，具體色號如下。

球體漸變色彩：

#b9d98a	#2bb284
C33 M0 Y56 K0	C72 M0 Y60 K0

#1979ad	#005757
C82 M44 Y15 K0	C91 M58 Y64 K17

13

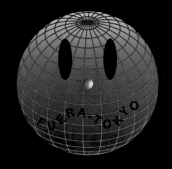

Arial Bold:
FUERA - TOKYO

13

在完成球體的製作後，逐步添加「眼睛」、「鼻子」，下方使用「路徑文字工具」製作「嘴巴」，使用的字體為：Arial Bold。最後添加上如劃痕、噪點的效果以提升復古的質感。

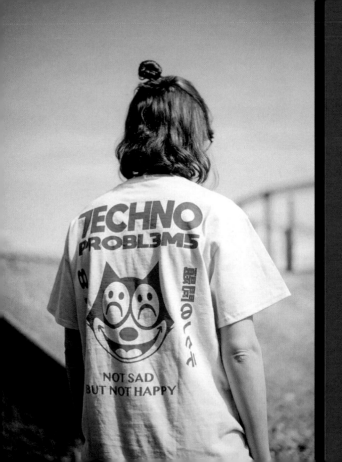

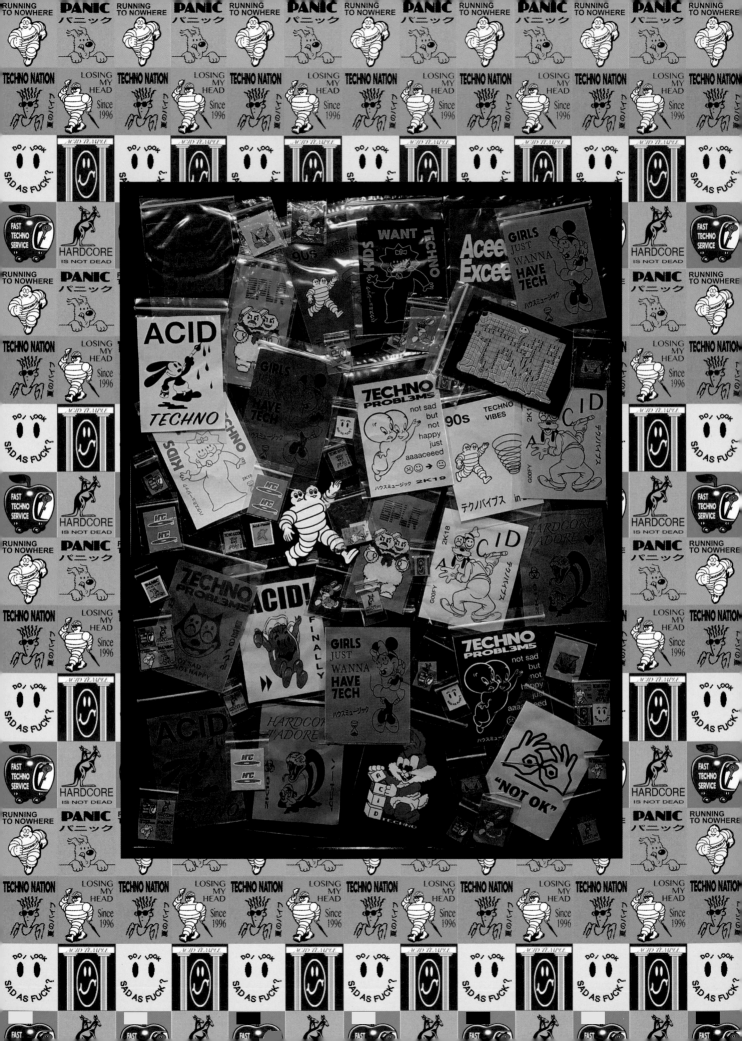

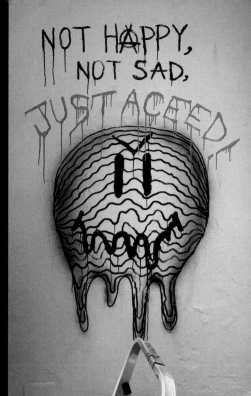

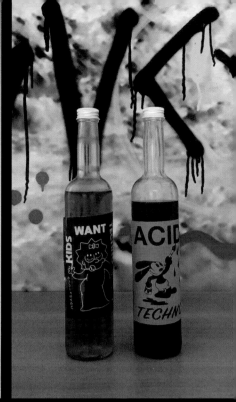

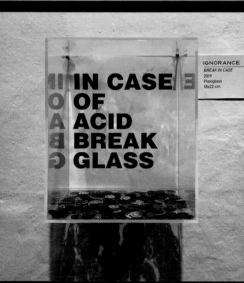

項目 4：米蘭 FITI 展

我在米蘭的第一次個展，名為「Not happy, not sad, just acid」，這是我人生中一個非常重要的里程碑。

在這次展覽中，我有機會呈現我作為藝術家的旅程，展出了很多線下的實體藝術品，並將它們與影片結合。

這個項目中，我採用了影片、掛畫、海報、徽章、全像列印等媒介。

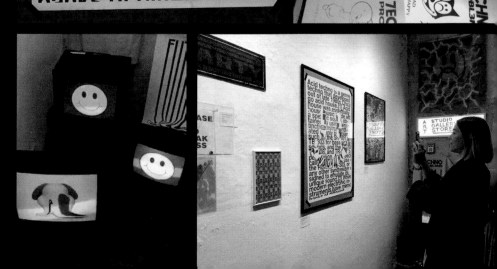

這是最有我個人特點的作品 —— 口袋小藝術品收藏系列。

當我開始在一個小袋子裏開發第一個圖形藝術作品時，我並不知道人們會這麼喜歡。「口袋印花」這一產品在最近幾年變得非常流行。

01

首先您可以通過拍攝一個自封袋或在網路上尋找相關素材作為項目的基底，並嘗試將主體與其結合。

02

針對選擇的主體，可以運用構成手法進行重塑再造，如疊加、替換、錯位等。

03

主體塑造完成後，首先確定配色，再根據版面需求，確定主體與文本放置的位置。在這張橙色印花中，設計師使用了Helvetica Neue Bold字體。

01

02

03

ABC
WHY

Technology ("science of craft", from Greek τέχνη, techne, "art, skill, cunning of hand"; and , -logia) is the sum of techniques, skills, methods, and processes used in the production of goods or services or in the accomplishment of objectives, such as scientific investigation. Technology can be the knowledge of techniques, processes, and the like, or it can be embedded in machines to allow for operation without detailed knowledge of their workings. Systems (eg. machines) applying technology by taking an input, changing it according to the system's use, and then producing an outcome are referred to as technology systems or technological systems.

The simplest form of technology is the development and use of basic tools. The prehistoric discovery of how to control fire and the later Neolithic Revolution increased the available sources of food, and the invention of the wheel helped humans to travel in and control their environment. Developments in historic times, including the printing press, the telephone, and the Internet, have lessened physical barriers to communication and allowed humans to interact freely on a global scale.

Technology has many effects. It has helped develop more advanced economies (including today's global economy) and has allowed the rise of a leisure class. Many technological processes produce unwanted by-products known as pollution and deplete natural resources to the detriment of Earth's environment. Innovations have always influenced the values of a society and raised new questions in the ethics of technology. Examples include the rise of the notion of efficiency in terms of human productivity, and the challenges of bioethics.

Philosophical debates have arisen over the use of technology, with disagreements over whether technology improves the human condition or worsens it. Neo-Luddism, anarcho-primitivism, and similar reactionary movements criticize the pervasiveness of technology, arguing that it harms the environment and alienates people; proponents of ideologies such as transhumanism and techno-progressivism view continued technological progress as beneficial to society and the human condition.

The use of the term "technology" has changed significantly over the last 200 years. Before the 20th century, the term was uncommon in English, and it was used either to refer to the description or study of the useful arts or to allude to technical education, as in the Massachusetts Institute of Technology (chartered in 1861).

The term "technology" rose to prominence in the 20th century in connection with the Second Industrial Revolution. The term's meanings changed in the early 20th century when American social scientists, beginning with Thorstein Veblen, translated ideas from the German concept of Technik into "technology." In German and other European languages, a distinction exists between technik and technologie that is absent in English, which usually translates both terms as "technology." By the 1930s, "technology" referred not only to the study of the industrial arts but to the industrial arts themselves.

In 1937, the American sociologist Read Bain wrote that "technology includes all tools, machines, utensils, weapons, instruments, housing, clothing, communicating and transporting devices and the skills by which we produce and use them." Bain's definition remains common among

scholars today, especially social scientists. Scientists and engineers usually prefer to define technology as applied science, rather than as the things that people make and use. More recently, scholars have borrowed from European philosophers of "technique" to extend the meaning of technology to various forms of instrumental reason, as in Foucault's work on technologies of the self (techniques de soi).

Dictionaries and scholars have offered a variety of definitions. The Merriam-Webster Learner's Dictionary offers a definition of the term "the use of science in industry, engineering, etc., to invent useful things or to solve problems" and "a machine, piece of equipment, method, etc., that is created by technology." Ursula Franklin, in her 1989 "Real World of Technology" lecture, gave another definition of the concept; it is "practice, the way we do things around here." The term is often used to imply a specific field of technology, or to refer to high technology or just consumer electronics, rather than technology as a whole. Bernard Stiegler, in Technics and Time, 1, defines technology in two ways: as "the pursuit of life by means other than life," and as "organized inorganic matter."

Technology can be most broadly defined as the entities, both material and immaterial, created by the application of mental and physical effort in order to achieve some value. In this usage, technology refers to tools and machines that may be used to solve real-world problems. It is a far-reaching term that may include simple tools, such as a crowbar or wooden spoon, or more complex machines, such as a space station or particle accelerator. Tools and machines need not be material; virtual technology, such as computer software and business methods, fall

under this definition of technology. Brian Arthur defines technology in a similarly broad way as "a means to fulfill a human purpose."

The word "technology" can also be used to refer to a collection of techniques. In this context, it is the current state of humanity's knowledge of how to combine resources to produce desired products, to solve problems, fulfill needs, or satisfy wants. It includes technical methods, skills, processes, techniques, tools and raw materials. When combined with another term, such as "medical technology" or "space technology," it refers to the state of the respective field's knowledge and tools. "State-of-the-art technology" refers to the high technology available to humanity in any field.

The invention of integrated circuits and the microprocessor (here, an Intel 4004 chip from 1971) led to the modern computer revolution. Technology can be viewed as an activity that forms or changes culture. Additionally, technology is the application of math, science, and the arts for the benefit of life as it is known. A modern example is the rise of communication technology, which has lessened barriers to human interaction and as a result has helped spawn new subcultures; the rise of cyberculture has at its basis the development of the Internet and the computer. Not all technology enhances culture in a creative way; technology can also help facilitate political oppression and war via tools such as guns. As a cultural activity, technology predates both science and engineering, each of which formalize some aspects of technological endeavor.

> 如何製作像素字體
怪誕像素

設計機構：Supernulla Creative Studio
設計師：Marcello Raffo
國家：義大利

在互聯網上，很難找到一種像素字體，具有能將像素和區塊形狀區分開的合適比例。

Pexel Grotesk 字體希望模仿一種無襯線字體的字母尺寸和比例，同時遵守嚴格的網格系統。有些字母雖然沒有經過設計，但我們認為它已經是像素字體。這讓字母之間變得有些不同，但同時保持一致。邊緣的圓度看起來不符合像素規則，卻使它們具備有趣的形狀，特別是以大字號使用的時候。

01

添加了金屬質感的 Pexel Grotesk 字體。

02

利用 Pexel Grotesk 字體設計的名片。

03

Pexel Grotesk 字體的大小寫字母、特殊字符、數字、符號和彩蛋的設計。

01

02

03

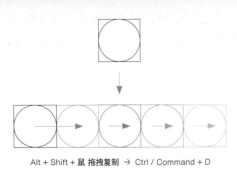

Alt + Shift + 鼠 拖拽复制 → Ctrl / Command + D

01

02

01

用Illustrator作為向量程序，使用0.25pt
黑色筆畫，無填色的樣式，繪製基於圓形和
正方形的網格作為模塊化基礎；並在此基礎
上，創建一個7x10模塊的網格。

您可以在完成單個圓形＋正方形子網格後，
按住Alt+Shift拖曳複製出另一個子網格，
然後按住Ctrl / Command連按D鍵複製出
多個子網格。

02

Ctrl / Command + A全選網格，然後執行
「對象 - 即時上色 - 建立」命令。此時，繪
製的網格已經創建成了一個即時上色組，以
方便接下來的操作。

03

 03

當網格轉換為即時上色組後,將「填色和筆畫」更改為填充黑色,無筆畫的狀態,並選擇「即時上色工具(K)」,然後依照網格單擊繪製出英文字母。

04

填充完字體後,全選網格,執行「對象 - 擴展」命令,然後 Ctrl / Command + Shift + G 取消群組,選擇黑色字體部分並刪除網格。

接著選中黑色字體,在「路徑管理員」面板點擊第一個按鈕「聯集」,將所有向量圖形合為一個整體。

04

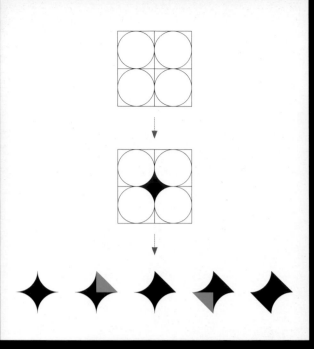

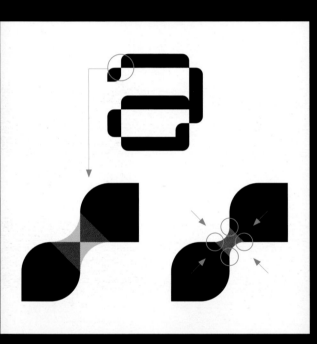

在上一步完成的字體中，邊角的轉折處沒有過渡，比較生硬，因此，我們需要繪製一個如圖的圖形來調整字體的轉角。

首先我們繪製4個與之前字體網格等大的子網格，並執行「對象 - 即時上色 - 建立」命令，然後用「即時上色工具（K）」填充中心交集的「菱形」區域。

填充後全選網格，然後執行「對象 - 擴展」命令，點擊 Ctrl / Command + Shift + G 取消群組，將中心黑色圖形取出，刪除網格。

使用鋼筆工具（P）將「菱形」的上端點與右端點、左端點與下端點以三角形的形狀連接，最終形成如圖的「桶型色塊」。

在路徑管理員面板，選中「桶型色塊」，點擊第一個按鈕「聯集」，將色塊拼合為整體。

06

將「桶型色塊」置於字體轉折處，並與轉折處保持中心對齊。選中「桶型色塊」，使用選取工具（V），並按住 Shift + Alt 從中心縮放，將「桶型色塊」的四個端點與字體邊緣處相切。

07

按照上述做法，將「桶型色塊」分別放置於字體的5處轉折處，形成圖 07 的效果。然後再次在路徑管理員面板執行「聯集」。

觀察字體，目前仍有 3 處邊角過渡不夠圓滑，我們使用「直接選取工具（A）」點擊邊角的錨點，會出現一個藍白相間的圓點，點擊不放並拖動這個圓點，即可改變邊角的曲率以調整局部的圓滑程度。

依照上述方法，在 Illustrator 中完成一整套字體的基本設計。

Part 2：Glyphs 調整並導出字體

09

將在 Illustrator 中設計完成的字母和符號複製黏貼到字體編輯器軟體 Glyphs 中，進行最後的字距和字符、字母間距調整，以獲得更好的視覺平衡。

字距調整：兩個特定字母的間距調整。

ABC → AB C

字符、字母間距調整：整段文本間距調整。

ABC → A B C

完成最終調整後，通過 Glyphs 導出字體文件並安裝就可以使用了。

MR. MITCH
PRIMARY PROGRESSIVE

PRIMARY PROGRESSIVE

A1. RESTART
A2. SETTLE
A3. PHANTOM
 DANCE
B1. SHOW ME
B2. CLOSURE

ALL TRACKS WRITTEN & PRODUCED BY MR. MITCH
MIXED BY PAUL BOYLAN & MR. MITCH
MASTERED BY BEAU @ TEN EIGHT SEVEN

ARTWORK & DESIGN BY ROSS AITKEN

gobstopper GOB028

創意總監：Ross Aitken
設計師：Ross Aitken
國家：英國
客戶：Mr. Mitch / Gobstopper Records

Miles（Mitch 先生）和我第一次見面是在
2016 年，當時我們在倫敦的廣播電台和唱
片公司 Rinse 工作。

2018 年，他請我為他即將發行的 EP 專輯
Primary Progressive 做藝術創作，這張
專輯將由他自己的唱片公司 Gobstopper
Records 發行。

這是我為 Miles 和 Gobstopper 所做的第一
個項目，從那以後，我就開始為該公司的大
部分作品進行藝術製作。

Part 1：音樂封套設計

01

上圖為唱片封套的封面，下圖為封底。

02

EP 的標題 Primary Progressive，是指原發
性進行性多發硬化症，邁爾斯的父親患有這
種疾病。這種病呈退行性，逐漸侵蝕患者的
身體和認知能力。這張專輯是關於 Miles 對
此進行沉思後的結果，以及這種疾病對 Miles
的影響，他與父親的關係等等。因此，我想
在作品中體現這種失落感和被破壞感。

項目使用字體：
Eurostile LT W 01 Bold Extended 2

03

唱盤設計沿用封套使用的字體，呈對稱編排。

04

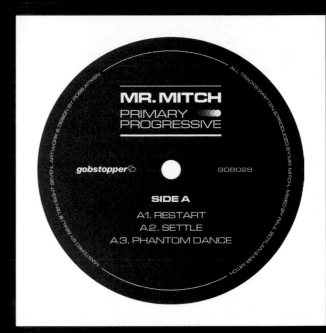

03

04

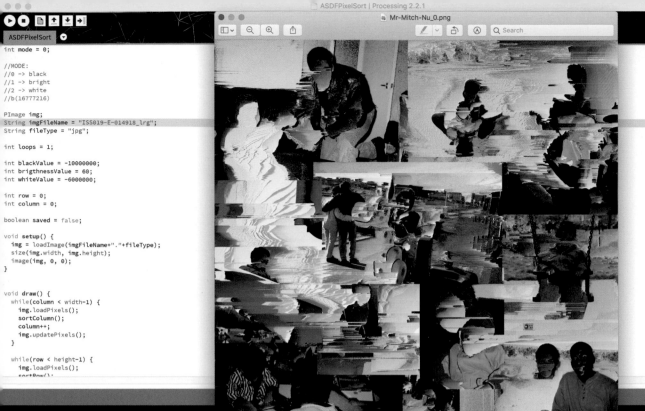

```
int mode = 0;

//MODE:
//0 -> black
//1 -> bright
//2 -> white
//b(16777216)

PImage img;
String imgFileName = "ISS019-E-014918_lrg";
String fileType = "jpg";

int loops = 1;

int blackValue = -10000000;
int brigthnessValue = 60;
int whiteValue = -6000000;

int row = 0;
int column = 0;

boolean saved = false;

void setup() {
  img = loadImage(imgFileName+"."+fileType);
  size(img.width, img.height);
  image(img, 0, 0);
}

void draw() {
  while(column < width-1) {
    img.loadPixels();
    sortColumn();
    column++;
    img.updatePixels();
  }

  while(row < height-1) {
    img.loadPixels();
    sortRow();
```

10

5

05

Processing 是一種開源編程語言，專門為
電子藝術和視覺交互設計而創建，其目的是
通過可視化的方式輔助編程教學，並在此基
礎之上表達數字創意。

具體來說，我使用了一種稱為像素排序的技
術，這是一種分離和重新排列像素線的過
程，導致圖像中出現熔化的、模糊失真的區
域。

在 EP 的封套設計中，採用了這些扭曲的圖
像作為封面和封底，並結合了簡單的粗體印
刷和模棱兩可的裝飾性符號，這是我作品中
常見的特徵。我使用了黑色的背景和白色的
文字，與照片鮮明的色彩形成強烈的對比。

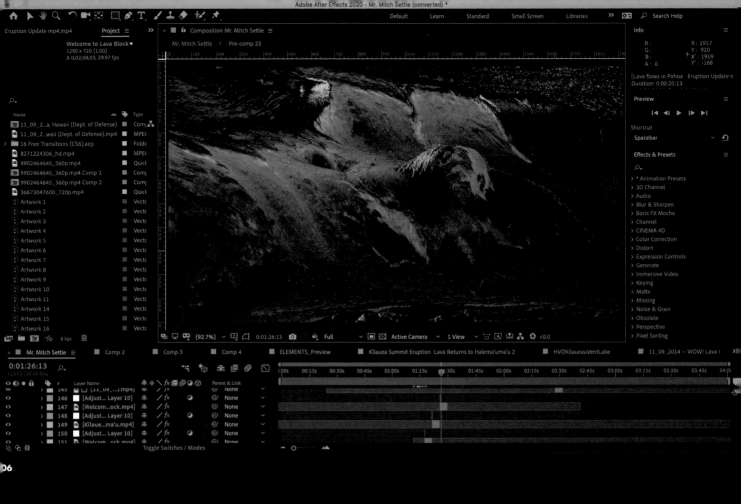

Part 2：影片製作

06

我還為 EP 的主打單曲 *Settle* 製作了一個音樂影片，使用了搜集的影片素材，結合動畫形狀和符號，類似於 EP 的藝術元素。我選擇了火山爆發和森林火災的鏡頭，這是對歌曲聲音樣本「you were not ready to settle down（關於安定，你還沒有準備好）」所暗示的不穩定性的充分反映。我使用 After Effects 對影片素材應用了相同的像素排列處理，這有助於通過這個項目的不同媒介創建一條一致的視覺線索。

總體上，我非常滿意這些扭曲的圖像，很好地反映出這張 EP 的情緒和潛在主題。這個項目也是我製作的第一個音樂影片，對我來說是一次很大的突破。

影片連結：https://www.instagram.com/p/BoPXkEfBbdn/

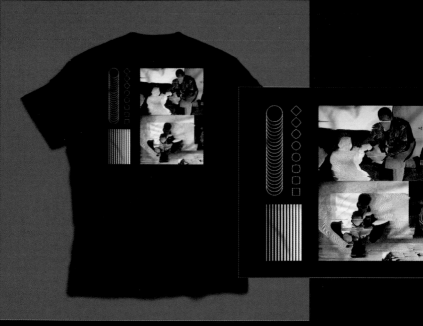

07

08

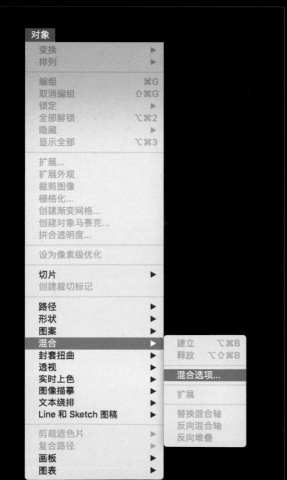

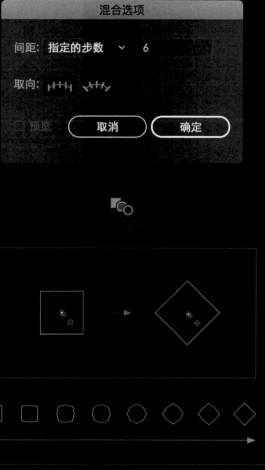

混合选项

间距: 指定的步数 ∨ 6

取向: ꜀꜀꜀꜀ ꜀꜀꜀꜀

□ 预览 （ 取消 ） （ 确定 ）

对象

变换	▶
排列	▶
编组	⌘G
取消编组	⇧⌘G
锁定	▶
全部解锁	⌥⌘2
隐藏	▶
显示全部	⌥⌘3
扩展...	
扩展外观	
裁剪图像	
栅格化...	
创建渐变网格...	
创建对象马赛克...	
拼合透明度...	
设为像素级优化	
切片	▶
创建裁切标记	
路径	▶
形状	▶
图案	▶
混合	▶
封套扭曲	▶
透视	▶
实时上色	▶
图像描摹	▶
文本绕排	▶
Line 和 Sketch 图稿	▶
剪裁遮色片	▶
复合路径	▶
画板	▶
图表	▶

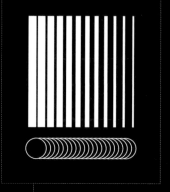

在彈出面板中選擇「間距 - 指定階數 - 6」，並點擊確定。

在工具欄找到漸變工具，首先點擊起始圖形正方形，將鼠標移動至結束圖形菱形時會看見「+」，點擊，即可完成指定步數變形的操作。

11

在完成上述步驟後，執行「物件 - 展開」命令，讓製作的圖形轉換為可編輯的狀態。

運用漸變工具，可以通過算法演化出從起始圖形到結束圖形變化的過程，值得注意的是，圖11下方的圖形漸變，需要明確起始端和結束端圖形的圖層順序，漸變工具會按照圖層順序從靠後的圖層向靠前的圖層執行漸變。

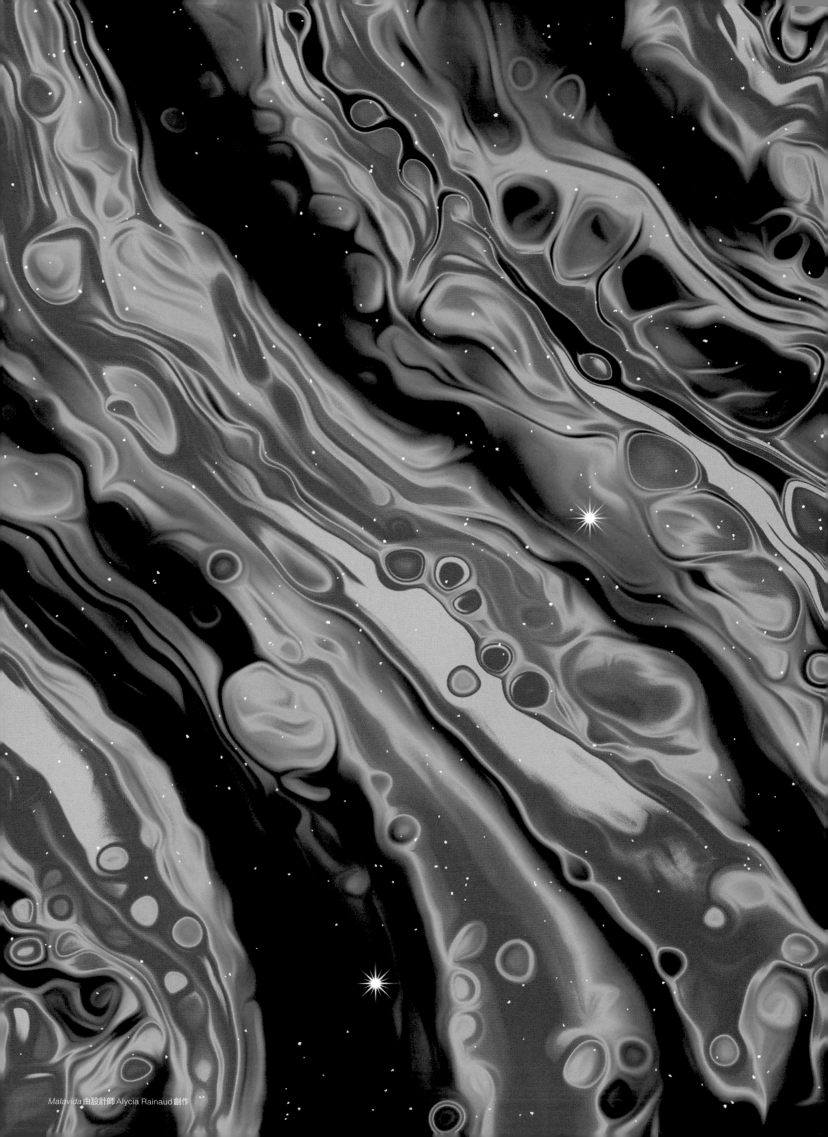
Malavida 由設計師 Alycia Rainaud 創作

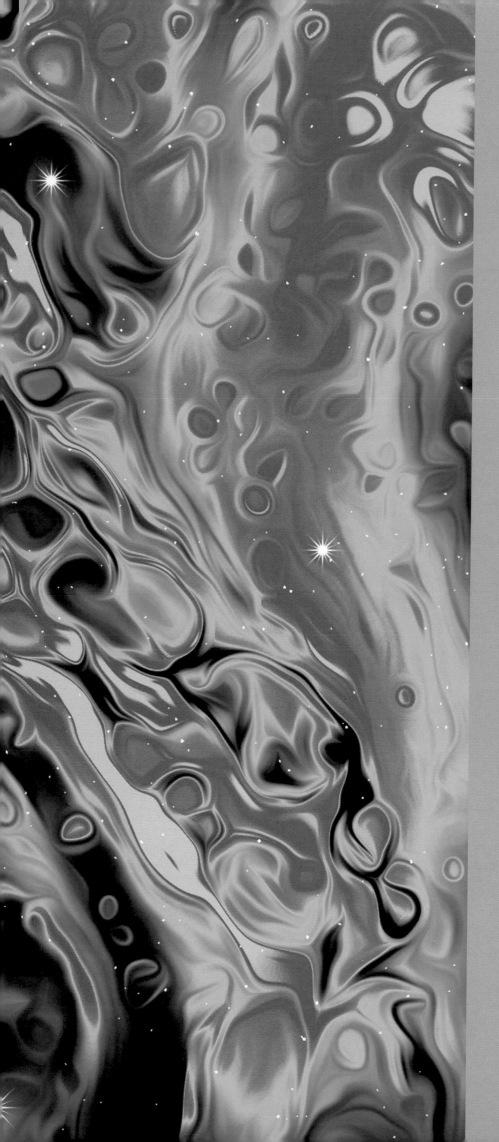

ILLUSION

「酸性平面（Acid Graphic）」是當下平面視覺設計中
非常流行的美學風潮。它由現代工具創造，具備「超級
新潮」的外觀，通過充滿活力的排版和使用重金屬風格
的瘋狂字體，呈現出一種違反常規的20世紀90年代
派對傳單的風格。這種充滿靈性的設計風格，早期更多
存在於相對自由的音樂行業。而隨著接受度的逐漸擴
大，這類設計風格也越來越多地被運用到其他行業的平
面表達中。

在這種風格的設計元素中，幾何形狀和鋸齒字體尤其受
到歡迎。這些字體被賦予太空飛船般的銀色、水紋光澤
的霓虹、拋光的磨砂黑等3D紋理等效果，甚至帶有熔
化鉛管滴下的水滴形曲線。它們被人們稱為「液態金屬
（Liquid Metal）」。這種圖形和字體不僅營造出一種未
來主義氛圍，同時體現了對設計界的極簡主義趨勢的再
次反叛。

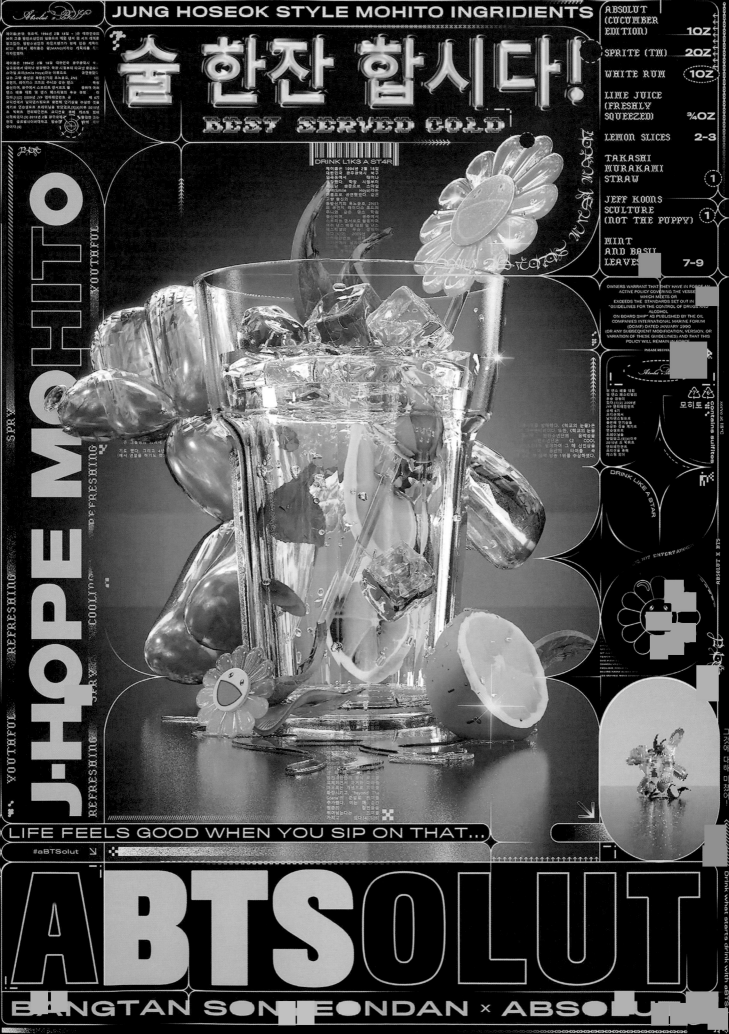

絕對 BTS

創意總監：Maria Nowicka
設計師：Maria Nowicka
國家：波蘭

ABTSOLUT 是我對傳統市場營銷海報的挑戰 —— 受絕對伏特加（Absolut VODKA）海報系列的啟發，用單一的斜角度光源點亮烈酒瓶。ABTSOLUT 是由「絕對」（ABSOLUT）+韓國組合「BTS」的名字進行文字混搭組合而成。我把BTS小組中的每個成員都化成不同的酒。

概念圍繞著用超現實的元素構建的7種不同的酒精飲料，突出7位BTS成員之間的不同個性，使得這些雞尾酒對觀眾來說顯得非常直觀，在購買酒精飲料的同時搭載這種幻想。

一切都始於玻璃形狀如何改變飲用體驗並賦予雞尾酒個性的概念。我為每種飲料收集3D對象（使用Cinema4D）並進行排列，創建了7種不同的3D雞尾酒。然後使用類似於老式「ABSOLUT」海報的燈光裝置進行渲染。在平面設計方面，使用Photoshop處理了7種不同的構圖，並添加了與飲品或歌手本人有關的細節。我還加入了自己創建的飲料配方，以強調飲料的超現實性。

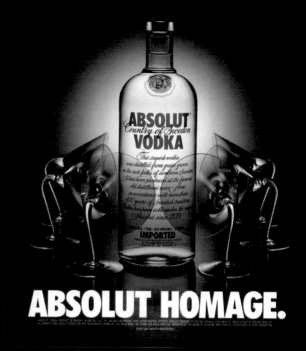

01《絕對伏特加》海報。

ABTSOLUT
BANGTAN SONYEONDAN × ABSOLUT

使用字體：Titling Gothic Family

술 한잔 합시다!

使用字體：Malgun Gothic

BEST SERVED COLD

使用字體：Ghouls Ghosts Goblins font

LEMON SLICES

使用字體：Embroidery Regular

使用字體：1413 - Gothique Cursive

REFRESHING

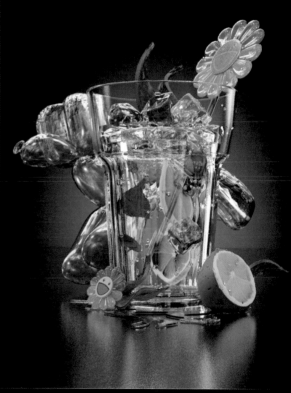

02 Cinema4D渲染的酒瓶，採用了與《絕對伏特加》海報相似的打光方式。

03 海報中使用了多款字體進行混合搭配，使用了多種裝飾元素並採用了漸變的方法。

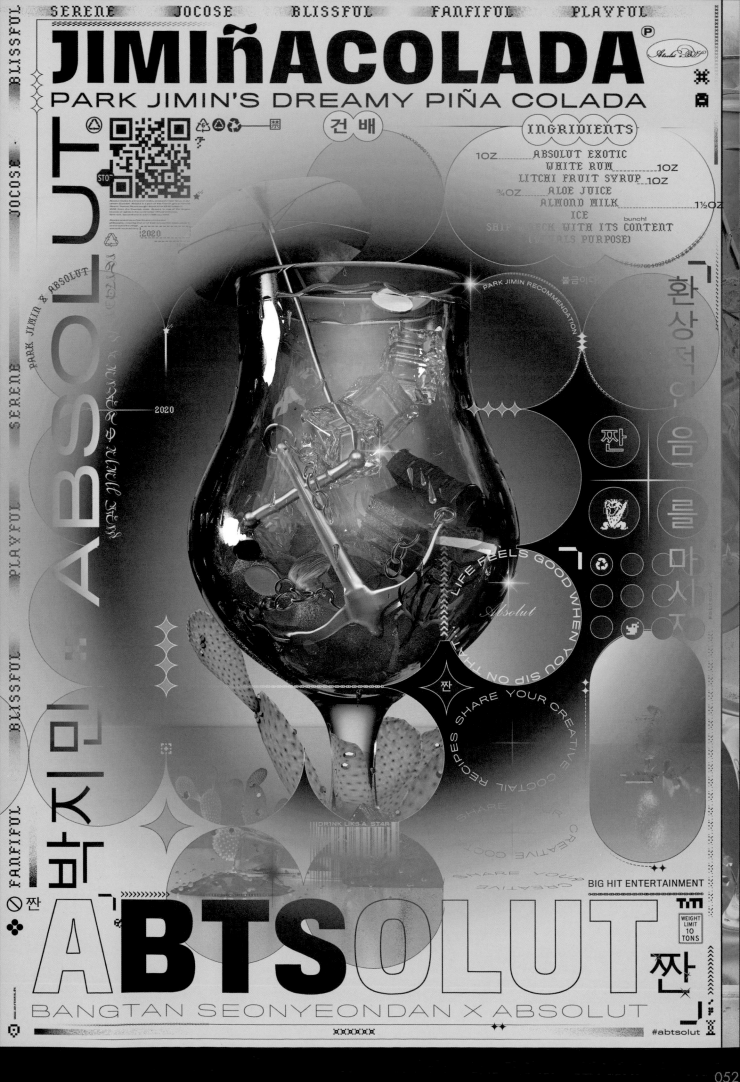

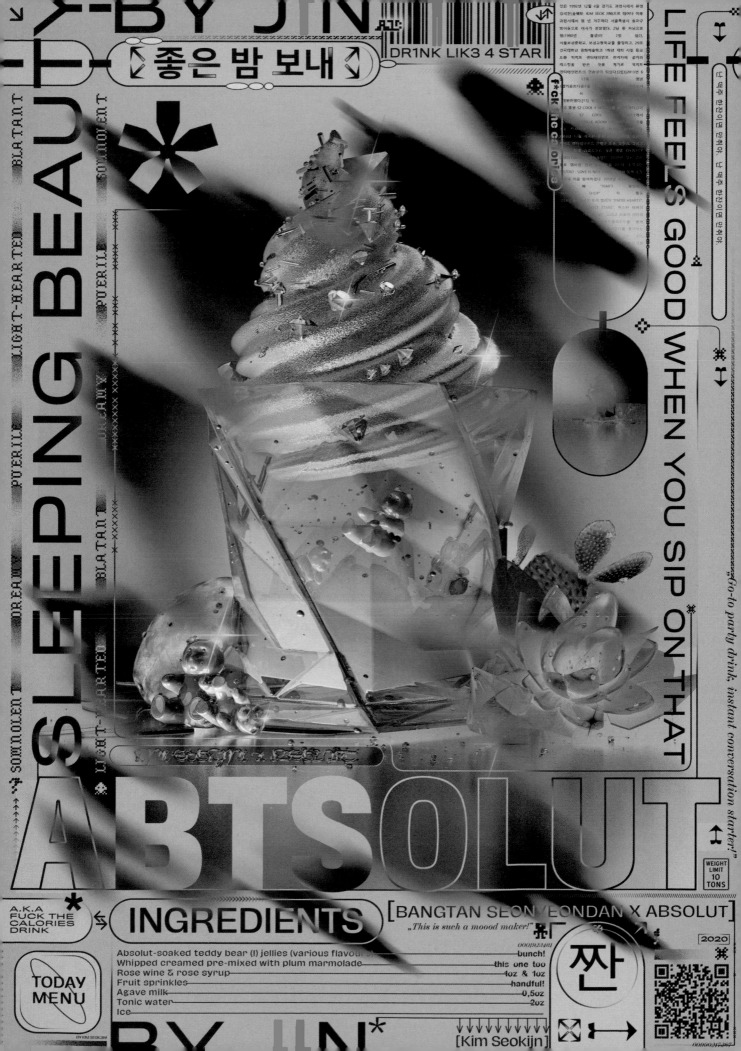

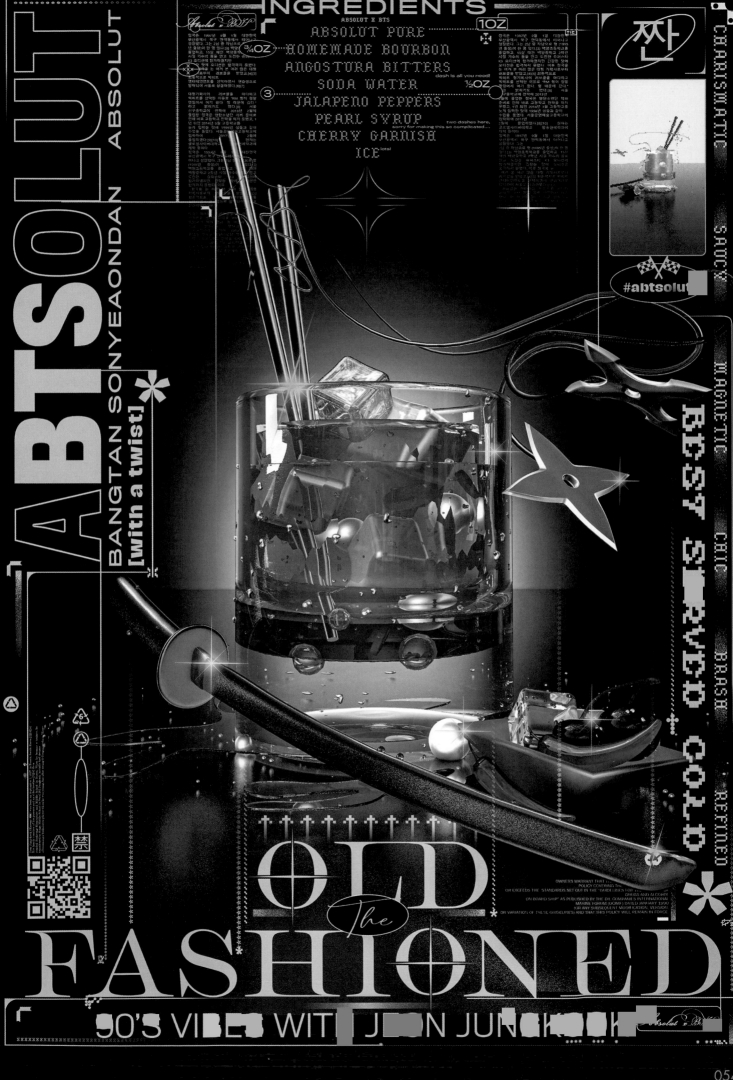

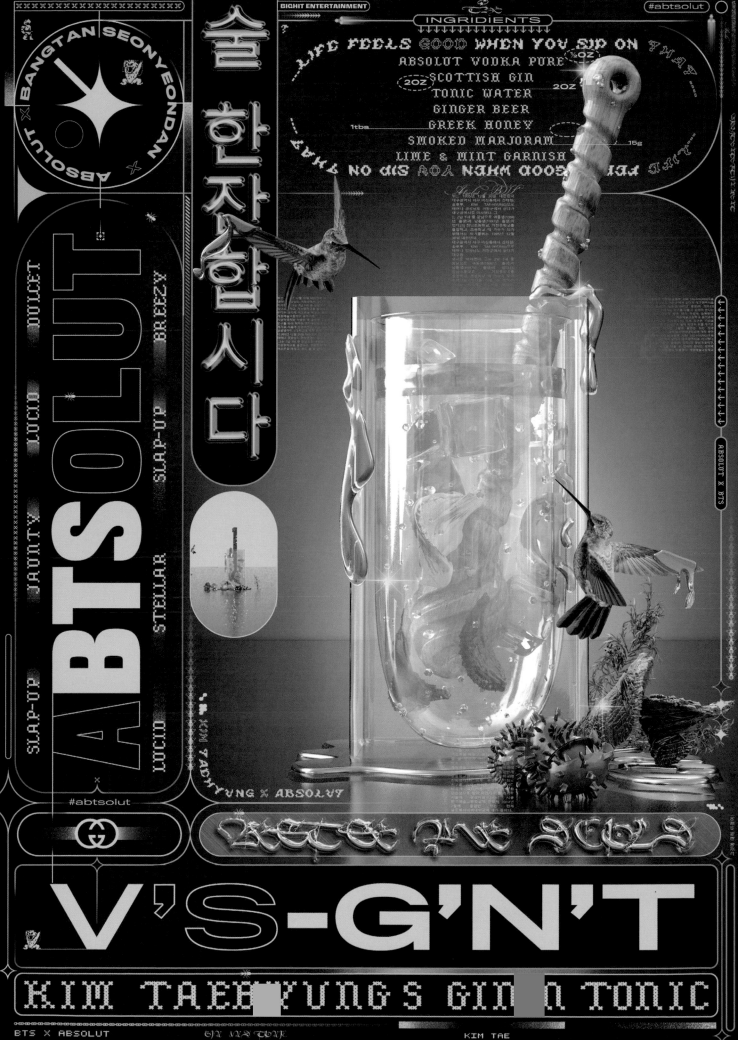

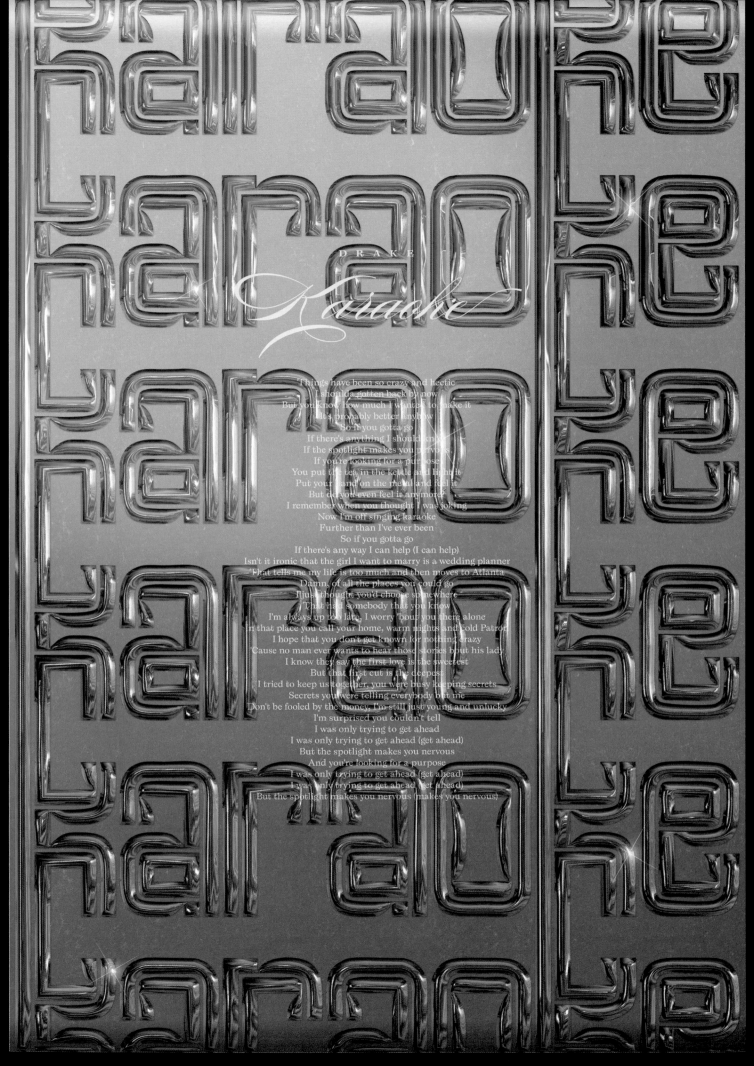

DRAKE

Karaoke

Things have been so crazy and hectic
I shoulda gotten back by now
But you know how much I wanted to make it
It's probably better anyhow
So if you gotta go
If there's anything I should know
If the spotlight makes you nervous
If you're looking for a purpose
You put the tea in the kettle and light it
Put your hand on the metal and feel it
But do you even feel is anymore?
I remember when you thought I was joking
Now I'm off singing karaoke
Further than I've ever been
So if you gotta go
If there's any way I can help (I can help)
Isn't it ironic that the girl I want to marry is a wedding planner
That tells me my life is too much and then moves to Atlanta
Damn, of all the places you could go
I just thought you'd choose somewhere
That had somebody that you know
I'm always up too late, I worry 'bout you there alone
In that place you call your home, warm nights and Cold Patron
I hope that you don't get known for nothing crazy
'Cause no man ever wants to hear those stories 'bout his lady
I know they say the first love is the sweetest
But that first cut is the deepest
I tried to keep us together, you were busy keeping secrets
Secrets you were telling everybody but me
Don't be fooled by the money, I'm still just young and unlucky
I'm surprised you couldn't tell
I was only trying to get ahead
I was only trying to get ahead (get ahead)
But the spotlight makes you nervous
And you're looking for a purpose
I was only trying to get ahead (get ahead)
I was only trying to get ahead (get ahead)
But the spotlight makes you nervous (makes you nervous)

這個項目並沒有確切的簡介。其實做自己的個人項目，很多時候不一定是從某個具體的目標開始的。在這種情況下，我更多的是將自己對排版的興趣、新的三維字母呈現技術和我對音樂的熱情這三者結合起來進行創作。

01 這個項目的概念是設計一個版式，將已有的音樂文本（'Karaoke'- Drake），做出一個符合感覺的字體和構圖。為了實現這個項目，我想使用我正在設計的字體（一種內聯等距字體），輔以新的處理技術。我選擇了鉻合金，因為它是一種讓我非常著迷的金屬。

Things have been so crazy and hectic
I shoulda gotten back by now
But you know how much I wanted to make it
It's probably better anyhow
So if you gotta go
If there's anything I should know
If the spotlight makes you nervous
If you're looking for a purpose
You put the tea in the kettle and light it
Put your hand on the metal and feel it
But do you even feel it anymore?
I remember when you thought I was joking

karaoke

Things have been so crazy and hectic

02 這個項目的一個重要特點是它的字體。背景中的單行距字體非常現代，很適合重複作為背景，而歌詞文本的字體採

03 背景單詞中的字母「K」，左邊的一豎採用了貫通的方式，將上

04 金屬字體使用 Glyphs 軟體設計，上圖為字體設計的錨點分布與細節。

05 建立一個 7×5.5 的網格系統，淡藍色區域放置背景內容。

06 在中心建立一個 3×4 的網格，淡藍色區域放置歌詞內容。

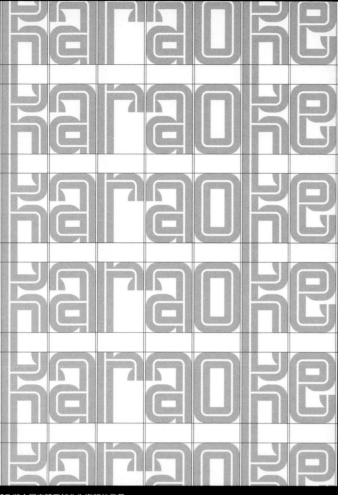

07 將金屬字體平鋪作為海報的背景。

08 將歌詞放置在中心的淡藍色區域。

09 第1行網格放置標題字體，第2～4行網格放置歌詞，並採用置中的方式進行排版。

10 整體排版效果。

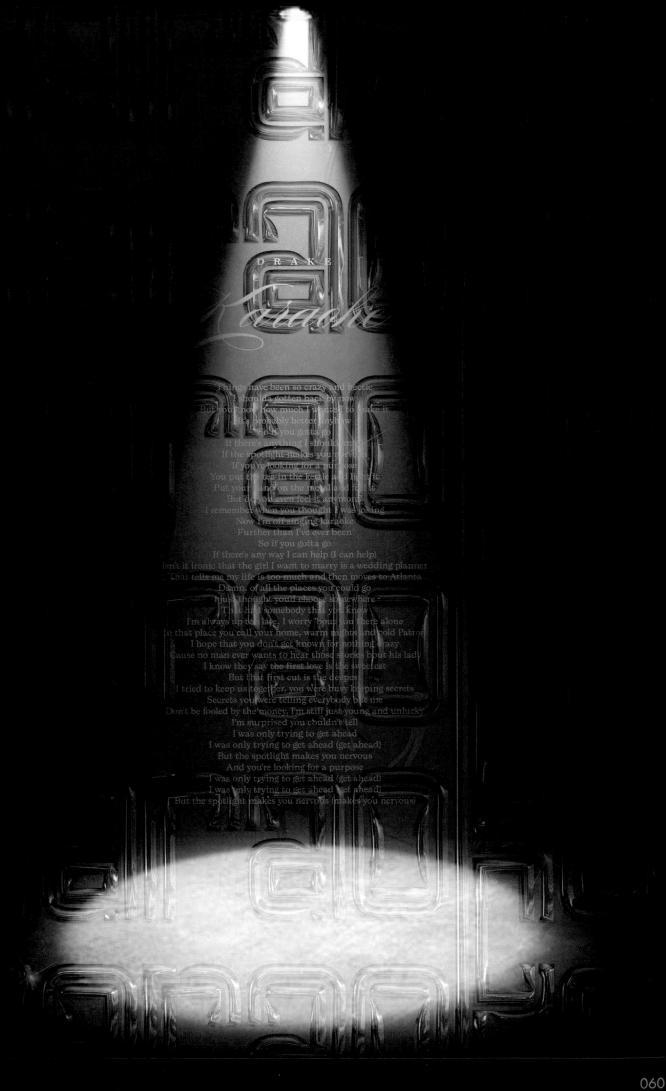

DRAKE

Karaoke

Things have been so crazy and hectic
I shoulda gotten back by now
But you know how much I wanted to make it
It's probably better anyhow
So if you gotta go
If there's anything I should know
If the spotlight makes you nervous
If you're looking for a purpose
You put the tea in the kettle and light it
Put your hand on the metal and feel it
But do you even feel it anymore?
I remember when you thought I was joking
Now I'm off singing karaoke
Further than I've ever been
So if you gotta go
If there's any way I can help (I can help)
Isn't it ironic that the girl I want to marry is a wedding planner
That tells me my life is too much and then moves to Atlanta
Damn, of all the places you could go
I just thought you'd choose somewhere
That had somebody that you know
I'm always up too late, I worry 'bout you there alone
In that place you call your home, warm nights and cold Patron
I hope that you don't get known for nothing crazy
'Cause no man ever wants to hear those stories 'bout his lady
I know they say the first love is the sweetest
But that first cut is the deepest
I tried to keep us together, you were busy keeping secrets
Secrets you were telling everybody but me
Don't be fooled by the money, I'm still just young and unlucky
I'm surprised you couldn't tell
I was only trying to get ahead
I was only trying to get ahead (get ahead)
But the spotlight makes you nervous
And you're looking for a purpose
I was only trying to get ahead (get ahead)
I was only trying to get ahead (get ahead)
But the spotlight makes you nervous (makes you nervous)

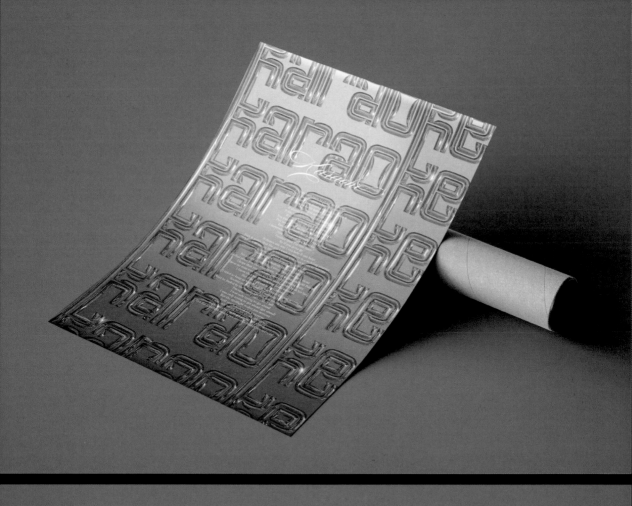

11 設計師的目標是設計兩張印刷海報來承載音樂文本，使它呈現神聖感。最終結果是同一張海報的兩個不同版本，尺寸為 70 cm×100 cm。

BALI BABY

BY

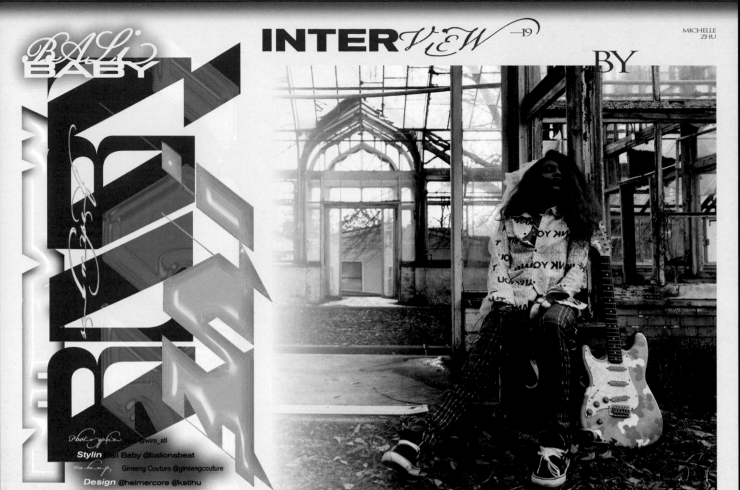

Photographie Nuno @wire_atl

Stylin Bali Baby @balionabeat

make-up Ginseng Couture @ginsengcouture

Design @heimercore @kstihu

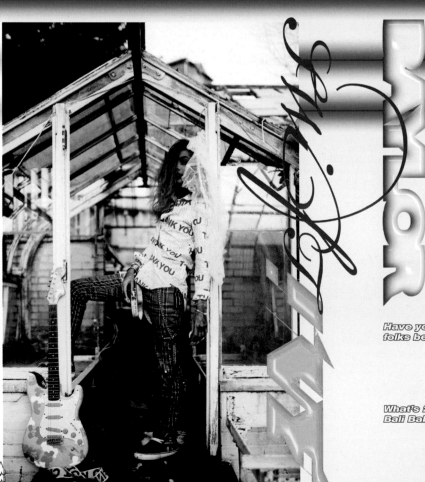

You draw so many references to different females in the music industry — who do you currently draw inspiration from?

Myself!

The music styles and genres you take on are so broad — what kind of fashion styles do you like to adapt in your videos?

Well i HAVE to stand out like i have to be dressed like im finna accept an award or something lol like i dress extravagant everyday i could be just going to the mailbox, still drippin. I love clothes & shoes & accessories thats gonna be my BIGGEST addiction when im FAMOUS like ughh i love it. Wait till im collabing with big brands omg its OVA FOR U HOES

Being an openly queer rapper, how have people and communities responded to your work?

Its been a lil roller coaster because ive had girlfriends AND boyfriends so people say me being gay is fake or whatever but this shit 100% real baby eat da kitty & all im deep in this shit ok but foreal though i like what i like & thats that & EVERYONE that accepts it i love you all & everyone like me FUCK WHAT THEY THINK! i do get TONS of love from the LGBT community they are my favs so fun <333

Have you ever felt tokenized by folks because of your queerness?

Not yet because its not super out there i dont really broadcast it you would just know if you know ! Lately ive been trying to put more of a voice on it because it was so much controversy around me being gay or bi so i had to correct it, but for the most part no issues yet

What's 2019 going to be like for Bali Baby?

EXTREME EPIC WILD EXCITING FUNNNNNNN

we are setting the BAR next year funbyyy ok so much in store outside of music its great im happy & excited to show the world!

BALi BABY

BRAZY BALi

BALi BABY BALi BABY

01 字體採用無襯線體＋花體的方式進行組合，通過拉開字型、字重、質感上的對比，賦予文字極強的裝飾性，從而成為版面的視覺焦點。

You draw so many references to different females in the music industry -- who do you currently draw inspiration from?

Myself!

The music styles and genres you take on are so broad — what kind of fashion styles do you like to adapt in your videos?

Well i HAVE to stand out like i have to be dressed like im finna accept an award or something lol like i dress extravagant everyday i could be just going to the mailbox, still drippin. I love clothes & shoes & accessories thats gonna be my BIGGEST addiction when im FAMOUS like ughh i love it. Wait till im collabing with big brands omg its OVA FOR U HOES

Being an openly queer rapper, how have people and communities responded to your work?

Its been a lil roller coaster because ive had girlfriends AND boyfriends so people say me being gay is fake or whatever but this shit 100% real baby eat da kitty & all im deep in this shit ok but foreal though i like what i like & thats that & EVERYONE that accepts it i love you all & everyone like me FUCK WHAT THEY THINK! i do get TONS of love from the LGBT community they are my favs so fun <333

Have you ever felt tokenized by folks because of your queerness?

Not yet because its not super out there i dont really broadcast it you would just know if you know ! Lately ive been trying to put more of a voice on it because it was so much controversy around me being gay or bi so i had to correct it, but for the most part no issues yet

What's 2019 going to be like for Bali Baby?

EXTREME EPIC WILD EXCITING FUNNNNNNN

we are setting the BAR next year puntyyyy ok so much in store outside of music its great im happy & excited to show the world!

02 版面左側放置主圖，利用文字破邊，增加畫面層次。版面右側遵循清晰合理的編排邏輯，採訪問題使用大字號、反白、筆畫的粗斜體，回答使用黑色的常規體，問、答位置錯開，且上下具有一定的對齊關係。

Have you had a good year?

Yes ive have an AMAZING year! Ive gotten so much done & surpasses so many accomplishments i made for myself & to see my Spotify numbers to be at 14 MILLION plays this year, im geeked!!

You integrate rock music and trap, so you clearly love experimentation and mixing thingsthat inspire you. What else do you want to incorporate into your music?

I want to start incorporating more switch ups – i wanna start making wild ass songs thats many genres in one like everyone likes something about the song.

What emotions do you channel when you make and perform your songs?

BRAZY BALI !!!!! She is the wild aggressive energy i love to channel in the studio and especially at shows with all the energy my fans give me. Like i will be all shy & quiet before i get in the booth or on the stage & as soon as its time i juts burst with the BRAZY.

I sensed some heartbreak on your album Baylor Swift, was making that album a form of therapy for your heartache?

Yes it was. I was going thru a huge breakup with my ex-girlfriend & i had sooo many emotions i didnt know what to do at first but i put it all into the booth & thats how Baylor Swift came alive. It healed me because music is so therapeutic to me.

How do you heal when you make music?

Because its my form of expression myself. Like if you wanna know how my life is at the moment just listen to my lastest track ive released. Talking stuff out is foreal the best way to heal through WHATEVER !

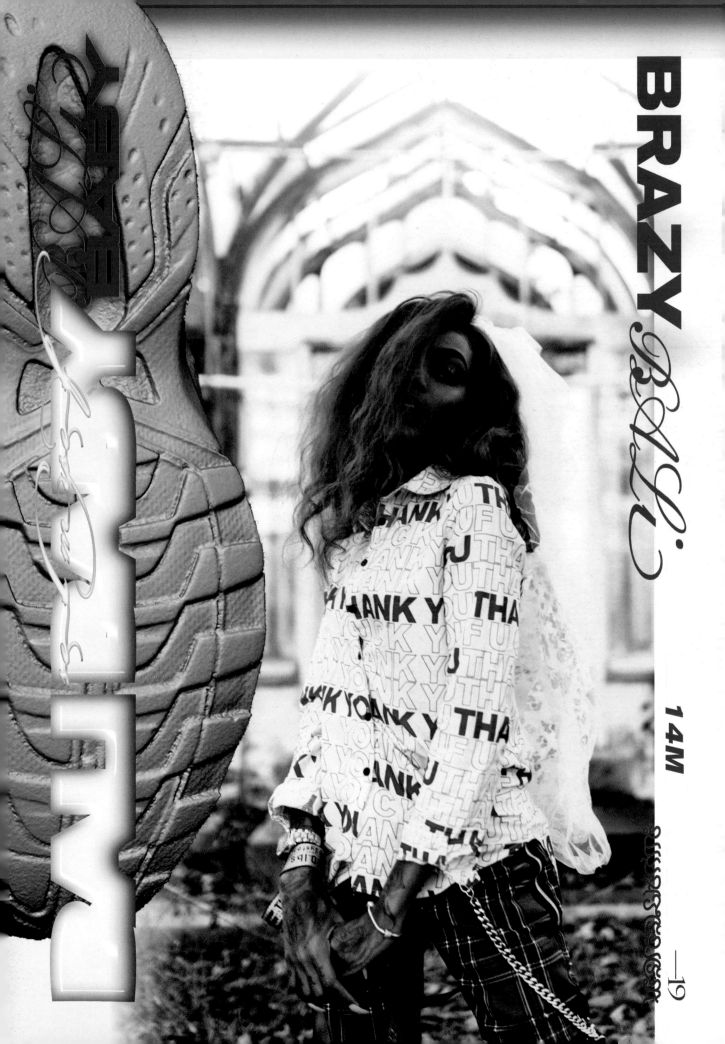

BRAZY *BABii*

14M

—19

MONTREUX
JAZZ FESTIVAL
54TH EDITION
SWITZERLAND

PROGRAMME

蒙特婁爵士節

設計機構：Daytona Mess
創意總監：Daytona Mess
設計師：Daytona Mess / Anne-Dauphine
Borione
國家：法國
客戶：ECV Paris

這個項目是為蒙特婁爵士音樂節製作官方海
報。在研究了音樂節中爵士樂的視覺表現之
後，我對本屆音樂節的形象有了大概的設
想。

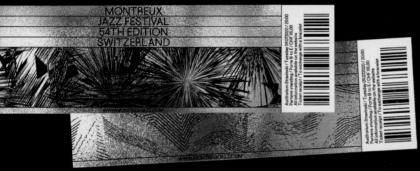

01 海報版式的設計邏輯清晰，以平行的橫線分割標題、副標題與
正文內容，文字以置中式編排，全字母大寫；畫面中心淡藍色區域
放置不同的頻譜圖，底色背景也隨之產生變化。

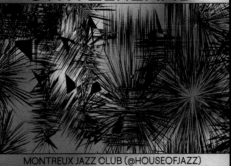

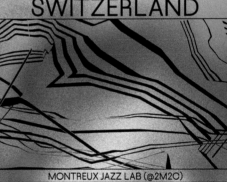

02 我創建了一個系統，使用了原色的顆粒漸變，黃色是最突出的顏色，結構化的排版和網格來自瑞士平面設計傳統，視覺靈感來自音頻波、鋼琴線和五線譜。

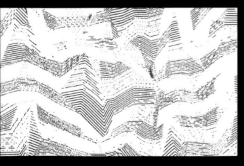

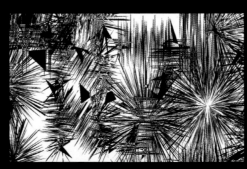

03 這個項目的目標是創造一種既不刻板也不具象的特徵，但仍然能保留節日的歡快氣氛和派對的理念，保留爵士樂的抽象特性。這樣一來，每一個版面的視覺都是獨一無二的，而且是半隨機產生的，象徵著
節日演奏和常規爵士樂演奏的細微差別。

SIR ELTON JOHN

Sir Elton Hercules John CBE (born Reginald Kenneth Dwight; 25 March 1947) is an English singer, songwriter, pianist, and composer. He has worked with lyricist Bernie Taupin since 1967; they have collaborated on more than 30 albums. John has sold more than 300 million records, making him one of the world's best-selling music artists. He has more than fifty Top 40 hits, as well as seven consecutive number-one albums in the United States, 58 Billboard Top 40 singles, 27 Top 10 singles, four of which peaked at number two and nine of which reached number one. His tribute single "Candle in the Wind 1997", rewritten in dedication to Diana, Princess of Wales, sold over 33 million copies worldwide and is the best-selling single in the history of the UK and US singles charts. He has also produced records and occasionally acted in films. John owned Watford F.C. from 1976 to 1987 and from 1997 to 2002, and is an honorary Life President of the club.

Raised in the Pinner area of London, John learned to play piano at an early age, and by 1962 had formed Bluesology, an R&B band with whom he played until 1967. He met his longtime musical partner Taupin in 1967, after they both answered an advert for songwriters. For two years they wrote songs for artists including Lulu, and John worked as a session musician for artists including the Hollies and the Scaffold. In 1969 John's debut album, Empty Sky, was released. In 1970 his first hit single, "Your Song", from his second album, Elton John, reached the top ten in the UK and the US. John has also had success in musical films and theatre, composing for The Lion King and its stage adaptation, Aida and Billy Elliot the Musical.

John has received five Grammy Awards, five Brit Awards, an Academy Award, a Golden Globe Award, a Tony Award, a Disney Legends award, and the Kennedy Center Honor. In 2004 Rolling Stone ranked him 49th on its list of 100 influential musicians of the rock and roll era. In 2013 Billboard ranked him the most successful male solo artist on the Billboard Hot 100 Top All-Time Artists, and third overall, behind the Beatles and Madonna. He was inducted into the Rock and Roll Hall of Fame in 1994 and the Songwriters Hall of Fame in 1992, and is a fellow of the British Academy of Songwriters, Composers and Authors. He was knighted by Elizabeth II for "services to music and charitable services" in 1998. John has performed at a number of royal events, such as the funeral of Princess Diana at Westminster Abbey in 1997, the Party at the Palace in 2002 and the Queen's Diamond Jubilee Concert outside Buckingham Palace in 2012.

John has been involved in the fight against AIDS since the late 1980s. In 1992 he established the Elton John AIDS Foundation and a year later he began hosting his annual Academy Awards Party, which has since become one of the highest-profile Oscar parties in the Hollywood film industry. Since its inception the foundation has raised over £300 million. John, who announced he was bisexual in 1976 and has been openly gay since 1988, entered into a civil partnership with David Furnish on 21 December 2005; they married after same-sex marriage became legal in England and Wales in 2014. Presenting John with France's highest civilian award, the Legion d'honneur, in 2019, French President Emmanuel Macron called him a "melodic genius" and praised his work on behalf of the LGBT community. In 2018 John embarked on a three-year farewell tour.

FAREWELL YELLOW BRICK ROAD TOUR

STADE DE LA SAUSSAZ, MONTREUX

SATURDAY JUNE 29TH

STARTING FROM 185 CHF

AaBbCcDdEe
FfGgHhIiJjKkLlMm
NnOoPpQqRrSs
TtUuVvWwXxYyZz
0123456789

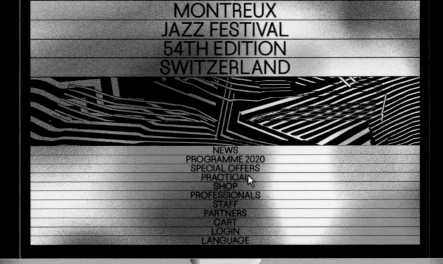

NEWS
PROGRAMME 2020
SPECIAL OFFERS
PRACTICAL
SHOP
PROFESSIONALS
STAFF
PARTNERS
CART
LOGIN
LANGUAGE

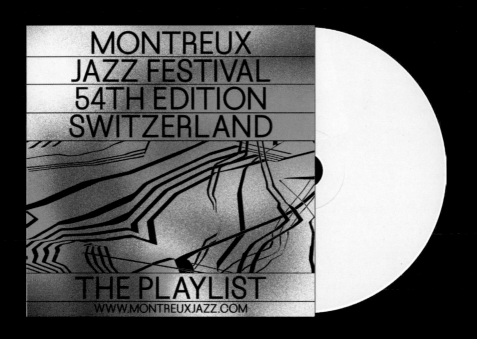

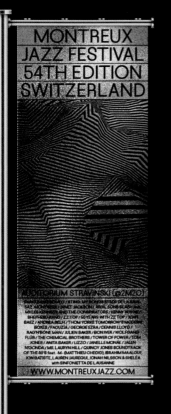

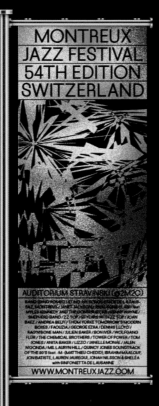

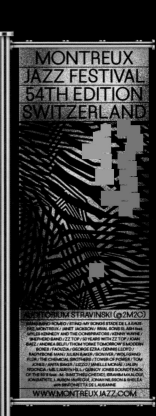

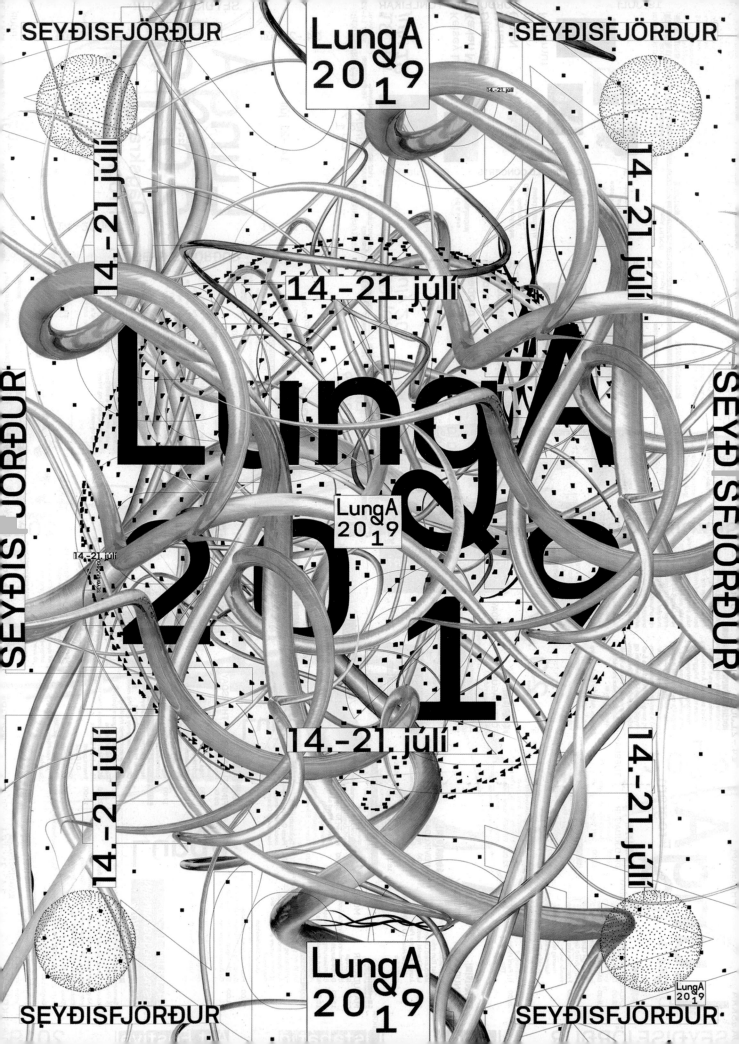

LungA 藝術節 2019

創意總監：Greta Thorkels
設計師：Greta Thorkels
國家：冰島
客戶：LungA Festival
攝影師：Greta Thorkels

LungA 藝術節是位於冰島最東部的城鎮塞濟斯菲厄澤（Seyðisfjörður）的地方性藝術和表演節日。它自2000年以來每年舉行一次，包括音樂會、表演，與世界知名藝術家和設計師進行的為期一周的研討會以及座談會。多年來，該音樂節已經確立了其在冰島藝術界的重要地位。

該創意概念根據當年的主題「未來展望」而定。一個難以描述的網格星球是設計走向的基礎。畫面以 Cinema 4D 渲染，並在 Indesign 中組合成拼貼風格。

大海報和節目宣傳單使用 Cyclus 膠版印刷。宣發用的傳單則採用 Cyclus 上的雷射打印。最突出的視覺效果莫過於使用3D渲染的「管子」、亂序的布局和DIY感覺。

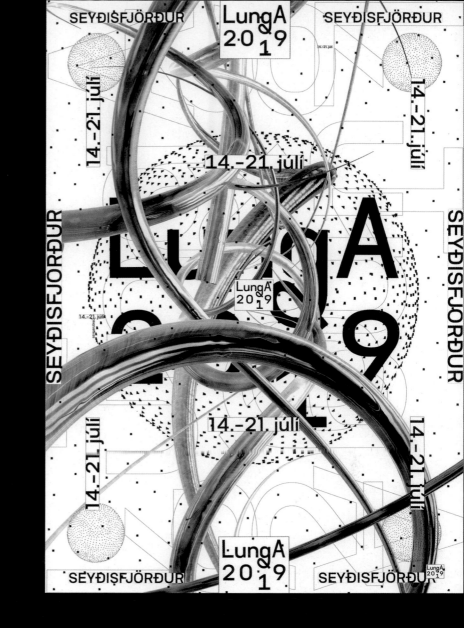

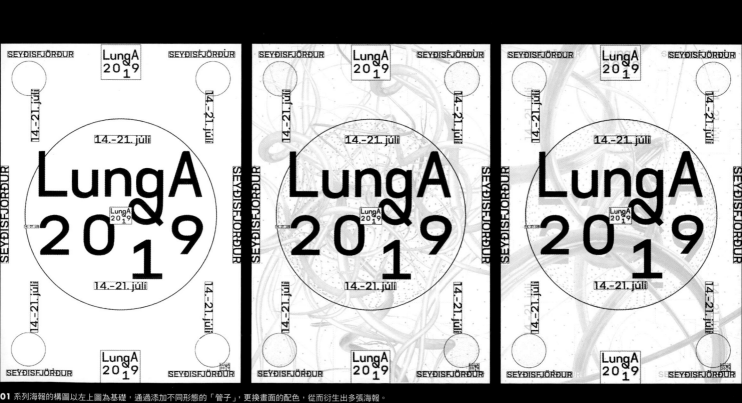

01 系列海報的構圖以左上圖為基礎，通過添加不同形態的「管子」，更換畫面的配色，從而衍生出多張海報。

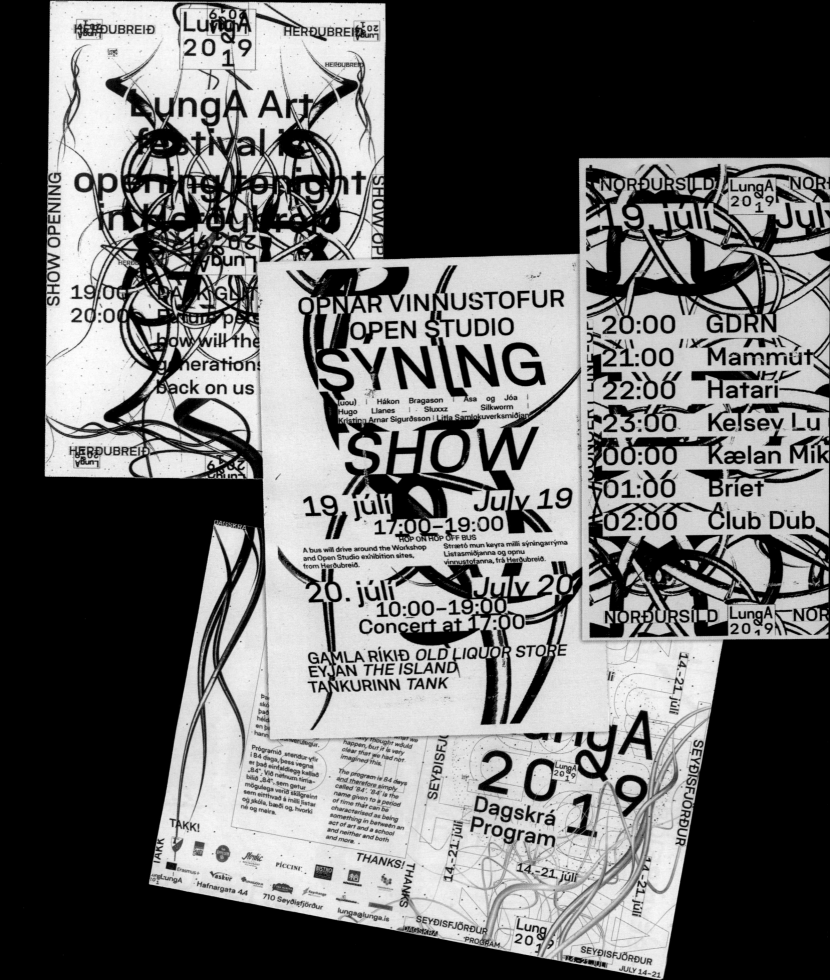

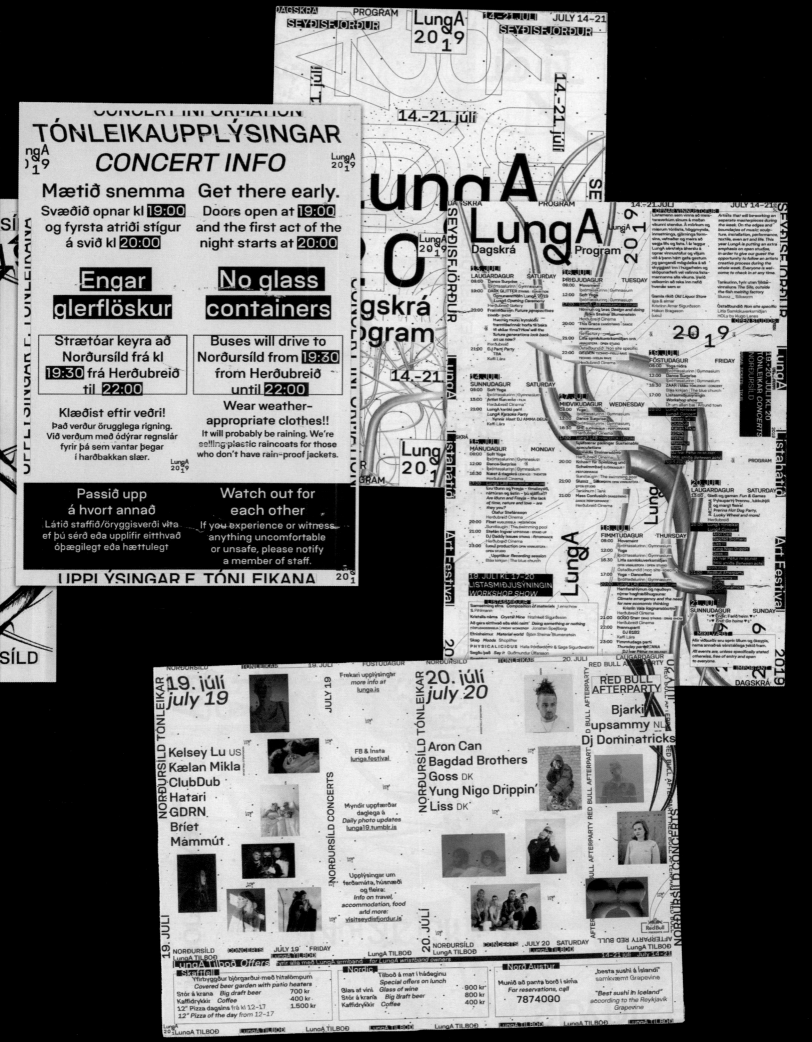

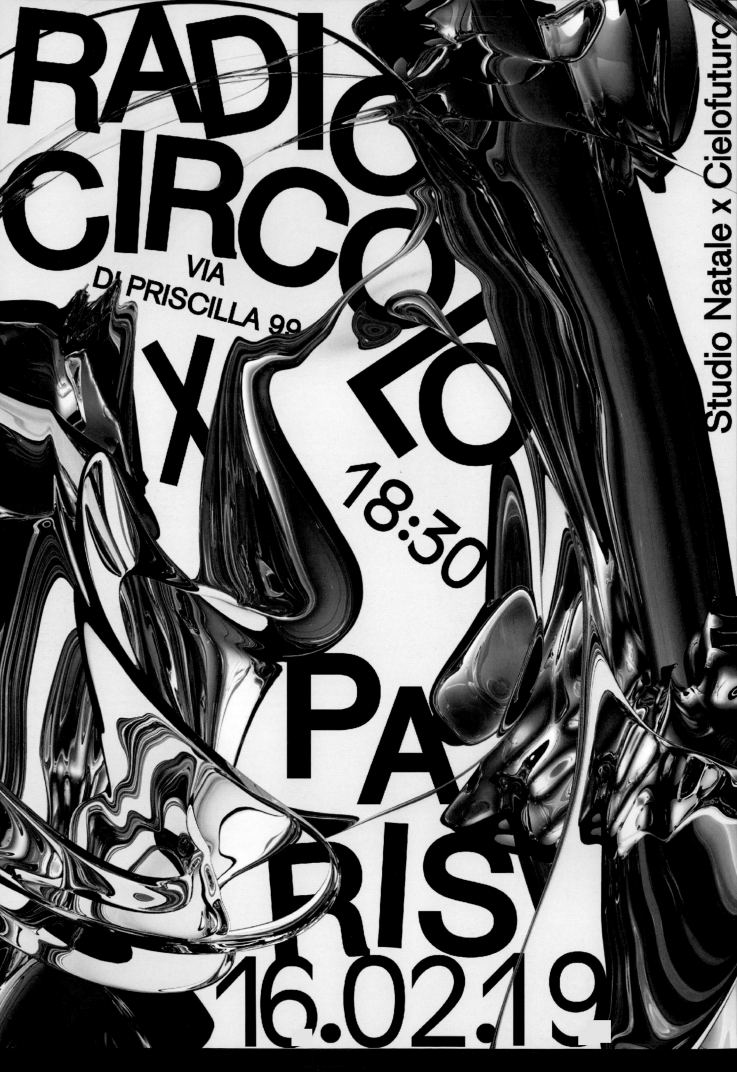

Radio Circolo x Paris 海報

設計機構：Studio Natale
創意總監：Alessio Natale Ferri
設計師：Alessio Natale Ferri
國家：義大利
客戶：PARIS VIA DI PRISCILLA

Radio Circolo x Paris 這個視覺形象來源於
與藝術家 Cielofuturo 的合作。這個想法從
一個旋轉的流體（圓形收音機）開始，進入
一個漩渦，代表了音樂給我們的能量。海報
是為一個特別的音樂會而製作的，晚會在一
家美麗的羅馬概念商店（巴黎甲骨文）舉
辦。

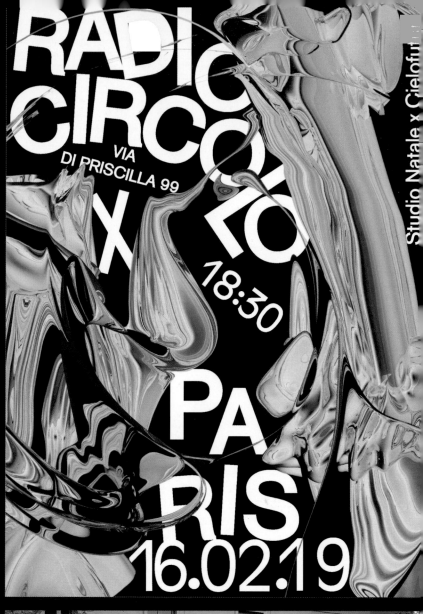

01 海報以液態金屬為主體占據版面的主要空間，文字根
據主體產生的「負形」進行繞排，符合閱讀的視覺流向。
海報傳達的文字訊息簡練，僅以必要的活動訊息與作者落
款，這給大面積放置文本創造了條件，通過抓眼的主圖與
醒目的字體，將海報對人們的吸引力最大化。

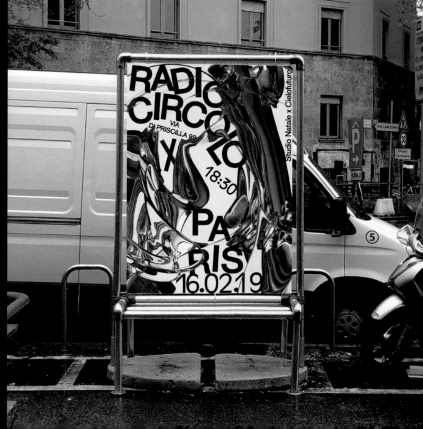

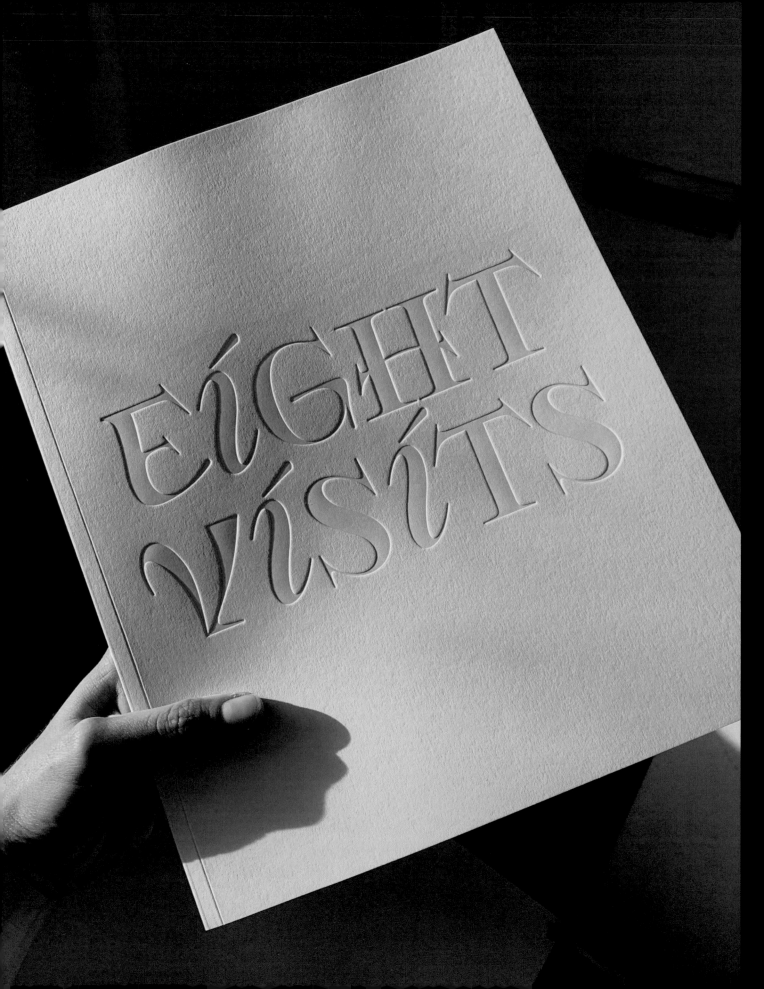

Eight Visits 字體設計

創意總監：Floriane Rousselot
設計師：Floriane Rousselot
國家：法國

《八尋》Eight Visits 是柏林攝影師索菲・克洛克的第一本攝影集，她在這本書中呈現了自己在東京走訪過的8個地方。她把重點放在她遇到的人以及他們各自所處的環境上。這本書由 Joseph Atkinson 設計，他建議我為本書設計定制字體。這個項目展現了 Sophie、Joseph 和我的三人合作。字體設計注入了日文字體感覺的襯線，並加入了平滑有機的曲線。

02 根據定調的字母「V」設計出其餘的英文字母。

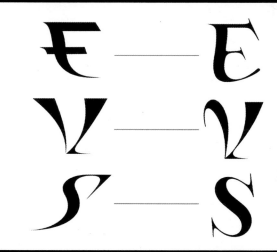

03 在此基礎上，調整字體的襯線，並進一步強化筆劃的曲線，讓文字呈現更平滑、有機的質感。

01 從雜誌標題字體中提取出「ハ」字，將其翻轉、調整

04 調整後最終的字體呈現。

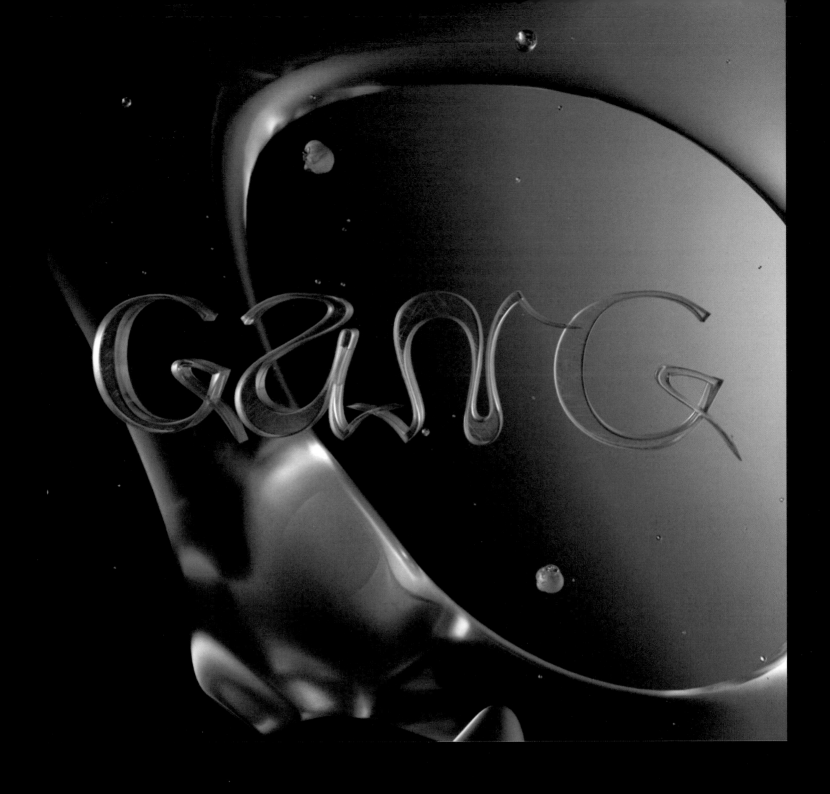

Gang 字體設計

創意總監：Floriane Rousselot
設計師：Floriane Rousselot
國家：法國

Gang 的靈感來源於德文尖角體（Fraktur）以及我在紐約實習時發現的形狀 —— 從我在街上找到的形狀開始，混合塗鴉、尖角字體、襯線字體和粗體字體。Gang 是所有這些靈感的混合體，它向「德文尖角體的歷史演變，以及最終成為流行文化的一部分」發問。

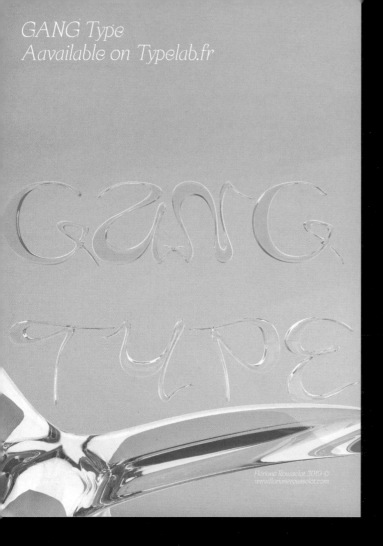

01 哥德體（Gothic），上圖來自《聖經》手抄本。

Fraktur

ABCDEFGHIJKLMNOPQRSTUVWXYZ
abcdefghijklmnopqrstuvwxyz

02 德文尖角體（Fraktur）。

德文尖角體是一種拉丁字母的書法體，屬於哥德體的一種，最早出現於15世紀。德文尖角體為哥德體的典型字體，在西方有時指代全部哥德體，有時也稱為「老英文字體（Old English）」。

ABCDEFGHI
JKLMNOPQR
STUVWXYZ

01 文字內容：BALENCIAGA（巴黎世家）。

02 文字內容：BETTER DAYS。

Deformi 字體設計

設計機構：Brando Corradini
創意總監：Brando Corradini
設計師：Brando Corradini
國家：義大利

這是一套商用字體，Deformi 代表一種變形、膨脹和拉伸的字體，特別為時尚領域而設計。

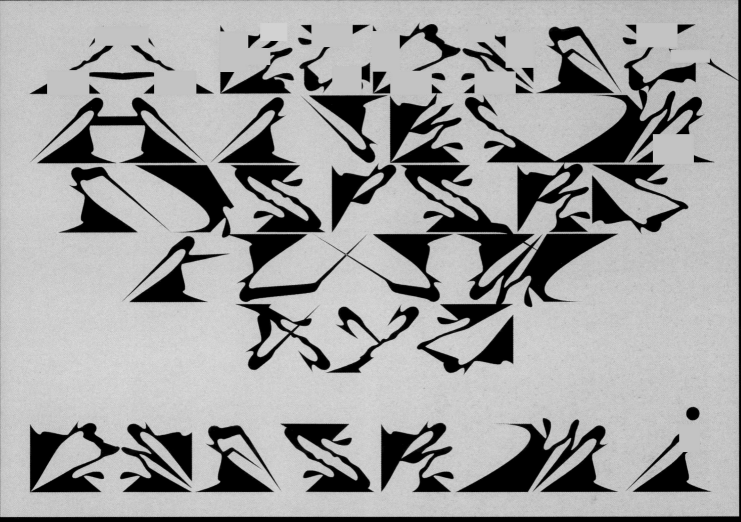

03 上方文字為英文字母 A ～ Z；下方文字為字體名稱：Deformi。

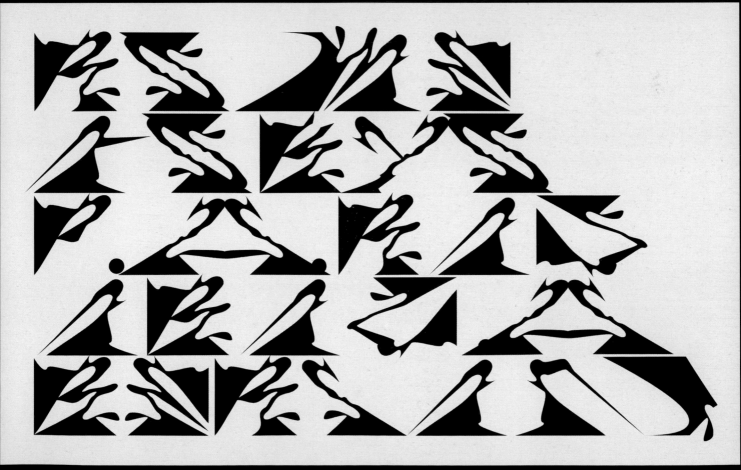

04 文字內容：ROME（羅馬）、TOKYO（東京）、PARIS（巴黎）、IBIZA（伊維薩島）、BERLIN（柏林）。

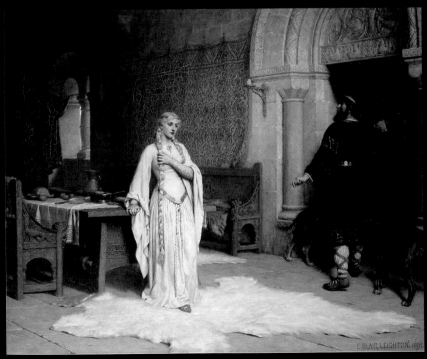

01 Lady Godiva 字體展示,從上到下分別為 A ～ Z 的英文大小寫,1～10 數字和 Lady Godiva Type 字樣。

02《戈黛娃夫人》,約翰・馬勒・柯里爾(John Maler Collier)所繪,約1898年。

Lady Godiva 字體設計

設計機構:Brando Corradini
創意總監:Brando Corradini
設計師:Brando Corradini
國家:義大利

項目靈感來自畫作中所呈現的 Godiva 夫人
形象,這種類型的女性高傲而優雅,披著長
髮,姿態美妙,在街道上自由地騎馬馳騁。
受此靈感啟發,我設計了這種字體,它的優
雅和冷酷體現了一種巨大的自由感。

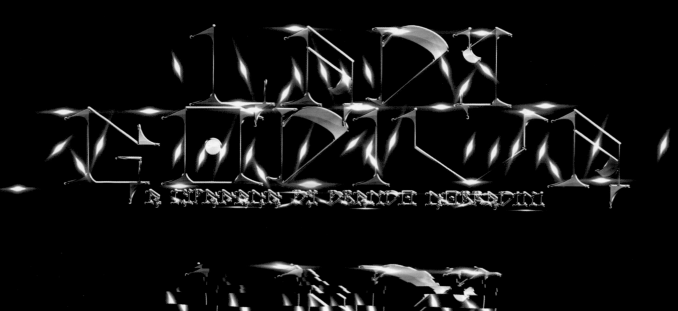

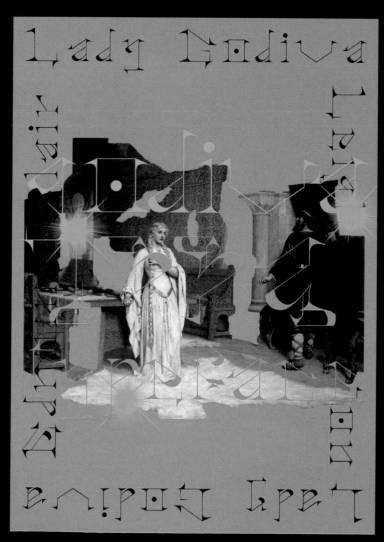

03 Lady Godiva 字體的渲染效果與使用該字體設計的兩款海報。

EDMUND BLAIR LEIGHTON

21-09-1852
LONDON, ENGLAND
1-09-1922

Leighton was the son of the artist Charles Blair Leighton (1823–1855) and Caroline Leighton (née Deesay). He was educated at University College School, before becoming a student at the Royal Academy Schools. He married Katharine Nash in 1885 and they went on to have a son and daughter. He exhibited annually at the Royal Academy from 1878 to 1920.

Leighton was a fastidious craftsman, producing highly finished, decorative pictures, displaying romanticised scenes with a popular appeal. It would appear that he left no diaries, and though he exhibited at the Royal Academy for over forty years, he was never an Academician or an Associate.

LADY GODIVA

Slyther 字體設計

創意總監：Floriane Rousselot
設計師：Floriane Rousselot
國家：法國

Slyther 是通過技術上的逆反而創造出來的。如何做到只使用兩個形狀，便可以定義整個字體？這就是 Slyther 背後的挑戰，用簡單的圖形創建整個字體的想法，使用「銳利」的動態形狀，來創造速度感。

01 設計師運用以上兩個形狀，通過旋轉、扭曲、疊加、融合等多種方式，創造出了 Slyther 字體。

02「Slyther」字樣。

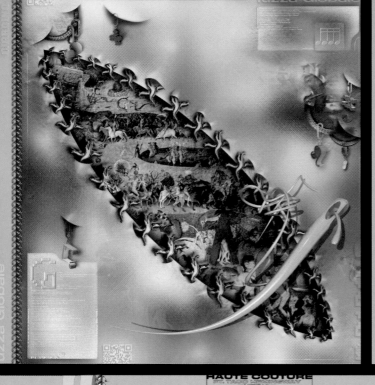

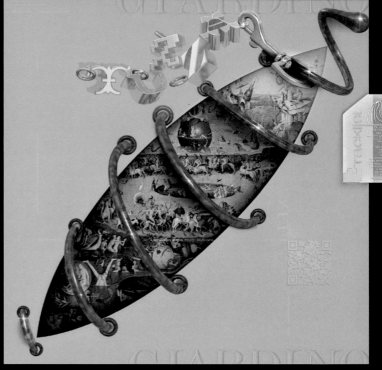

01 在上為 CD 封面，有上為 CD 封底，下方為 CD 歌詞本。三者組成一個「跨頁箋容」。整體設計將「新（現代設計）語言」和「舊（古典藝術畫作）和諧地融合在一起，創造出全新的氛圍。

Giardino《花園》唱片專輯

創意總監：Maria Nowicka
設計師：Maria Nowicka
國家：波蘭
客戶：Tuzza Globale

插圖的靈感和概念是為 Tuzza Globale 的唱片專輯 *Giardino* 而創作的。Giardino 是義大利語，意思是「花園」。整張專輯呈現的是暗黑、迷宮般的陰鬱圖像，我發現這與荷蘭藝術家耶羅尼米斯・波希（Hieronymus Bosch）的作品非常契合。

我的目標是嘗試突破唱片封套的維度限制。封面和封底可不可以是同一東西的正反兩面，從而塑造出一個唱片內核的感覺呢？

於是我想到了把縫線、針和其他紋理，通過 3D 效果的手法組織起來。我想探索「縫製」海報的概念，就好像是布料縫合一樣。音樂家的名字 Tuzza Globale 的字體，沿襲了中世紀的感覺。封面封底和歌詞三部分組合在一起時所表現出的邪惡笑容，也標誌著音樂家的品牌形象。

02 建模草圖。

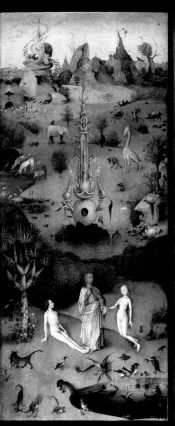
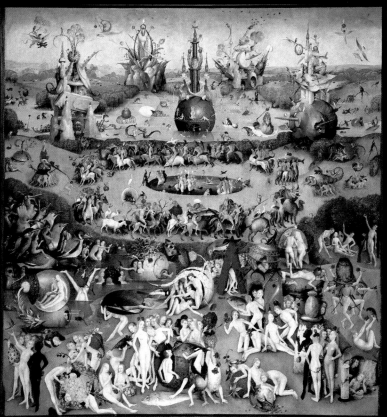
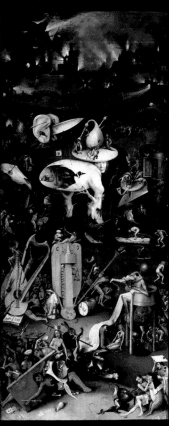

03 耶羅尼米斯・波希《人間樂園》。

01 UNO包裝盒。

UNO 牌

創意總監：Maria Nowicka
設計師：Maria Nowicka
國家：波蘭

該項目實質上是對UNO卡的思維發散。我使用了UNO游戲中常用的4種顏色，並將它們與自然的力量 ——火、水、土地和空氣聯繫在一起。為了與UNO牌漂亮和童話般的含義形成對比，我選擇了工業、重型機械的3D物象作為項目的核心。

我首先在創建主要場景的3D環境中工作。我向自己挑戰，要在引擎和其他工業物體固

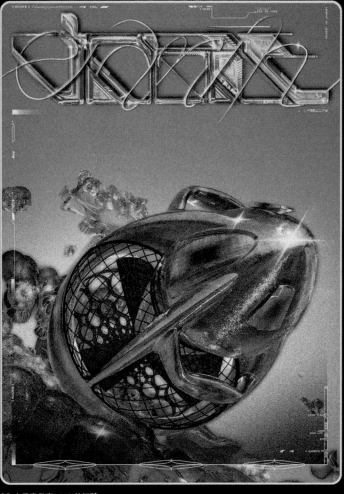

03 火元素代表 UNO 的紅牌。

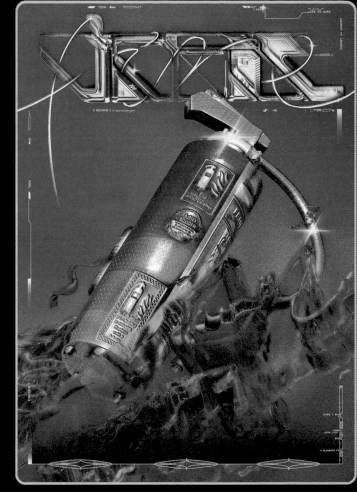

04 水元素代表 UNO 的藍牌。

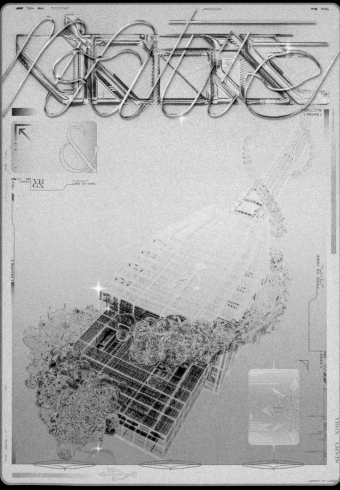

05 土元素代表 UNO 的黃牌。

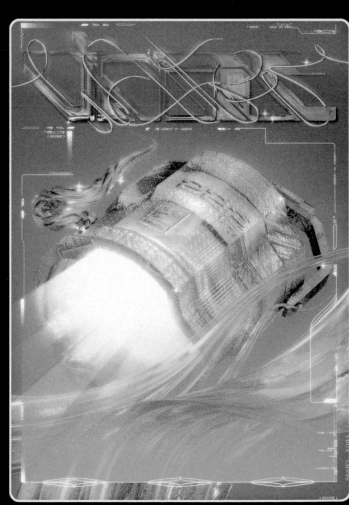

06 空氣元素代表 UNO 的綠牌。

SHADES

MALAVIDA
OCT. 18

22th October, 2018

Shades, poster serie
Directed by Alycia Rainaud
@maalavidaa

— An interpretation
based on a collaboration w/
Beth Design
@hello.bethdesign

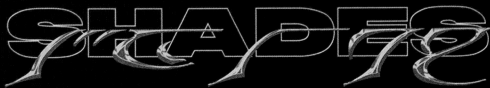

Fiendish wonder in the carnival's wake, though it caresses once again irritate. Tread softly stranger, move over toward the danger that you seek. You think excitement has receded and the mirror distracts. The logic of the trance quickly reaches and grasps.
Handsome and faceless and weightless, your imagination roams. And now it's no ones fault but yours, at the foot of the house of cards. You thought you'd never get obsessed, you thought the wolves would be impressed.

And you're a sinking stone but you know what it's like to hold the jeweler's hand. That procession of pioneers all drowned. In the moonlight they're more thrilling, those things that he knows. As he leads you through the grinning, bubble blowers in the snow. Watching his exit is like falling off the ferry in the night. The inevitables gather to push you around. Any old voice makes a punishing sound. He became laughter's auteur shortly after he showed you what it was. If you've a lesson to teach me, I'm listening, ready to learn. There's no one here to police me. I'm sinking in, until you return.

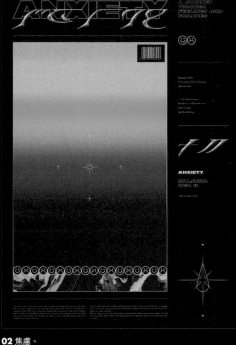

02 焦慮。

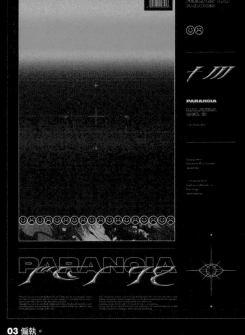

03 偏執。

第一階段

第二階段

陰影系列海報：一段情感旅程

設計師：Alycia Rainaud
國家：法國

這個項目是平面設計師、數字藝術家 Alycia
Rainaud 創作的《陰影》系列海報，該系列
包括 3 幅海報，展示了一段情感旅程的 3 個
不同階段。跨越色彩鮮明的梯度節奏 ——
愛，焦慮和偏執，然後按時間順序合併在第
四張附加海報上。轉變的最後階段讓生動的
情感並肩站立，相互補充，而不是彼此衝
突。

アニメ ANIME AND 漫画 MANGA

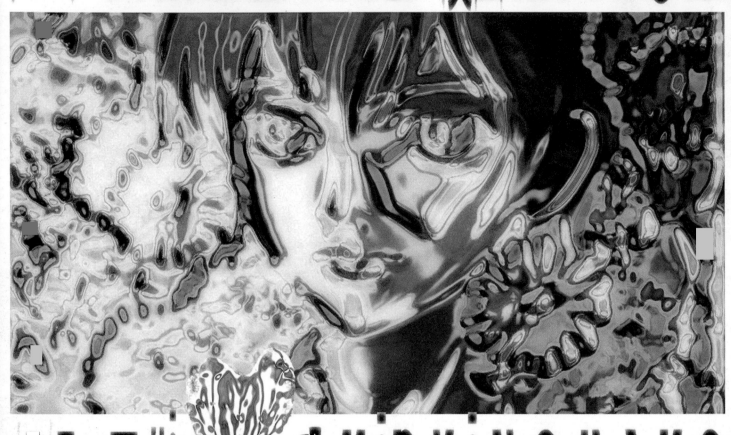

姑獲鳥の匣 MŌRYŌ NO HAKO

PERIOD: 1994–PRESENT GENRE: FICTION MYSTERY HORROR

京極夏彦 NATSUHIKO KYOGOKU

日本動漫海報

設計機構：Brando Corradini
創意總監：Brando Corradini
設計師：Brando Corradini
國家：義大利

動漫與漫畫海報是一個研究項目，源自對漫
畫世界的渴望。在製作過程中，我想向這個
奇妙而獨特的世界致敬。

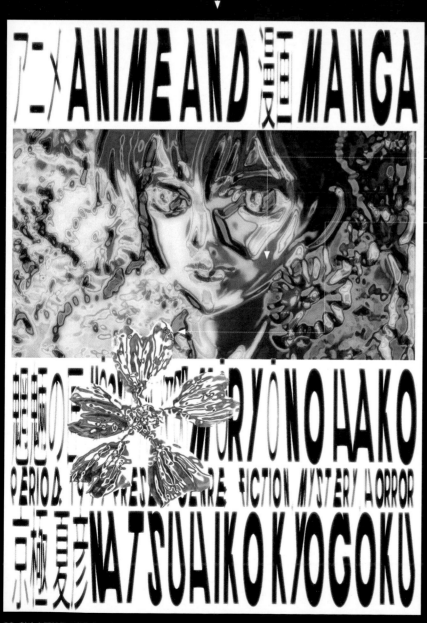

01 文字使用了瘦長型的字體，並添加了內發光的效果以模擬反射的質感。

02 對比右圖純黑白的海報，左圖海報中人物（偏暖）與花朵（偏冷）的灰度做出了細微的色相區別，這樣有利於拉開畫面中各元素的前後關係，體現更好的層次感。

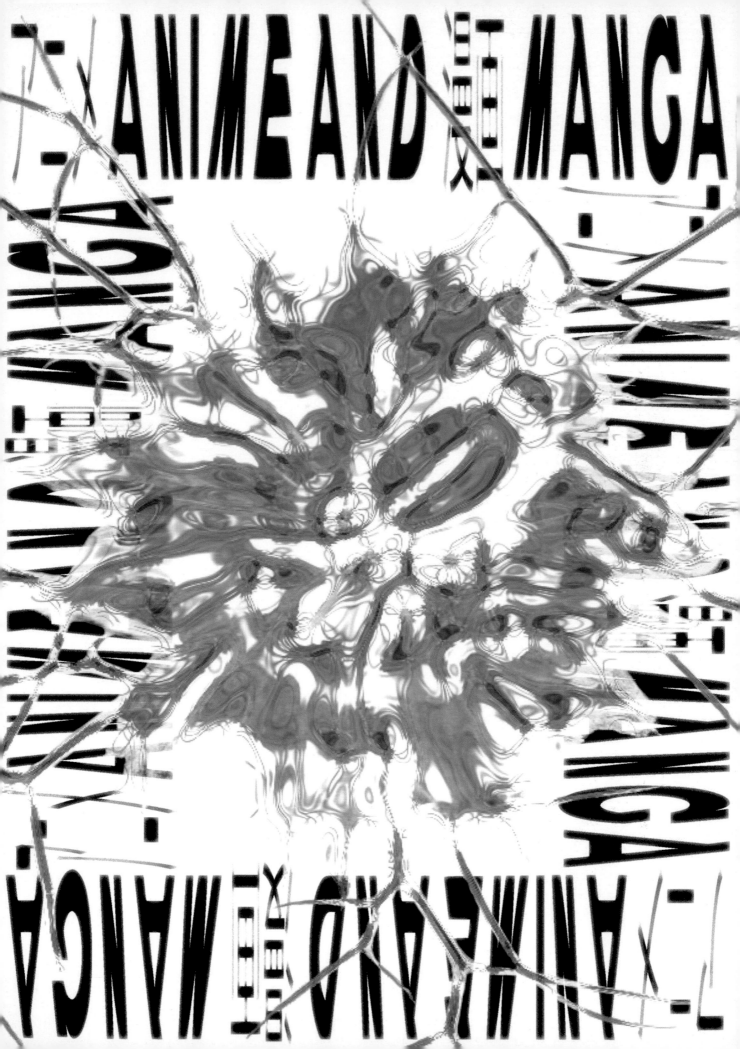

Brando Corradini

Portfolio
Visual Communication

Brando Corradini
Portfolio
Visual Communication

Brando Corradini
Portfolio
Visual Communication

設計機構：Brando Corradini
創意總監：Brando Corradini
設計師：Brando Corradini
國家：義大利

這是我的 2020 作品集，這個項目代表了
我過去的一年，其中包括了我在 2019 和
2020 年使用 Adobe Dimension 程序創作
的一些 3D 作品。在這些項目中，我想強調
的是實驗性和人類瘋狂的夢想。

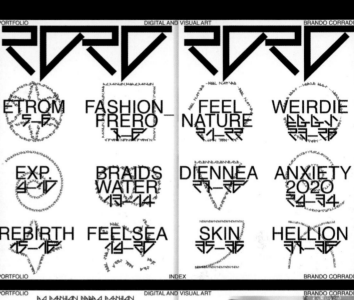

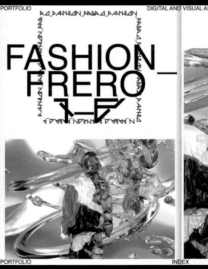

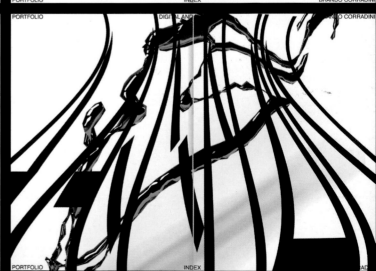

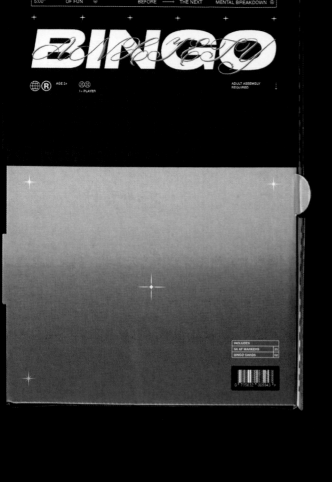

Occupations

設計師：Alycia Rainaud
國家：法國
注：該作品系與特別嘉賓
Mathieu Le Berre, Jack Eder,
Alexandre Tamisier 共同合作完成

自由時間最適合創作。在作為自由職業者的
第一年裏，平面設計師和數字藝術家 Alycia
Rainaud 把職業作為一個個人項目來進行，
以便讓她的想法自由放飛。這些零零碎碎的
物件，作為一種實驗的方式，與她喜歡探索
的話題（心理健康，音樂等）聯繫起來，同
時進一步推動她特定的視覺風格。

在這個項目中，設計師的想法是為每個設計
選擇一個不同的主題，並通過不同的印刷物
品和材料，圍繞它來探索和訓練創造力。選
擇一個你喜歡的圖案，想像它將如何成為設
計主題。

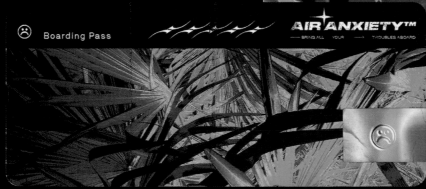

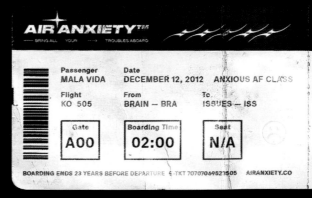

01 全像漸變的效果貫穿整體設計，與黑色產生強烈的對比。　　　　　　　　　　　　使用字體：Saoldisplay-light

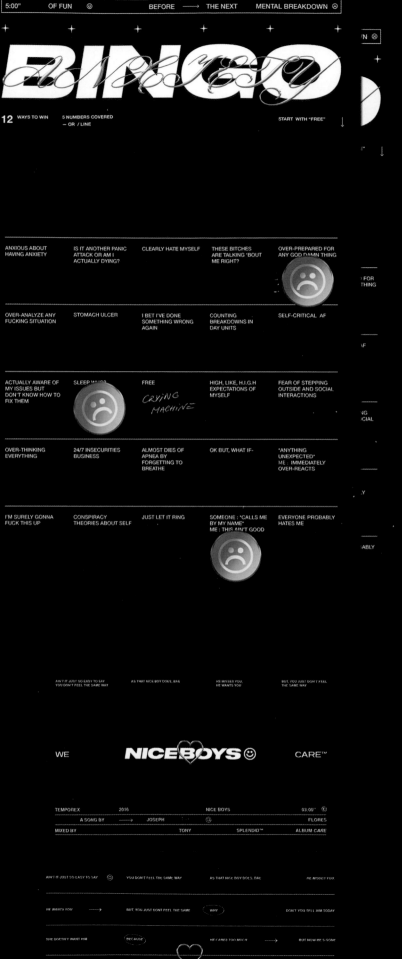

BINGO

12 WAYS TO WIN 5 NUMBERS COVERED — OR / LINE START WITH "FREE"

ANXIOUS ABOUT HAVING ANXIETY	IS IT ANOTHER PANIC ATTACK OR AM I ACTUALLY DYING?	CLEARLY HATE MYSELF	THESE BITCHES ARE TALKING 'BOUT ME RIGHT?	OVER-PREPARED FOR ANY GOD DAMN THING
OVER-ANALYZE ANY FUCKING SITUATION	STOMACH ULCER	I BET I'VE DONE SOMETHING WRONG AGAIN	COUNTING BREAKDOWNS IN DAY UNITS	SELF-CRITICAL AF
ACTUALLY AWARE OF MY ISSUES BUT DON'T KNOW HOW TO FIX THEM	SLEEP WHO?	FREE / CRYING MACHINE	HIGH, LIKE, H.I.G.H EXPECTATIONS OF MYSELF	FEAR OF STEPPING OUTSIDE AND SOCIAL INTERACTIONS
OVER-THINKING EVERYTHING	24/7 INSECURITIES BUSINESS	ALMOST DIES OF APNEA BY FORGETTING TO BREATHE	OK BUT, WHAT IF-	"ANYTHING UNEXPECTED" ME : IMMEDIATELY OVER-REACTS
I'M SURELY GONNA FUCK THIS UP	CONSPIRACY THEORIES ABOUT SELF	JUST LET IT RING	SOMEONE : "CALLS ME BY MY NAME" ME : THIS AIN'T GOOD	EVERYONE PROBABLY HATES ME

AIN'T IT JUST SO EASY TO SAY YOU DON'T FEEL THE SAME WAY AS THAT NICE BOY DOES, BAE HE MISSES YOU, HE WANTS YOU BUT, YOU JUST DON'T FEEL THE SAME WAY

WE **NICEBOYS** ☺ CARE™

TEMPOREX	2016		NICE BOYS	03:00" ©
A SONG BY ⟶	JOSEPH	☺		FLORES
MIXED BY		TONY	SPLENDID™	ALBUM CARE

AIN'T IT JUST SO EASY TO SAY ☺ YOU DON'T FEEL THE SAME WAY AS THAT NICE BOY DOES, BAE HE MISSES YOU

HE WANTS YOU ⟶ BUT, YOU JUST DON'T FEEL THE SAME WHY DON'T YOU TELL HIM TODAY

SHE DOESN'T WANT HIM BECAUSE HE CARES TOO MUCH ⟶ BUT NOW HE'S GONE

BINGO ↓ BINGO

使用字體：Druk Wide（Bold Italic）

ANXYETY

使用字體：Aerolite Script（並在此基礎上進行變形）

| NUISANCES | RECORDS | | ® |
| PARIS ⟶ | BASED | | LABEL |

0 705632 085943 ALL RIGHTS RESERVED ® N

⊕

| PRS-FR | 75 |
| MUSIC + EVENTS | |

NUISANCES RECORDS

DEAD INSIDE

PUT THE FUN IN FUNERAL

HOW TO SELL ANXIETY ONLINE

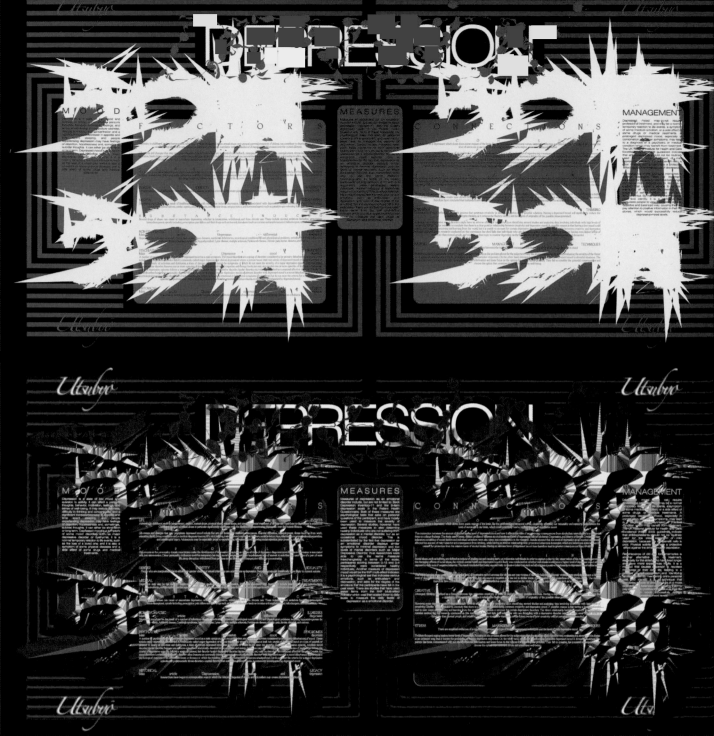

01 設計師運用了高飽和的紅、黃、藍色與黑色搭配，並使用帶有爆炸效果的圖形、類似血液效果的字體，來傳達強烈的視覺感受。

V. of E.S. —— 情感的視覺化

創意總監：Anton Synytsia
設計師：Anton Synytsia
國家：烏克蘭
尺寸：30 cm x 30 cm

這個項目揭示了我最近正在經歷的情緒狀
態 —— 憂鬱、攻擊、平衡。每一種都在視

aggression

harmful, tention unpleasantness vidual. or frustration cause can be aggression characterized behavior someone. by social group. is social of It due aggression intended the behavior intended of overt interaction inflicting upon provocation initial physical to latter covert, the or damage another Human direct cause is or to an with goals and former is or harm individual often in other reactively humans, can aggression indi is verbal characterized the or

EQUILIBRIUM

EMOTIONAL SELF-REGULATION, OR EMOTION REGULATION IS THE ABILITY TO RESPOND TO THE ON-GOING DEMANDS OF EXPERIENCE WITH THE RANGE OF EMOTIONS IN A MANNER THAT IS SOCIALLY TOLERABLE AND SUFFICIENTLY FLEXIBLE TO PERMIT SPONTANEOUS REACTIONS AS WELL AS THE ABILITY TO DELAY SPONTANEOUS REACTIONS AS NEEDED. IT CAN ALSO BE DEFINED AS EXTRINSIC AND INTRINSIC PROCESSES RESPONSIBLE FOR MONITORING, EVALUATING, AND MODIFYING EMOTIONAL REACTIONS. EMOTIONAL SELF-REGULATION BELONGS TO THE BROADER SET OF EMOTION-REGULATION PROCESSES, WHICH INCLUDES BOTH THE REGULATION OF ONES OWN FEELINGS AND THE REGULATION OF OTHER PEOPLES FEELING.

EMOTIONAL REGULATION IS A COMPLEX PROCESS THAT INVOLVES INITIATING, INHIBITING, OR MODULATING ONES STATE OR BEHAVIOR IN A GIVEN SITUATION - FOR EXAMPLE THE SUBJECTIVE EXPERIENCE (FEELINGS), COGNITIVE RESPONSES (THOUGHTS), EMOTION-RELATED PHYSIOLOGICAL RESPONSES (FOR EXAMPLE HEART RATE OR HORMONAL ACTIVITY), AND EMOTION-RELATED BEHAVIOR (BODILY ACTIONS OR EXPRESSIONS); FUNCTIONALLY, EMOTIONAL REGULATION CAN ALSO REFER TO PROCESSES SUCH AS THE TENDENCY TO FOCUS ONES ATTENTION TO A TASK AND THE ABILITY TO SUPPRESS INAPPROPRIATE BEHAVIOR UNDER INSTRUCTION. EMOTIONAL REGULATION IS A HIGHLY SIGNIFICANT FUNCTION IN HUMAN LIFE

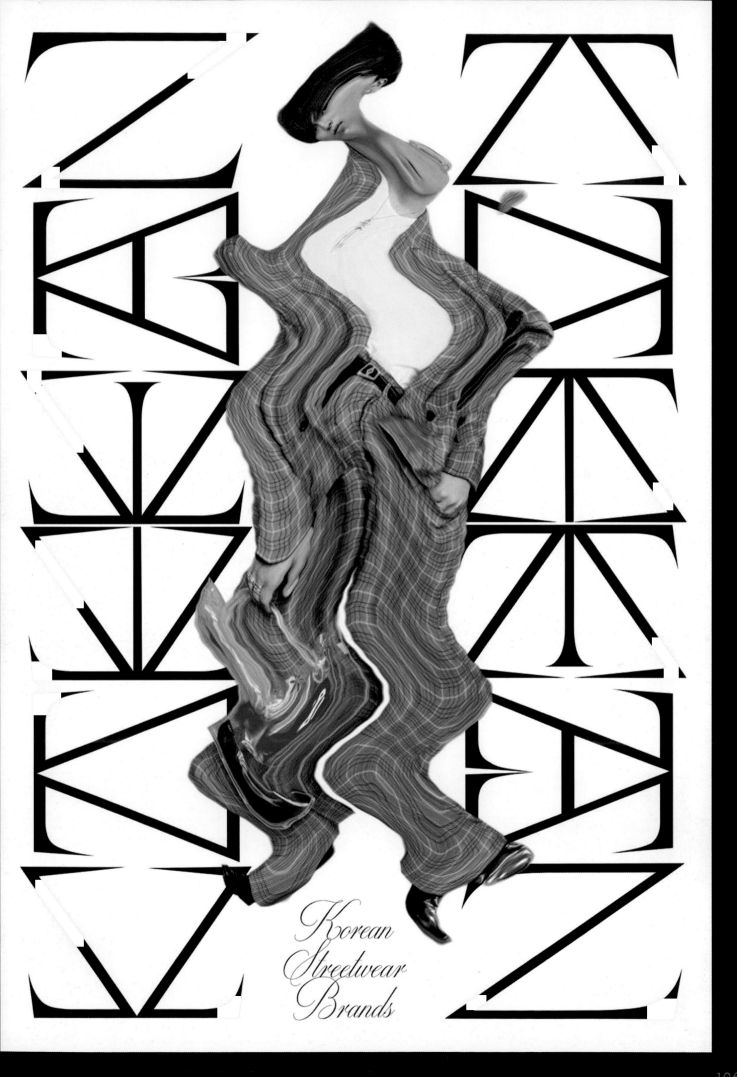

Korean
Streetwear
Brands

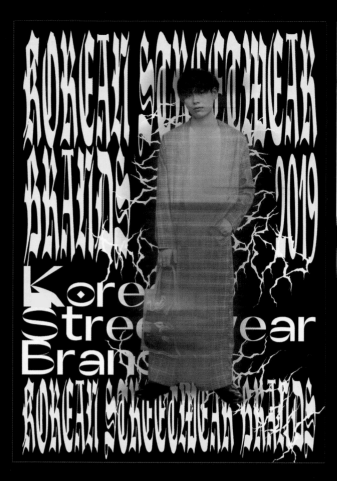

韓國街頭服飾品牌海報

設計機構：Brando Corradini
創意總監：Brando Corradini
設計師：Brando Corradini
國家：義大利
客戶：Digital Portfolio

韓國街頭服飾品牌海報，是一個從街頭服飾
開始，研究韓國文化各方面的個人項目。

Typeface in use:
Lil Thug • designed
by Brando Corradini
SKKVE • KESIGNEK
E KKANK KOKKAKINI
Fette Trump Deutsch •
designed by Dieter Steffmann
Millon One • designed by Youssef Habchi

01 系列海報所使用的字體。

01 海報以影響當今青少年成長的物品作為線索，點明該期雜誌的主題。設計師通過破碎、低閱讀性的字體，再配合帶有錯視效果的背景，營造出一種迷幻、不安的視覺感受。右圖在此基礎上，利用誇張的動態模糊效果，更進一步強化了這種畫面感受。

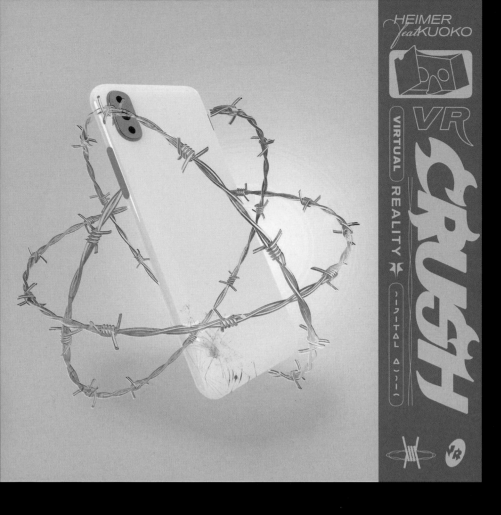

01 歌手名字採用無襯線字體，單詞「feat」則採用手寫體。

02 VR眼鏡的擬物Icon。

03 專輯名稱，在無襯線粗斜體的基礎上進行變形。

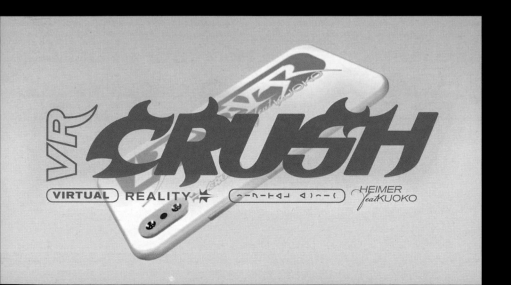

VR Crush Music Video

創意總監：Ksti Hu
設計師：Ksti Hu, Heimercore
國家：德國
客戶：Kuoko
攝影師：Kuoko

Kuoko和Heimer的最新流行歌曲描述了
對數字微觀世界的迷戀，以及想停滯在永
久烏托邦關係中的狀態。這種狀態從來沒
有 —— 可能也永遠不會有。

「VR Crush」反映了一種千禧一代的普遍心
態，這種心態讓我們對每一次更新、發文和
點讚都充滿希望、好奇和熱愛。

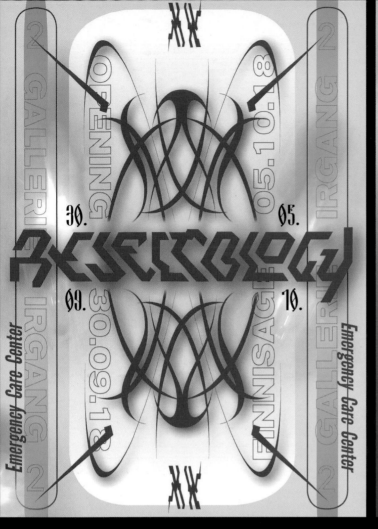

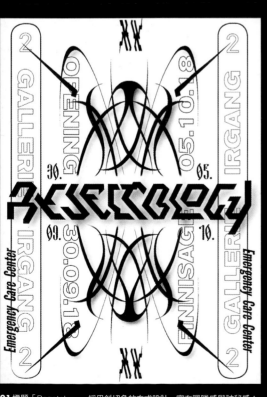

01 標題「Regetology」採用斜切角的方式設計，富有圖騰感與神秘感；海報採用對稱式設計，標題從中心橫向貫穿，強化版面張力，其餘元素從中心向外擴散，對稱排布；文字採用實底與筆畫兩種形式，以便在相對飽滿的畫面中拉開主次。

Rejectology 展覽海報

創意總監：Ksti Hu
設計師：Ksti Hu
國家：德國
客戶：Gallery, Ekaterina Elizarova

2018 年 9 月，在柏林 Irrgang 畫廊舉行了 Rejectology - Emergency Care Center 藝術項目展覽，我為展覽設計了海報。

「Rejectology: Emergency Care Center」（「拒絕」急救中心）是一個綜合的怪誕藝術展，每一件藝術作品都是為那些被排斥觀念影響的人而設計的。

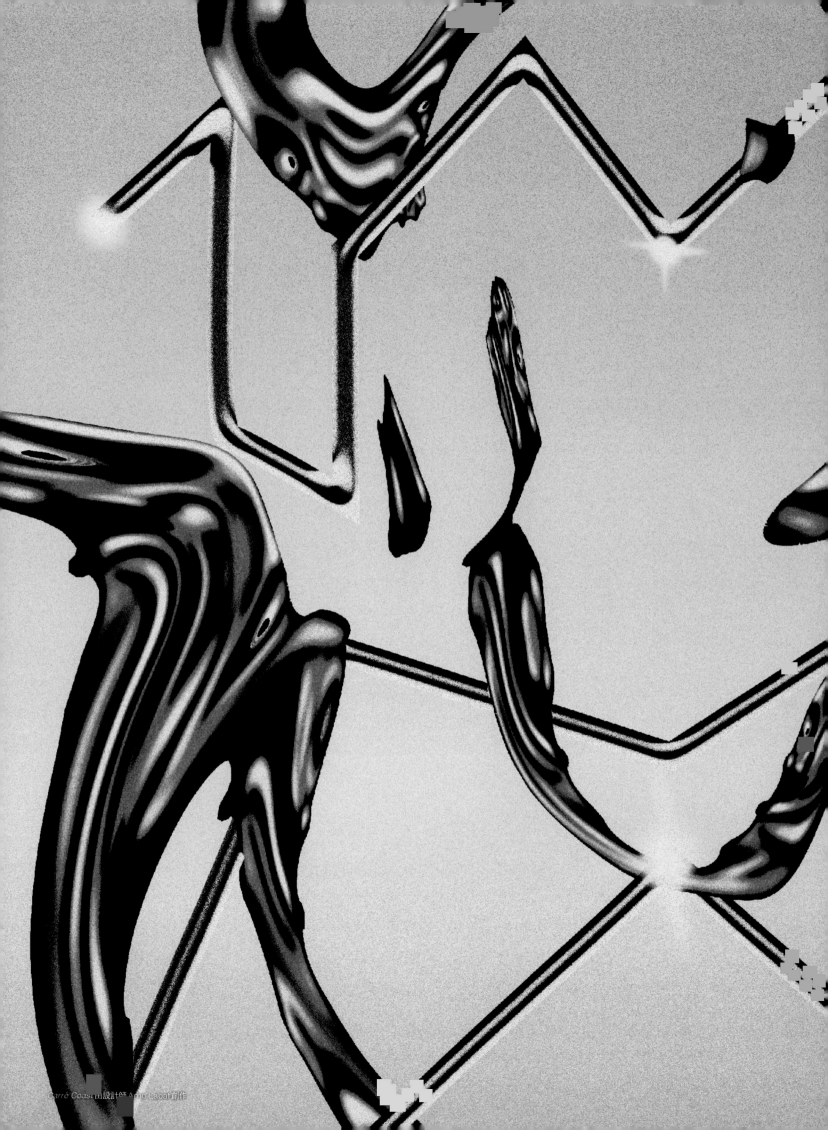

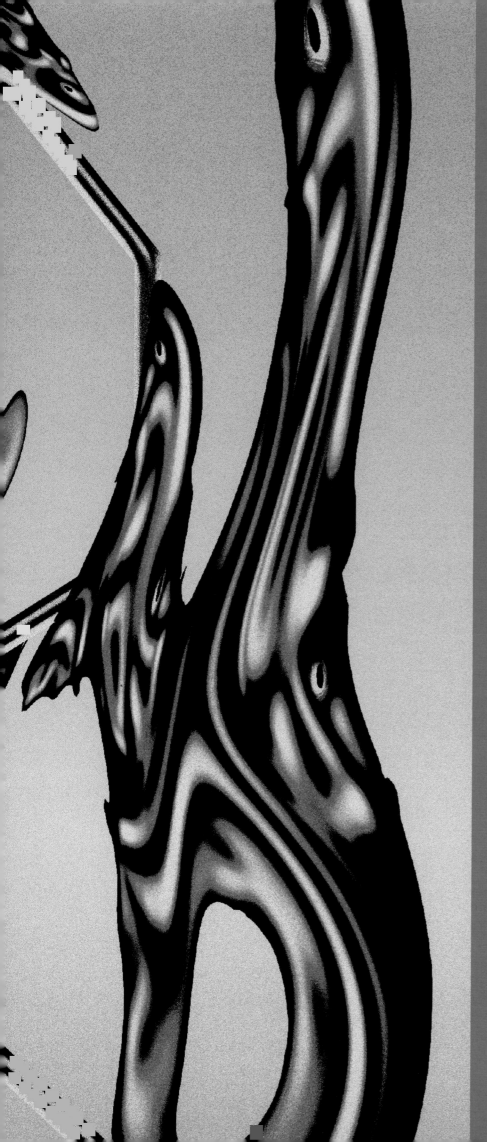

COLLisiON

作為一種並不被大眾接受的設計風格，這種突破鄙視一切墨守成規，往往會更隨心所欲。這種追求極致落差的行為，更多是一種創作行為。能否在更廣泛的層面把它與商業相結合，目前看來似乎還是個未知數。

這種風格大多具備強烈的色彩對比的特點，強調感性，並以此來抓住受眾眼球。混亂且戲謔的藝術語言，時刻挑戰著大眾的審美底線。也許，設計本身就不該被局限，它需要不斷被打破。誰能說「新醜風」在某種程度上不是一種優秀的設計？

concerts, dj sets, label market, conferences, and more. schiev *is* a brussels based music festival which offers a broad v*i*sion of avant-garde pop music.

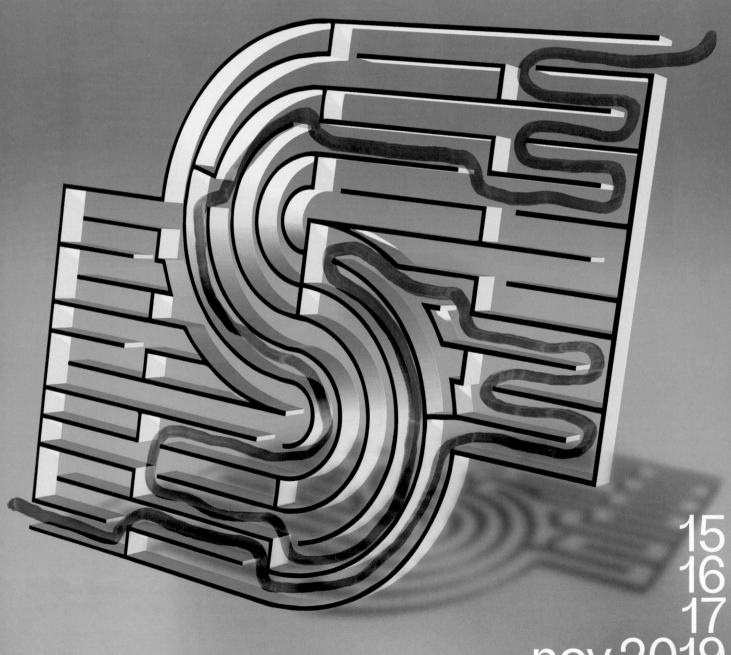

15
16
17
nov.2019
schiev beursschouwburg
a simple music festival brussels

schiev 小型音樂節視覺設計

設計機構：Alliage
創意總監：Lucile Martin and Julien Pik
設計師：Lucile Martin and Julien Pik
國家：比利時
客戶：schiev Festival

schiev 是獨立的電子音樂節，由Shape Platform 提供支持，旨在推廣當代歐洲音樂人。

將海報做成遊戲的目的，是通過強大的可識別的視覺傳達，吸引觀眾的注意力，增強娛樂性。基於這個原因，我們選擇了一些簡單、好玩且知名的遊戲，比如2018年的畫謎（Rebus）和2019年的迷宮（Labyrinth）。

我們試圖做出最直接的設計，並且根據節日的不同傳播需求，設計出適合的形式（海報、傳單、橫幅、影片、Instagram圖片、廣告等）。

我們製作了幾個3D迷宮，並在上面添加了不可擦除的路線標記。整合手繪的線條，增加了整個平面的亮色，打破數位／3D的硬朗感覺。這種虛與實的交織，創造出一種奇妙的張力。

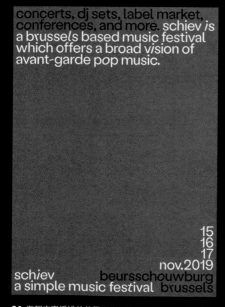

01 海報文字編排的位置固定，放置在畫面的上下部分，迷宮圖形放置在畫面中央。

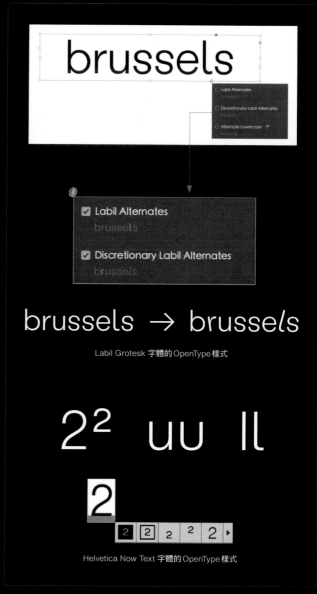

02 海報使用了字體：Labil Grotesk（Light），這是一款特殊的OpenType字體。

「無襯線字體中固有的平衡受重力影響發生變化」，這個概念是這款字體的設計靈感。將無襯線體的規整與傾斜兩種特徵混合在一起，使文本屈服於其自身的重量。字母受到重力的影響，就像真實的物體掉下來或者彼此靠在一起相互支撐一樣。

Labil Grotesk 字體利用OpenType在細節上提供了豐富、有趣的變化，規整中伴隨著傾斜的字體特性也與「新醜」的風格不謀而合。

Labil Grotesk 字體的OpenType 樣式

Helvetica Now Text 字體的OpenType 樣式

03 OpenType是由Microsoft和Adobe公司共同開發的一種字體格式，除了作為一種新型的跨平台字體文件格式，還能為用戶提供豐富的排版特性（如上下標、連筆、小型大寫字母、字形替換等多種功能）。OpenType已經成為一種業內標準，越來越多的軟體支持這種字體格式，越來越多的字體廠商將自己的字庫升級到OpenType字體格式。

儘管如此，目前仍有部分字體不支持OpenType功能，您需要進入相關軟體（如Adobe Indesign）進行確認。具體操作如下：在選擇您心儀的字體後，單擊文字方塊右下角的「O」型按鈕，如果您所選的字體支持這項功能，則會彈出可勾選的灰色小框，您可通過勾選不同的選項選取不同的樣式；當然您也可以單獨選中某個字符，懸停後也會出現OpenType選項。如上圖兩個例子：Labil Grotesk字體可以通過勾選選項實現字母的傾向，Helvetica Now Text則支持數字的多種樣式或字母「u」和「l」等部分字型的替換樣式。

concerts, dj sets, label market, conferences, and more. schiev *is* a brussels based music festival which offers a broad vision of avant-garde pop music.

15
16
17
nov.2019

schiev
a simple music festival

beursschouwburg
brussels

concerts, dj sets, label market, conferences, and more. schiev *is* a brussels based music festival which offers a broad vision of avant-garde pop music.

15
16
17
nov.2019

schiev
a simple music festival

beursschouwburg
brussels

Kneaded AaBbCcDdEeF Proofed GgHhIi
Baked JjKkLl
MMMMMMMMMMMM
MMMMMM
mNnOoPpQqRrSs
TtUuVvWwXx
YyZzÆæØøÅå

MATSTREIF

01 項目使用的字體為 Smaks Sans，這是一款變量／可變字體（Variable Fonts），字體的粗細會隨著所選數值的變化而產生變化。下圖為這次美食節的 Logo，同樣採用 Smaks Sans 字體進行設計。

Variable (124)
Variable (192)
Variable (261)
Variable (368)
Variable (496)
Variable (626)
Variable (838)

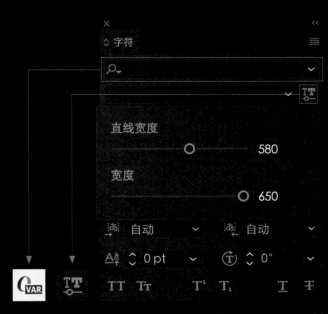

02 在這款字體中，數值越靠近100，字體越瘦長，越靠近900，字體越寬扁。變量／可變字體是字體設計的未來發展趨勢，在過去，您需要安裝整個字體家族，幾款甚至幾十款字體來實現多種字重的切換，而現在僅需安裝一款字體，並通過操作軟體中的滑塊，即可實時、細微、精確地字體的重量、寬度、傾斜比例等。甚至這一切還可以在網路上實時發生，是響應式設計的自然組成部分。

03 目前 Illustrator（2018 及之後版本）已經支持變量／可變字體，您可以在軟體中搜索字體的下拉選項裏尋找帶有「Ovar」圖標的字體，這些字體就是變量／可變字體。在選中字體後，會出現上方第二個小圖標（兩個 T ＋滑塊），點擊這個圖標即可查看所選字體所支持的調節選項（部分字體支持寬度的調整，部分字體還可以支持傾斜角度的調整）。

Vetle Majgren Uthaug
國家：挪威
客戶：Innovation Norway
攝影師：Marthe Thu
字體設計師：Robin Mientjes

Matstreif 是挪威奧斯陸當地的美食節。在
2019 年，為了吸引更多人參加這個節日，
美食節需要一種辨識性更強、更不同和更現
代的品牌形象。

該項目的目的是在奧斯陸及整個挪威都能引
起視覺衝擊，這是一種扭轉遊客人數下降趨
勢的積極方法。Matstreif 節日和它的形象
充滿了生活感、品位、幽默和活力。作為參
考，我們在某些音樂節的語言體系中找到了
靈感。

農夫們的傳統和他們生產的食物，作為本
次設計案例的核心，也變身成為這個周末
的搖滾明星。我們使用的元素是自定義字
體 Smaks Sans，一種可變字體，可以在所
有格式中混用。獨特的插圖風格、鮮豔的色
彩，是我們受味覺啟發而產生的設計理念。
雅致幽默的語＿＿＿特的聲音和音樂輪廓以
及類似紀錄片的照片風格，活動形象和這個
節日的氛圍充分融合在一起。充滿活力和靈
活的識別系統，不斷地改變口味、質地和節
奏。

Søt	Sur	Salt	Bitter	Umami
HEX E03E52	HEX F6EB61	HEX C6D6E3	HEX 7AE1BF	HEX FFD2BB
R224 G62 B82	R246 G235 B97	R198 G214 B227	R122 G225 B191	R255 G210 B187
C0 M79 Y58 K0	C0 M0 Y56 K0	C20 M3 Y1 K2	C36 M0 Y24 K0	C0 M21 Y30 K0
PMS 710 C	PMS 100 C	PMS 643 C	PMS 3375 C	PMS 475 C
NCS 0570-Y90R	NCS 0540-G90Y	NCS 1515-R90B	NCS 1040-B90G	NCS 1015-Y60R

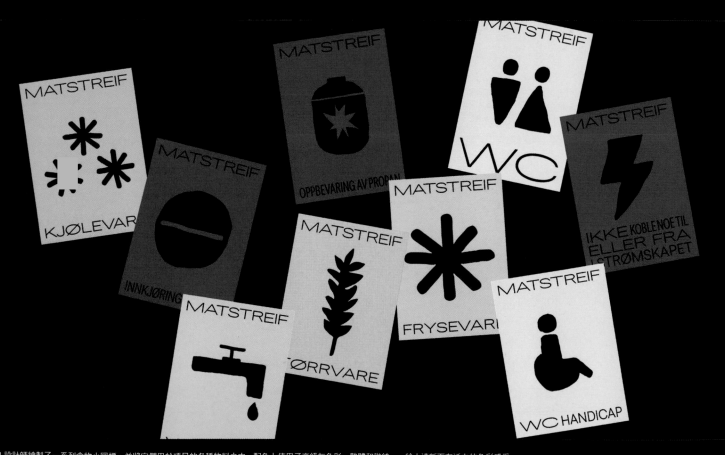

04 設計師繪製了一系列食物小圖標，並將它們用於項目的各種物料之中。配色上使用了高級灰色彩，整體和諧統一，給人清新而有活力的色彩感受。

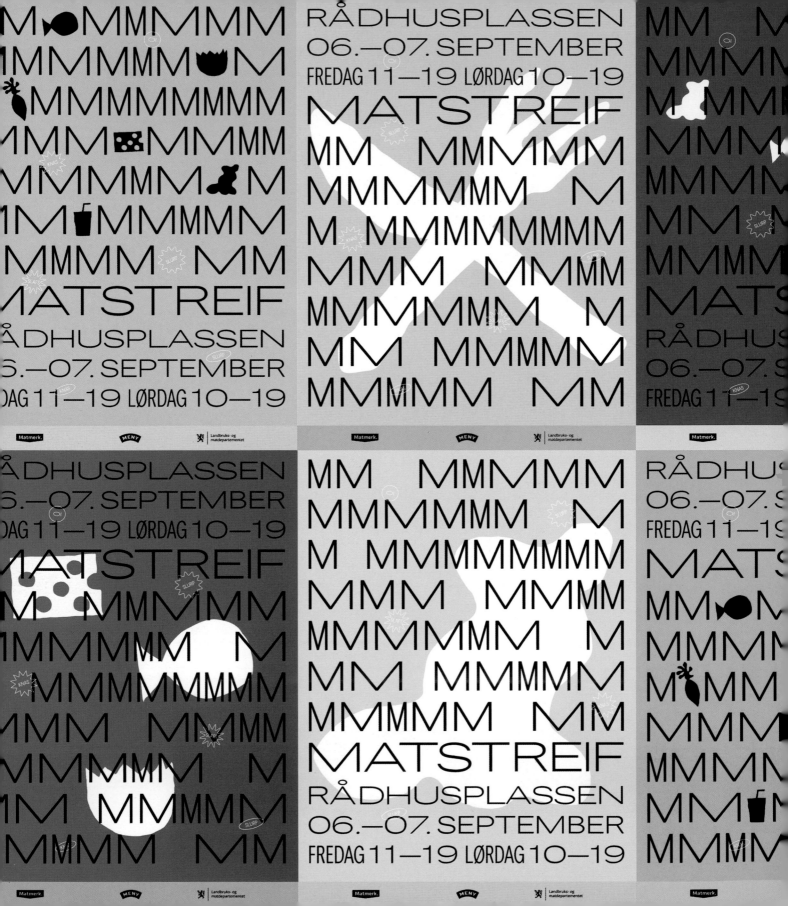

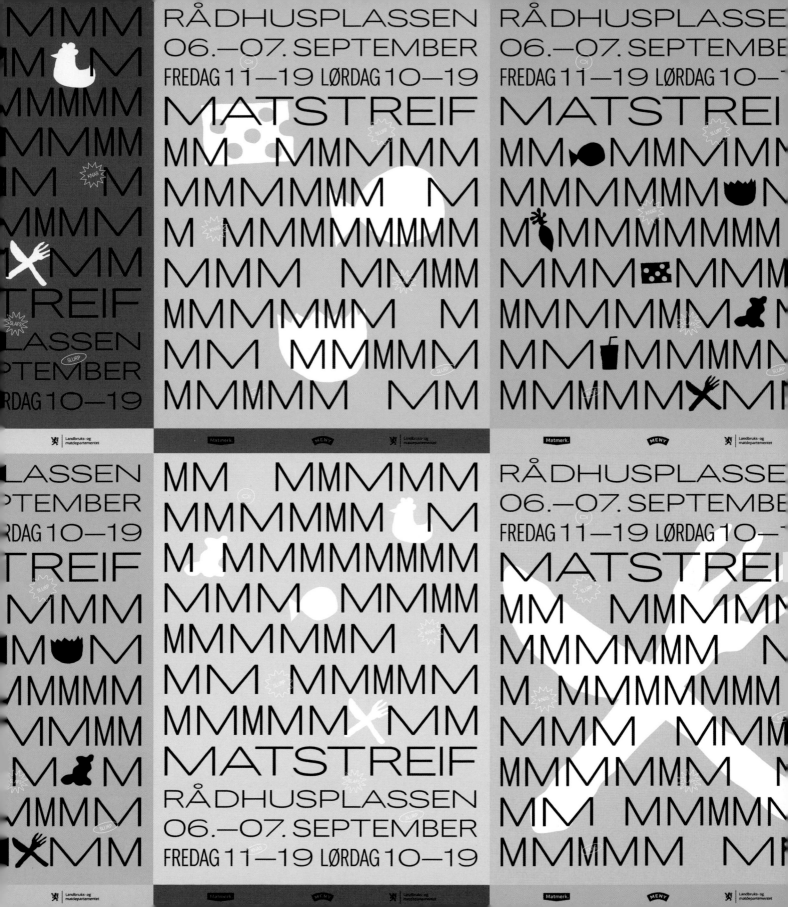

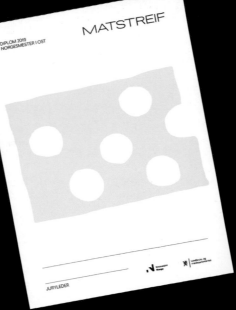

OG ◆ SJOKOLADE
KTE 🥕 SKOLESALATEN
RY & PASTRY 🧁 CUP
ST 🎲 2019 ✳
KK 🥛🥛🥛 EN FARGERIK ENERGIBOMBE
TEN 🥣 DU HAR SPIST

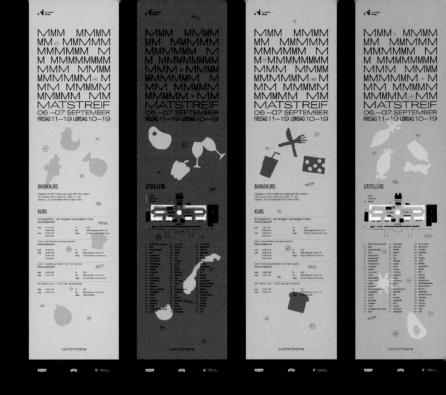

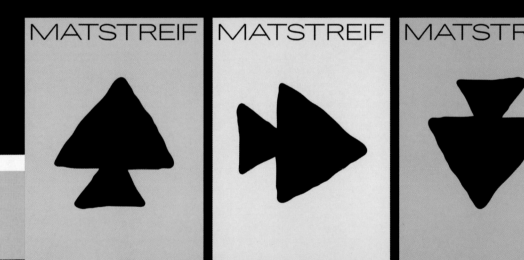

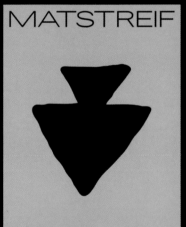

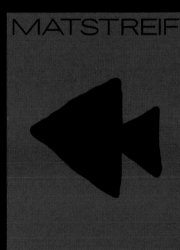

g drikkeflaska

g drikkeflaska,
r designglasset til årets
usplassen. I år vil vi
kkestasjoner med ekte
n rett fra kranen..

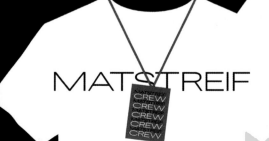

國家：法國
客戶：Carré Coast

我們與 Carre Coast（俱樂部）的合作始於
2018 年。起初，這些海報沒有任何視覺特
徵，其想法是圍繞奇怪的字符創建不同的布
局。然後我們建立了一個視覺的、版式上的
形象，給予更多的創作自由，讓人看了能聯
想起漫畫世界。

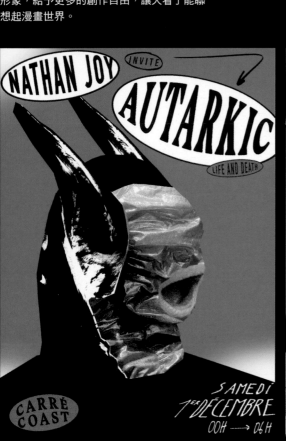

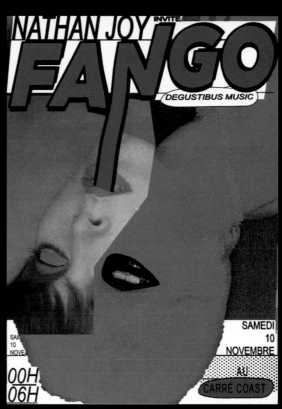

01 這 5 張海報是 2018 年創作的，整體色調明
亮、鮮艷，極具視覺衝擊力。在創作手法上，拼
貼、重組相關元素讓畫面產生了質感上的層次與
觀看時的聯想。

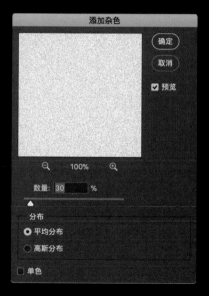

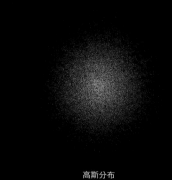

平均分布　　　　　高斯分布

02 海報運用了大量強烈的噪點做質感上的渲染，與平滑的色塊拉開關係。在 Photoshop 中，您可以通過「導航欄 - 濾鏡 - 雜色 - 添加雜色」打開面板進行調節。

在「添加雜色」面板中，「數量」可以控制噪點的密度；「分布」中，「平均分布」相較於「高斯分布」會更能保留原圖細節與層次（如明暗過渡），而「高斯分布」添加噪點的效果更加強烈；「單色」可以只添加黑白噪點。

因此，如果想在添加雜色的基礎上保留物體的體積感，則應選擇「平均分布」，如添加雜色的目標為平面或需要更強烈的噪點，則選擇「高斯分布」。

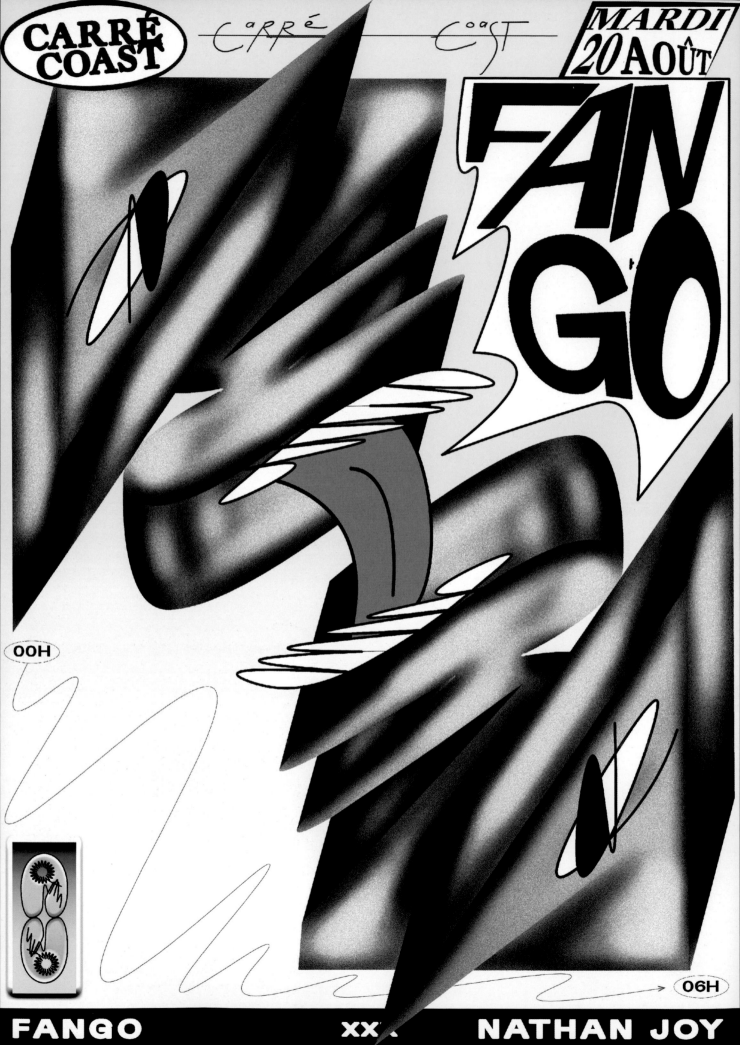

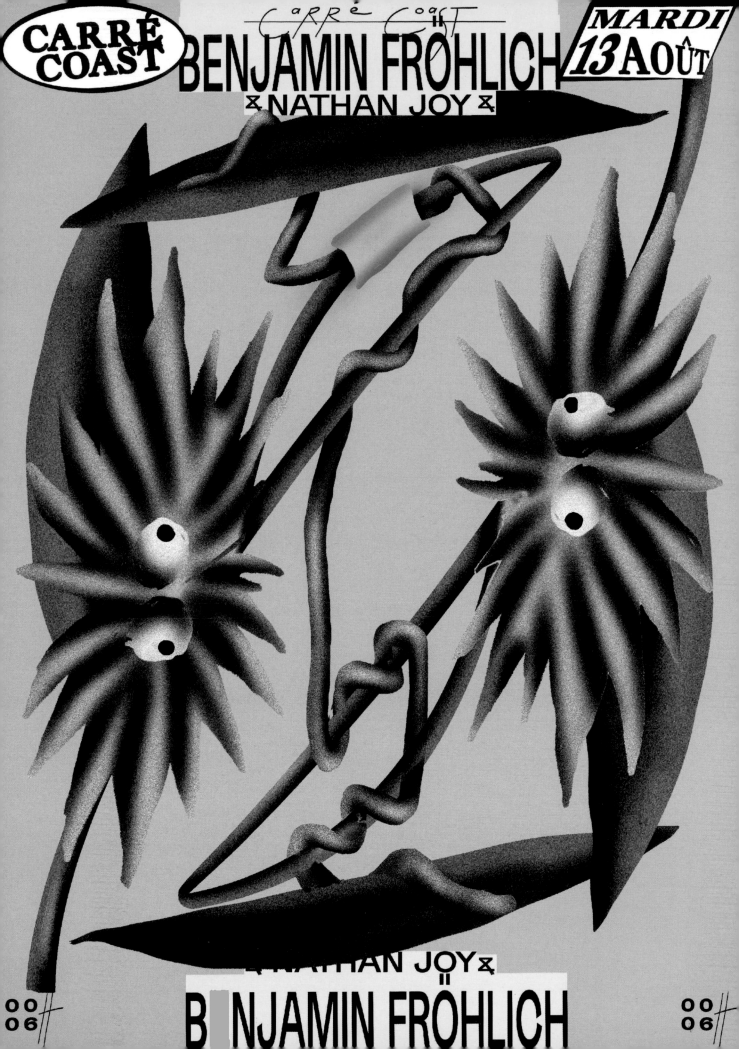

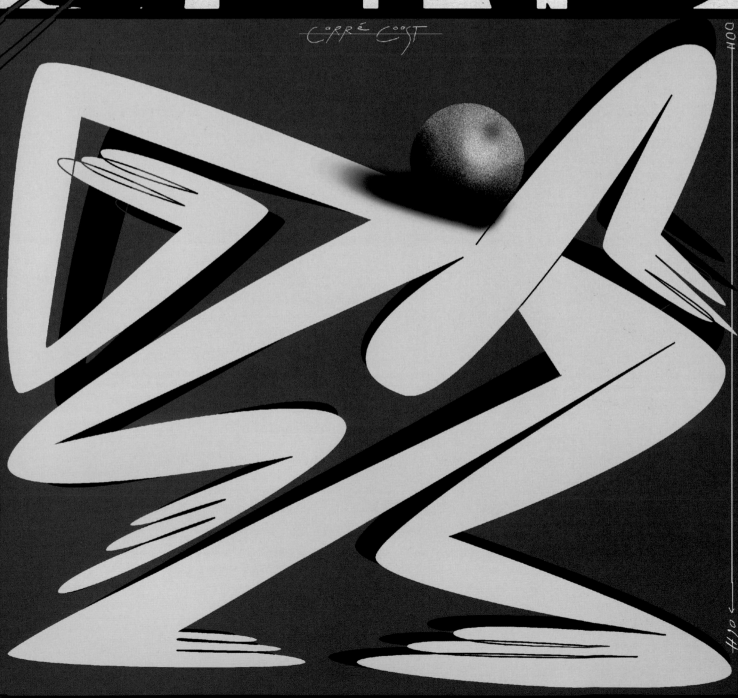

CARRÉ COAST

GERD
GERD

VENDREDI
16 AOÛT

GERD JANSON ⚙ NATHAN JOY

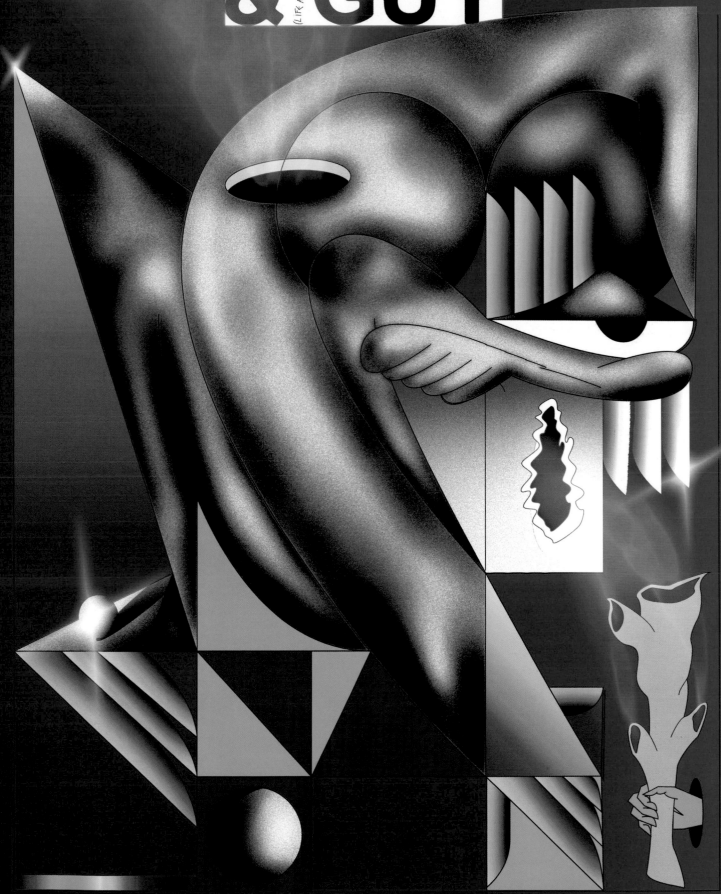

CARRÉ COAST

NATHAN JOY
INVITE
MARVIN
& GUY
(LIFE AND DEATH)

SAMEDI
21 SEPT-
EMBRE

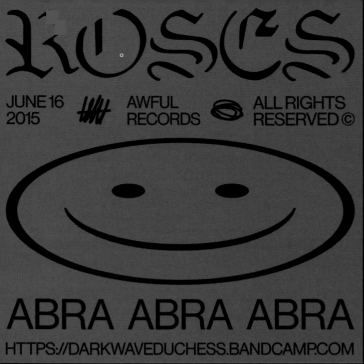

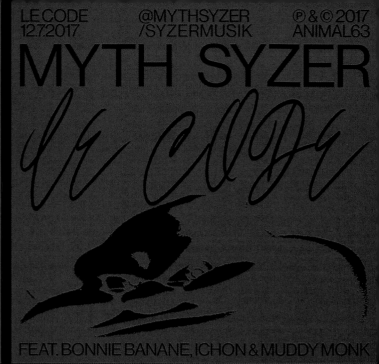

RÖSES

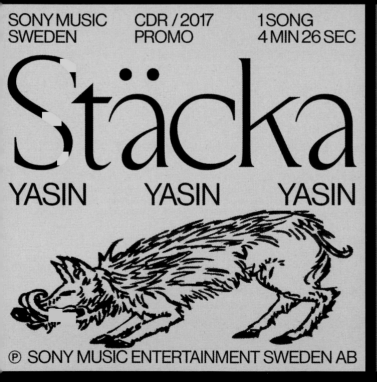

LE CODE

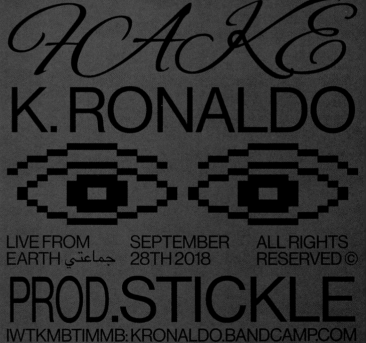

專輯封面尺寸為 2480 px × 2480 px，構圖統一為主標題與圖形占滿版心，其他訊息自分三欄呈現，專輯下方的字體是設計師為 4 首單曲所設計的。

唱片實驗

設計機構：Lars Högström
創意總監：Lars Högström
設計師：Lars Högström
國家：芬蘭

我為自己最喜愛的四首單曲
Abra 的 *Roses*、Mys Syzer 的 *Le Code*、
Yasin 的 *Stäcka*、K.Ronaldo 的 *Fake*
所製作的專輯封面和海報。

在這個項目中，我想嘗試一種非常規的想
法，即用設計系統來製作封面，使封面更像
一個系列（這對獨立唱片或者小專輯非常適
用）。在這個項目中，我創造了一組詼諧的
字體，以創建一個視覺上看起來有趣的系
列，這樣就不會讓人對統一的版式有太刻板
的感覺。

02 海報版面分為三欄，左側一欄以標題豎排占滿，底部網址橫向貫穿版心，上方訊息靠右貼近第二、第三欄。

03 海報的尺寸為 50 cm x 70 cm。

GerillAR 動態海報展

設計機構：Compact Studio
創意總監：Compact Studio
設計師：Áron Borbély, Gerg Faragó
國家：匈牙利
攝影師：Bence Szemerey

GerillAR 藝術項目的理念基於我們如何使用和欣賞公共領域的廣告空間，比如海報和廣告牌。隨著招貼在現代社會的貶值，藝術海報在城市中已不再占有一席之地。如今，公共空間中的海報僅用於營銷，而作為獨立平面創作的藝術海報，或反思當前社會問題，或向公眾引入一些新的訊息，其數量已微不足道。我們在思考還能怎樣利用海報呢，如果把城市的街道變成一個展覽，是不是任何人都可以快速方便地進入參觀？

通過這個項目，我們想讓人們更好地瞭解他們生活的城市。我們使用了 AR（增強現實）技術，為我們創建的海報賦予相應的線上內容，如反映城市環境、自然環境和歷史等。我們還發起了一項競賽活動，任何藝術家都可以加入成為海報動態內容創作的一分子。

我們為這次活動做了宣傳海報和形象識別設計。整個形象識別系統都是黑白的，因為我們包含的內容太過龐大。展覽海報和形象識別只是為設計師創造的內容提供了一個框架，內容才是豐富多彩的，因此我們把對創作者產生影響的可能性降到了最低。圖像的設計過程就像一個黑白的視覺游戲。

對於海報，其目的是融入展覽的形象識別，具有吸引力，在觀看者和動態圖像之間建立聯繫。我們使用的圖形選自一個獨特的幾何元素集（為展覽的圖像設計），因此每一個海報都像是一個獨特的視覺代碼。我們希望這些元素是好玩的。

我們成功聯繫了 40～50 個地方展示海報，最終我們在 44 個地方展出了 44 位設計師的海報。在線下的小型展覽中我們選擇了其中的 20 張海報進行集中展覽。

這個項目最大的特點是，每張海報都是一個入口，可以使用 AR 技術掃描每張海報。掃描海報後，動態的內容出現，所有這些內容都是匈牙利年輕設計師創作的，這使得項目非常多樣化。從一開始，我們就認為與其他設計師合作非常重要，不僅要使內容盡可能多樣化，而且要能夠在不同地方盡可能多地展示匈牙利年輕設計師的作品。

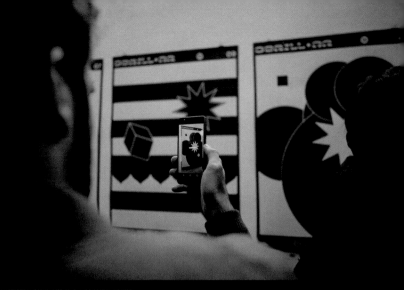

01 現場觀眾利用手機的 AR 功能觀看展覽。

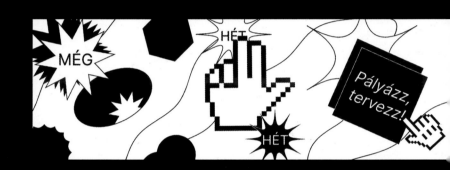

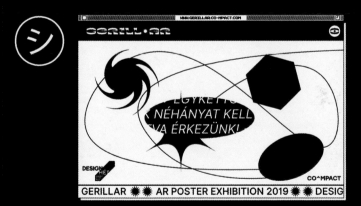

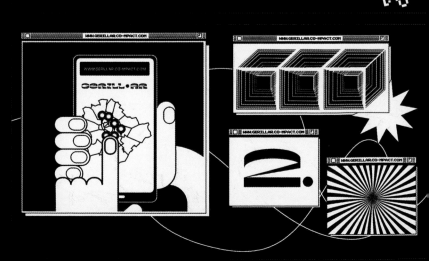

02 設計師運用稚拙、簡約的圖形創造出了一系列黑白動畫，用於網路宣傳（動圖連結：https://co-mpact.com/）。

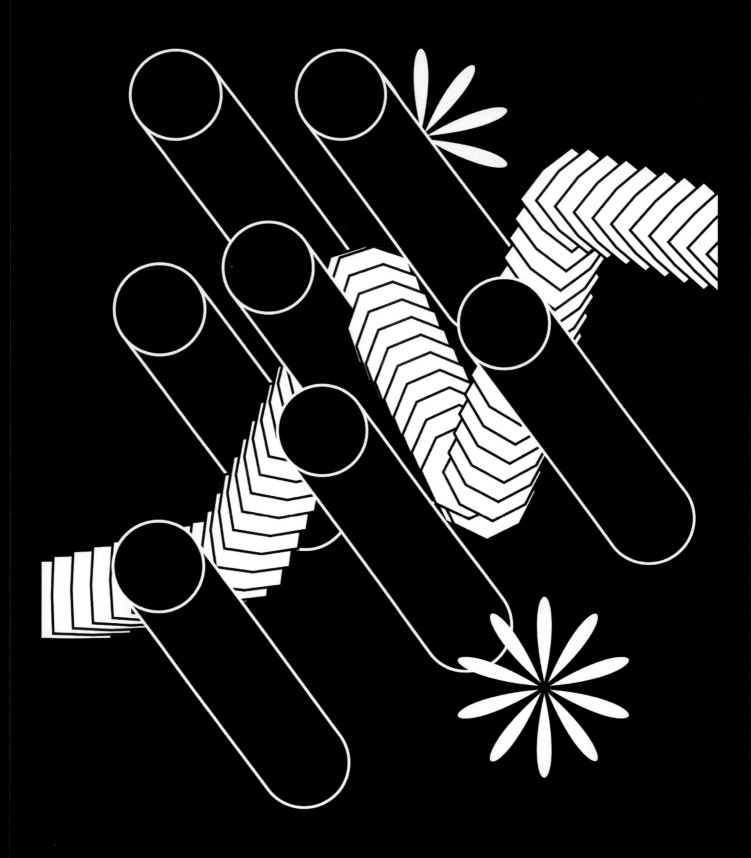

GORILL✦AR

 22

App store Google Play

ART**IVIVE**

CO^MPACT
graphic design studio

BARTÓK BÉLA
BOULEVARD

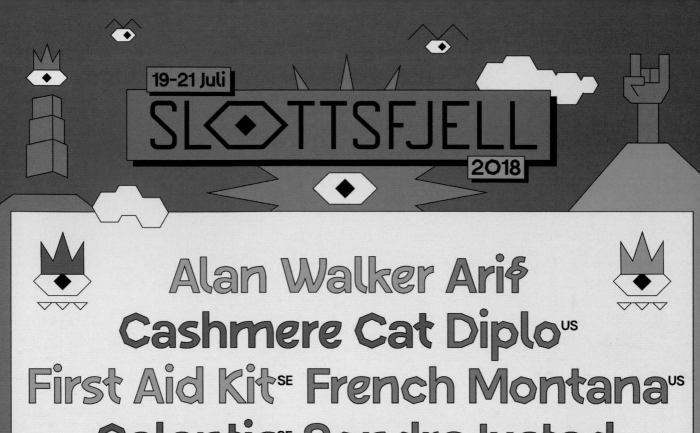

19-21 Juli
SLØTTSFJELL
2018

Alan Walker Arif
Cashmere Cat Diplo US
First Aid Kit SE French Montana US
Galantis SE Sondre Justad
Two Door Cinema Club UK
Unge Ferrari

Daniel Kvammen ◇ Fanny Andersen ◇ EMIR
Lauv US ◇ Hkeem ◇ Ila Auto ◇ Kakkmaddafakka
Kjartan Lauritzen ◇ Lil Xan US ◇ Milky Chance DE
Silvana Imam SE ◇ Sløtface ◇ Jon Olav
Confidence Man AU ◇ Ezzari ◇ Fieh ◇ Halie
Virkelig ◇ Agnes Stock ◇ +++

www.slottsfjell.no

Slottsfjell 音樂節

設計機構：Scandinavian Design Group
設計師：Sunniva Grolid,
Nicklas Haslestad, Even Suseg,
Sindre Setran and Vetle Berre.
國家：挪威
客戶：Slottsfjell

Slottsfjell 是挪威滕斯貝格當地的綜合音樂節。音樂節以電子、搖滾、流行和說唱類型的大咖陣容為特色，每個人都能在其中找到自己喜歡的音樂。Slottsfjell 於 2003 年開始舉辦，憑藉其包容、折中的氛圍和獨特的地理位置，至今已發展成為國際性的文化活動。音樂節的場地圍繞著古老的城堡塔樓而建，採用露天的大劇場舞臺，觀眾可以同時欣賞到城市的美景。

我們首先對節日的歷史和挪威文化進行了研究。最終，一個使音樂節帶上部落、童話色彩的想法，從山上的塔樓，傳遞到我們的腦中。壁塔上鐫刻的詩句「願這座城市，屹立在庭院中，一千年花開」是由著名作家比約恩·比昂森（Bjørnstjerne Bjørnson）撰寫的。這句話成為我們「神秘童話式設計」的起點，也是這次的品牌 logo 靈感來源，從鳥類的角度看 Slottsfjell，令人眼前一亮，為節日注入真實的生命。挪威的習語，挪威人的遠足傳奇，樹林中的幽默和嬉戲的人們，使節日充滿了歡樂。我們讓 Slottsfjell 變成了一個小社會，是您可以想像的最怪異、最瘋狂的遠足者盛會。

01 城堡山塔樓於 1888 年建成，位於挪威的古老城鎮滕斯貝格。塔樓城墻上鐫刻了「願這座城市，屹立在庭院中，一千年花開」這句詩詞。

SLOTTSFJELL RIPLEY

Use on all surfaces

ABCDEFGHIJ
KLMNOPQRST
UVWXYZÆØÅ!
0123456789

Dere er best!

SE DE UK US AU

Drikk vann

WC TRAPPER

Kongescenen

GUCCI MANE
CASHMERE
DIPLO CAT 20.30
No. 4 LAUV

Brooklyn
Baby!!!!!!!!

Performer:
Lana Del Rey

abcdefghij
klmnopqrst
uvwxyzæøå.

02 項目使用字體：Ripley Regular。

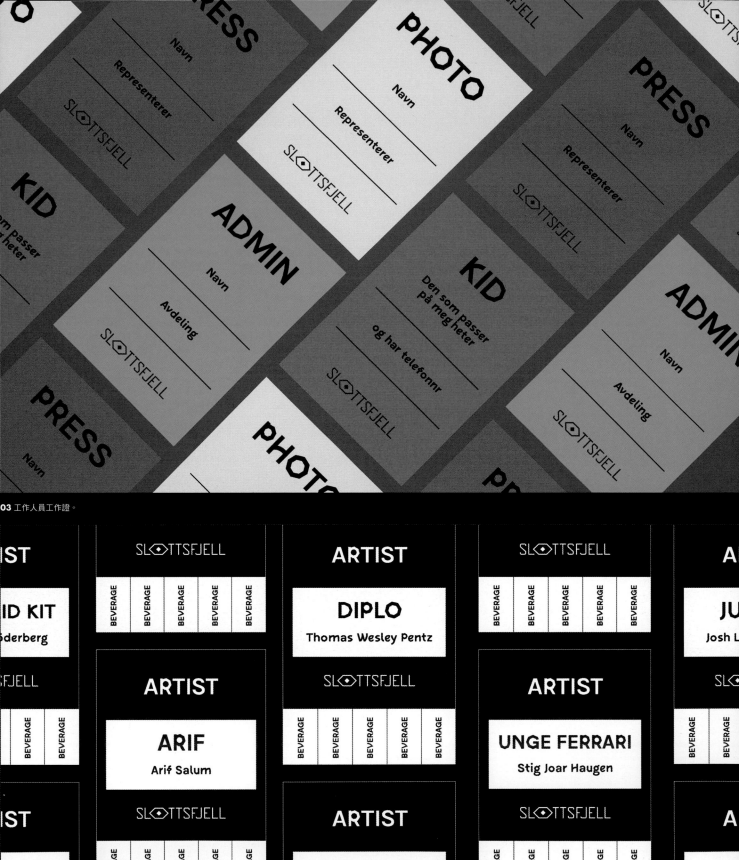

03 工作人員工作證。

04 參演藝術家工作證。

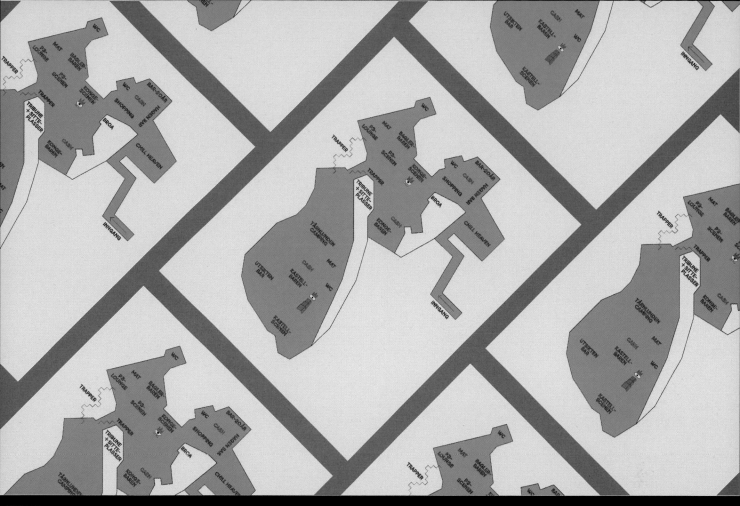

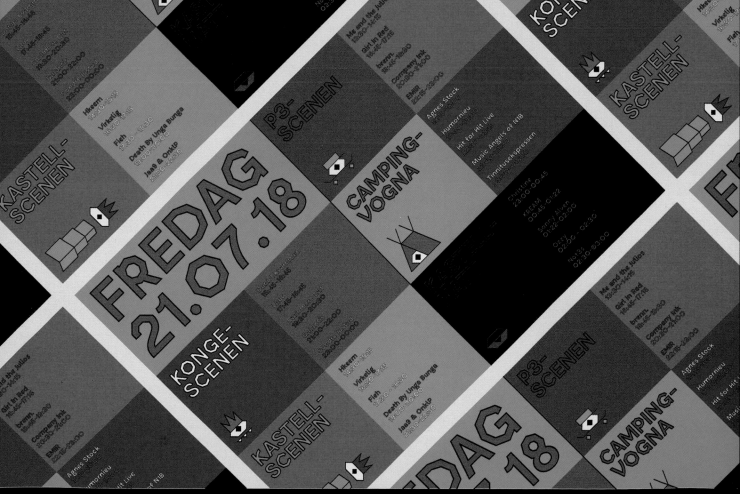

07 音樂節紀念Ｔ恤。

08 音樂節腕帶。

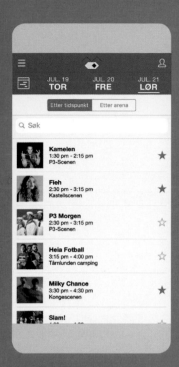
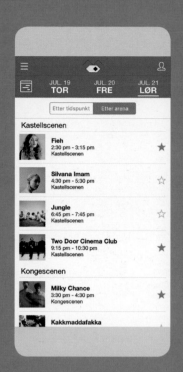
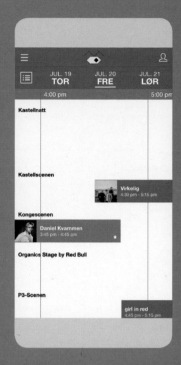

08.MA
BEURSSCHOUWBUR

1 yea
Psst Mlle

DEBATE — DANCE PERFORMANCE — LIVE CONCERT — DJ SETS

Psst Mlle
女性藝術家平台視覺形象

設計機構：Alliage
創意總監：Lucile Martin and Julien Pik
設計師：Lucile Martin and Julien Pik
國家：比利時
客戶：Psst Mlle

Psst Mlle是一個位於布魯塞爾的推廣女性藝術家的平台。這個項目開展6個月之後，委托我們重新設計平台形象。

我們面臨的挑戰是，想像一個女權主義的世界，同時又不太刻板和性別化。我們將身體圖像和一些視覺性很強的排版元素，通過3D和手工紋理結合在一起。

Psst Mlle是我們真正的實驗場。我們做了很多打破規則的嘗試。我們用一些構建的方法和特效來組成整個傳播設計，但最終還是憑直覺工作。

平台的每個事件都是一個特定的主題，我們的設計首先要基於這個特定的關鍵詞。我們想的是為每一個事件賦予一個特定的形象，但同時保持力度的一致。

在一周年活動的海報上（圖01）出現了一道電子/激光弦。這其實是一次無心的滑鼠操作失誤，但我們認為這是一個奇妙的神來之筆。從那時起，它就成為了Psst Mlle平面形象的一部分。

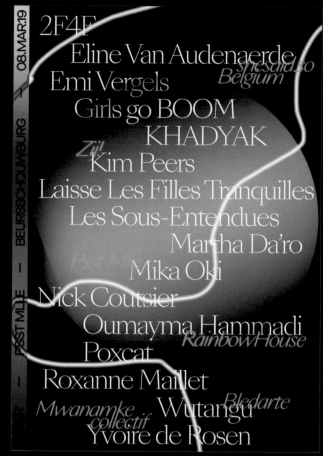

02 海報背面。

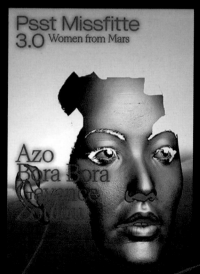
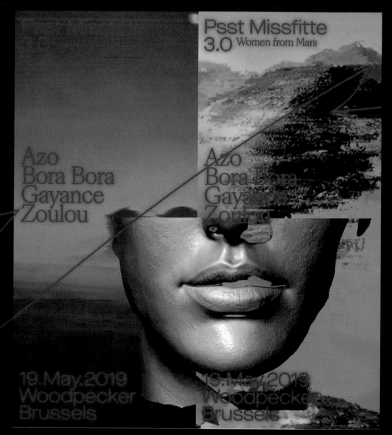

03 活動影片的截圖，採用了粗糙、破碎的3D模型作為畫面主體，背景為移動的火星地貌，整體色調低暗、渾濁，卻傳遞出一種獨特的視覺美感（影片連結：http://alliage.work/）。

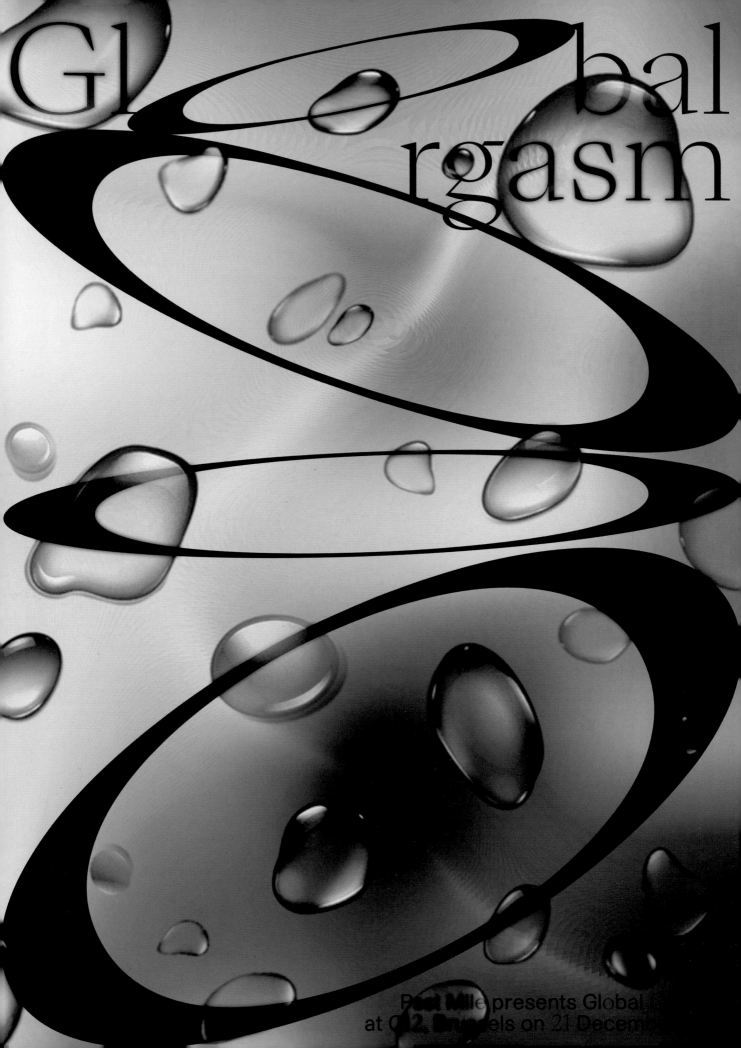

Global
rgasm

Paul Mille presents Global
at C.2. Brussels on 21 Decem

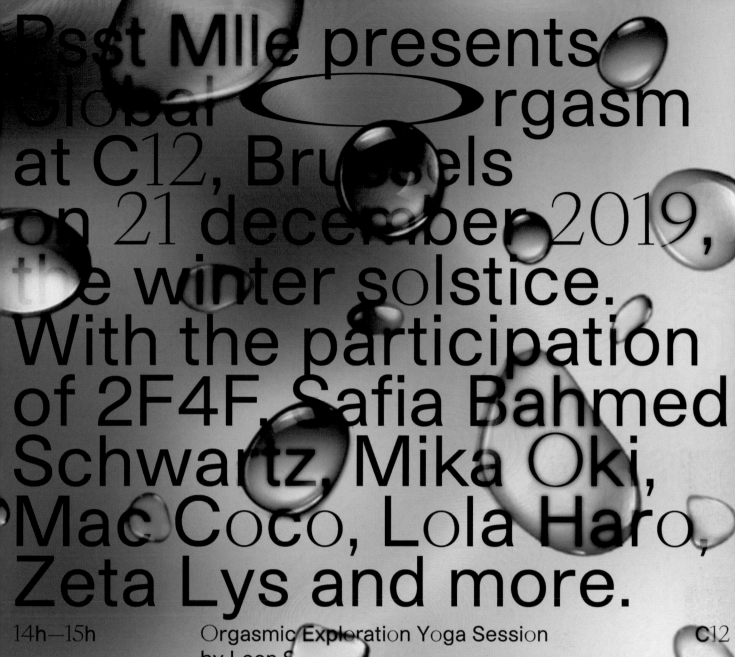

Psst Mlle presents
Global ⬭ Orgasm
at C12, Brussels
on 21 december 2019,
the winter solstice.
With the participation
of 2F4F, Safia Bahmed
Schwartz, Mika Oki,
Mac Coco, Lola Haro,
Zeta Lys and more.

14h—15h	Orgasmic Exploration Yoga Session by Leen S.	C12
15h—20h	Orgasm Market 'zines, erotic illustration, feminist sextoys and so on...	C12
Starts at 17h	Opening Exhibition of Safia Bahmed Schwartz	C11
17h—22h	Loop listening session of Orgasm podcasts by QUD Magazine	C11
Starts at 20h30	Performance L'Encastrable by Mac Coco	C11
—		
00h—02h	Lola Haro	C11
02h—05h	Mika Oki b2b Zeta Lys	C11
—		
Video projections and scenography by 2F4F		

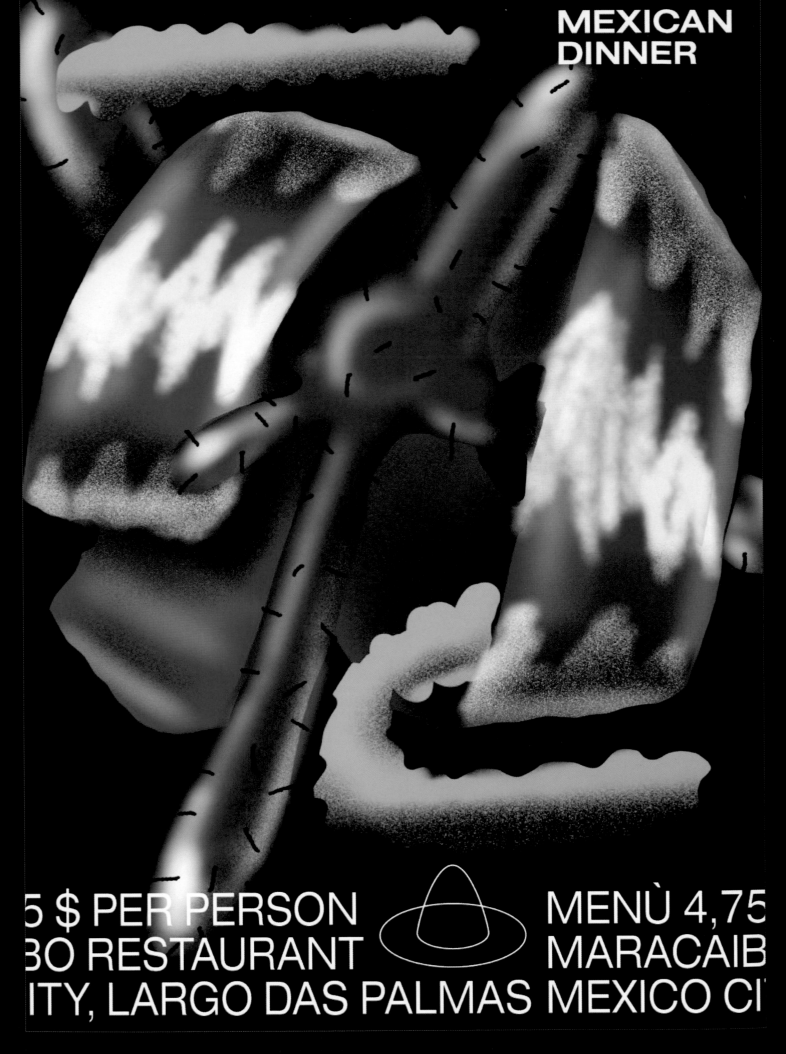

MEXICAN
DINNER

5 $ PER PERSON

BO RESTAURANT

ITY, LARGO DAS PALMAS

MENÙ 4,75

MARACAIB

MEXICO CI

Trash.Been 海報系列

設計機構：Trash.Been
創意總監：Marcello Raffo
設計師：Marcello Raffo, Nicolò Tromben
國家：義大利

Trash.Been 的海報將流行文化和所謂的垃圾桶文化打碎，使用復古以及早期互聯網的視覺重新包裝，他們似乎在懷念那個他們當時因年紀太小而無法體驗的時代。

他們使用的視覺語言是「蒸氣波」「新醜風」「故障藝術」和其他樣式，並將其進行個性化的組合。如果他們有宣言，那就是宣布拒絕任何規則，但是對於像 Trash.Been 這樣的自由團體來說，寫什麼宣言似乎都是一個不合時宜的想法。

01 科米蛙（Kermit the Frog）是《大青蛙布偶秀》（The Muppet Show）電視節目的角色，該節目是一檔真人秀，播出時間為 1976 年到 1981 年，2004 年這個角色及電影製作所有版權被迪士尼購買。

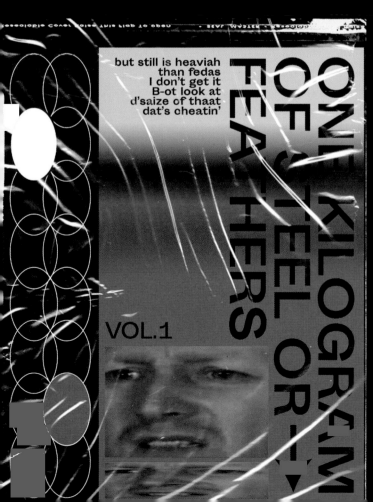

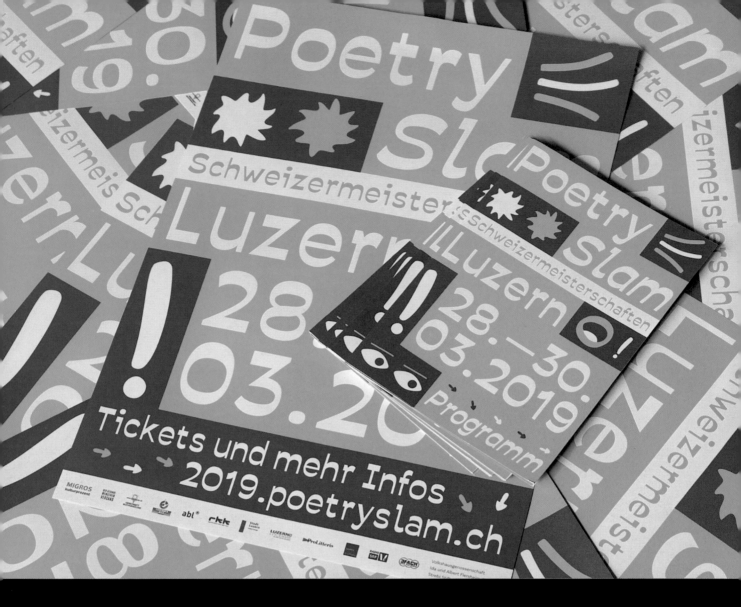

Poetry *Slam*
Schweizermeisterscaften
Luzern
28.—30.
03.2019
Programm

PANTONE 802 U
#3BD23D

PANTONE 814 U
#7B5EC6

02 項目使用了螢光油墨來呈現鮮豔的色彩，其色號分別為 PANTONE 802 U（綠色）和
PANTONE 814 U（紫色）。在 PANTONE 色卡中，色彩編號後面的「C」跟「U」代表
承印物的差異：如 802 C 代表用於塗布紙上（Coated），802 U 則代表用於非塗布紙上
（Uncoated）。常見的塗布紙有銅版紙、啞粉紙、超感紙等光面質感的紙張，常見的非塗

01 使用字體：Savate Regular + Italique。

2019瑞士詩歌大賽

設計機構：Anders Bakken Design
創意總監：Anders Bakken
設計師：Anders Bakken
國家：挪威
客戶：瑞士詩歌大賽組委會

瑞士詩歌大賽是一個朗誦活動，為了在視覺上表現出趣味性和文化性，該設計使用了一套明亮的色彩搭配方案。有趣的字體加可愛的圖標，通過螢光油墨用彩通色彩印刷出來。該項目包括活動標識、一個網站以及印刷宣傳材料。

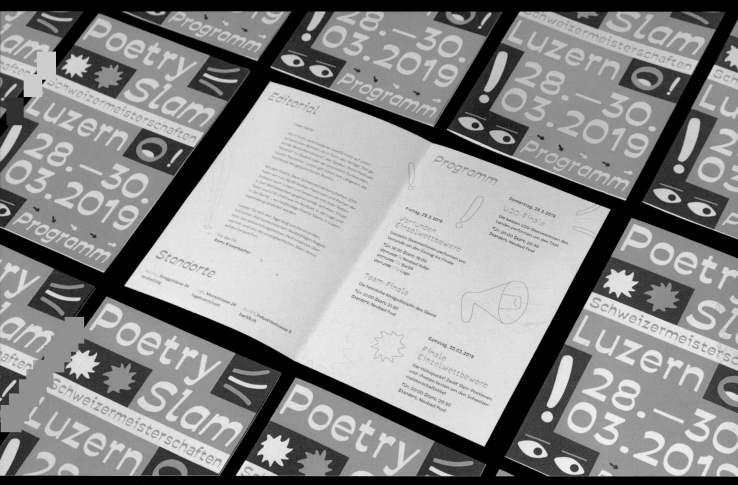

03 由於大賽是聲音傳播性質的活動，挑戰在於如何用視覺來表達聽覺。有趣的版式和霓虹燈色彩的圖標風格，成為我們選擇的方式，以傳達和突顯大賽的活力與創造性。

04 這些圖標都是可動的，供網站和媒體活動推廣時使用。

Postwebrutalism
（後互聯網主義）系列海報

設計機構：Decart IT-production
設計師：Mikhail Boldyrev
國家：俄羅斯

「Postwebrutalism」（後互聯網主義）項目
是系列海報作品，研究當代平面設計。該設
計將天真與真摯，迷幻與超現實，動感與寧
靜，數位與自然材料交織在一起。

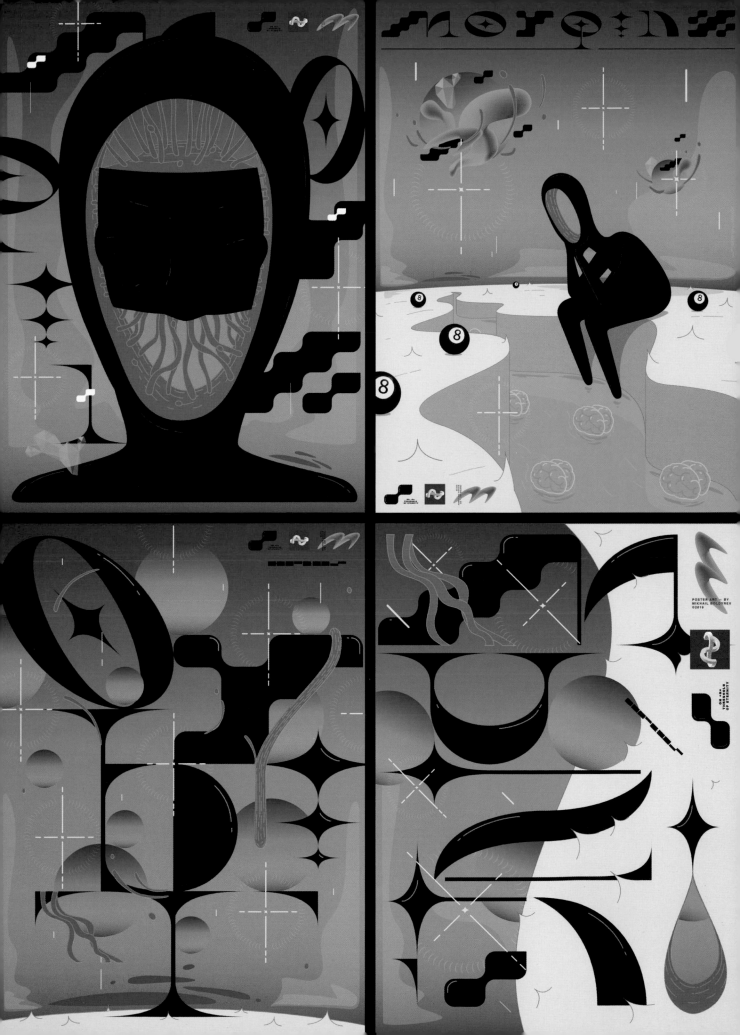

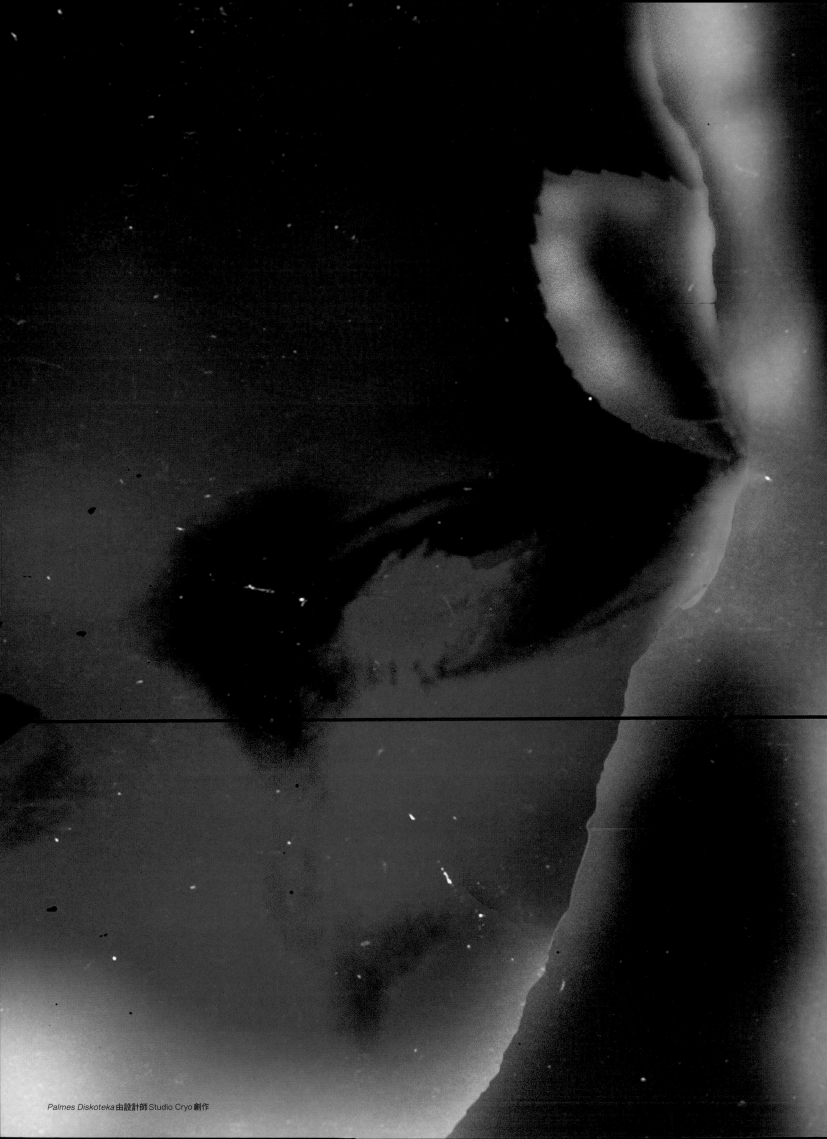

Palmes Diskoteka 由設計師 Studio Cryo 創作

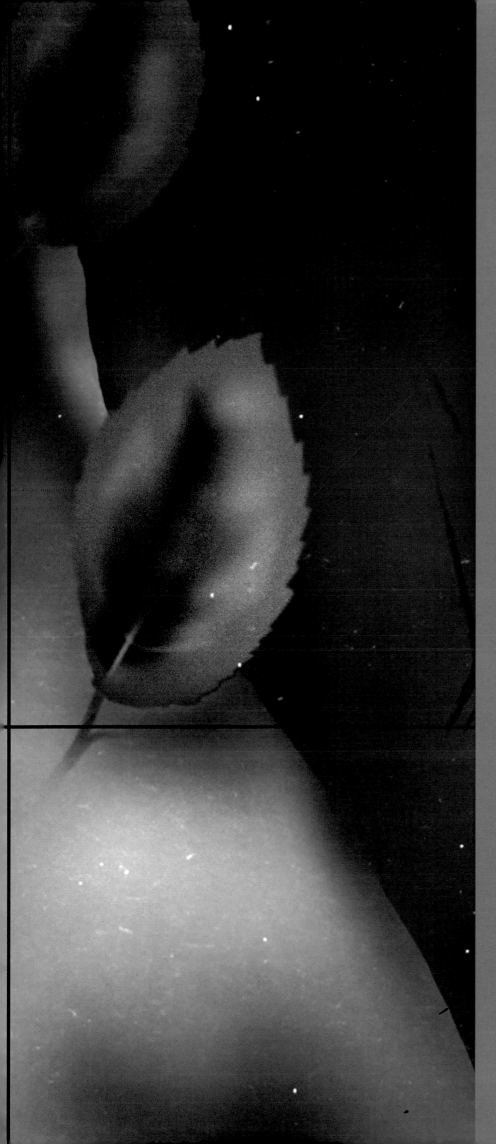

NOSTALGIA

在顛覆「現在」的設計風格中,有的來自「未來」,有的則來自「過去」。通過強調歷史風格的復古,來實現對現代設計中刻板、沉悶、理性的反對,這種風格的核心並不是表面上的「向後看」,而是借助懷舊來諷刺現在,體現多元化的設計手法。在本章節精選的作品中,有的運用了絲網印刷的手法,有的使用了復古的畫面元素,刻意舊化的色調與光影,恰到好處地體現了設計主題中想要傳達的感覺。

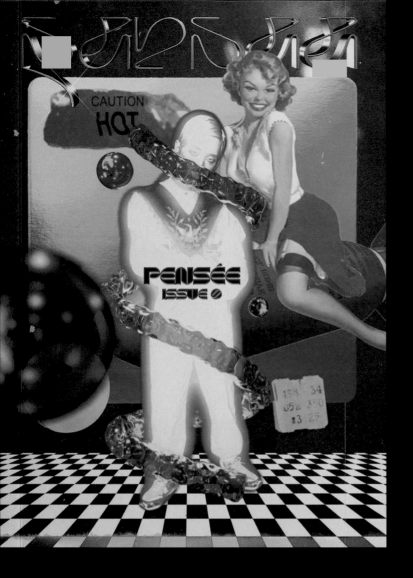

Pensée

設計師：Cristiano Cola
國家：義大利

Pensée 是 2020 年誕生的一本探尋美與當代雜誌文化的獨立電子雜誌。

Pensée 是地下文化與流行文化交匯之地，是一個特立獨行的範本，以及個性表達的空間。這個主題旨在成為激進時尚、風格和圖形的文化先鋒和新風向標。

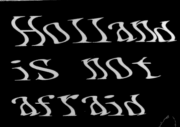

As the first openly gay star in a genre that has a complex relationship with queerness, the singer is pushing K-pop's conservative limits.

TEXT BY TAYLOR GLASBY

Squatting in the upper corner of Holland's music video for his early 2018 debut, "Neverland", is a bright red dot with the number '19' in it — the Korean age rating for its depiction of two fully clothed men exchanging a kiss.

In a song about struggling for self acceptance, this kiss risked rendering the then 21 year old K-pop idol invisible. In his home country, no mainstream broadcast media would air the video when it came out in January. Homosexuality is legal in South Korea, yet members of the LGBTQ+ community are still social pariahs, routinely shoved into the shadows by unpunishable discrimination, public protests and large scale petitions to the president's office.

A little over a year later, on a quiet Saturday morning, the summer sun streams into Holland's family home just outside Seoul, where he's make up free and wearing a rumpled, black Rolling Stones t-shirt over his thin frame. The day before, he'd sent me a warm greeting over the KakaoTalk app and when, several days later, I email an extra question that's been in the back of my mind, he promptly responds.

It's far removed from the standard K-pop interview where idols — with pristine hair and make up are closely supervised by publicists and managers, their interview answers screened and their phones confiscated.

Unlike many of his K-pop peers, Holland isn't interested in smoke and mirrors. Prior to his self titled debut mini album, released in March, agencies advised him to stay in the closet. He refused. "During my school days, if there'd been no (international) artists representing LGBTQ+ rights, it would have been even harder for me," he tells me. "I know how significant their influence is and Korea also needs that kind of artist.

"For me, lying to fans and not being able to receive love for my true self would have made me uneasy. If my generation (goes by) without any such movement, the future generation will also (never experience) change, so the goal of proving I can receive love regardless of whether I love a man or a woman was big."

On Instagram, where his electric platinum haircut was debuted, Holland looks just as liberated, taking selfies in acid washed Harajuku streetwear, emblazoning his face with peach bum emojis, and captioning a stroll along a railway track with "There is no more you". One top, a high sheen vest by Korean brand More Than Dope, spells the words "Psychedelic Summer Trip".

10–6

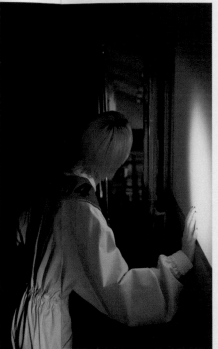

Despite queerness being used as a marketing tool routinely in K pop (from choreography to fan service games, where same sex idols pass thin sheets of paper mouth to mouth), LGBTQ+ performers are shunned in actuality. As such, Holland, who started making music when he was studying for an art degree at Seoul Institute of Arts (he's since put his studies on hold to focus on his career), was unable to secure a deal at an entertainment agency, and lacked the money and connections needed to appear on the country's variety and music programmes, which play a major part in the careers of idols.

Through the internet, however, K pop performers can resonate with millions beyond Asia, and the "Neverland" kiss ricocheted loudly around the world. On Twitter, #HollandDebutDay trended. The song hit #3 on the US's K pop iTunes chart. On YouTube, despite the age restriction, the view count rose to 1.6 million in 24 hours. It currently stands at more than 12 million.

The outpouring of support caught Holland (whose real name is Go Tae seob) up in its whirlwind. Since then, he's crowdfunded over £80,000 to record and release his eponymous mini album, been championed by international media, won 2018's Dazed 100 list, and amassed more than a million social media followers (known as Harlings), with whom he primarily communicates with in English. "I was surprised by the interest, but there was no time to be happy," says the 23 year old. "Rather than being in the moment, the first thing that came to mind was what I was going to do next."

The artist — who took his stage name from the first country to legalise same sex marriage — isn't the first openly LGBTQ+ Korean pop star, but, as K pop continues to grow in global popularity, he is the most visible gay performer the country has produced. Before him there was Harisu, the group Lady, and girl group member Choi Han bit, all of whom are trans women. Despite this, K pop's conservatism has meant that Holland's presence is a very big deal. He has become a queer poster boy, the one with a megaphone in a country full of whispers, and he's unwittingly — riskily — been tasked with speaking for the whole community. Korea is a country that grew very quickly economically but (because of that) we didn't have as much energy to focus on culture," Holland says of the slow road to acceptance.

10·7

In fact, Holland's profile in Korea may soon blow up. In early June, the musician announced on Twitter that he'd found an entertainment company to sign with. Although he still can't give out details, the clincher for signing, he says, was the agency's focus on maintaining the artistic freedom he's now accustomed to.

Until now, he's done everything on his own, and that's proved to be a double edged sword. Communicating with fans, building a network of industry allies, and his maturation during that process are what he calls the "precious" moments.

"There are people who question whether gay people even exist! The fact that I debuted (as an artist) is a small change in itself. Other K pop idols will talk about supporting LGBTQ+ (people) on their live streams or at concerts, but it's not on broadcast TV. When those people are able to say such things on TV and I'm able to promote very freely, maybe a lot of people will talk about this topic much more."

Holland's most vocal supporters are international; he isn't even sure how many fans he has in South Korea. "People are careful when supporting me publicly or following me online," he says. In other words, the implication follows, if you support a gay pop star, you, too, must be gay.

He hasn't even yet held fan meetings, as idols often do to help build loyalty. There are, he says, "many religious or homophobic people that threaten to hurt my fans if I hold one. But I do get a lot of private messages (of support)." Often, people ask for his advice — "It can be small, like, 'This thing happened to me today, I'm really upset,' or, 'I really like this person but I don't know what to do'" — and he does his best to respond.

Nequas nonsedis dolorib erumenis dicipici cuptatiorrum facero milliquae nosandebit, aut omniatempor aliquia ducient.

Os sed expedis tendanimi, explabo. Cium voloreperum ut ped magnitecus sit ium evello consers pientet fuga. Itatem que nitatenem aut erovita sequasp eriscium fuga. Quisit odi offic temqui ut et, voluptatur, sin eatur, nam que cus essero con cus quis am volupta nonsentur?

Me nonse pa ped maximus, omnissi nienim fugiateceat ex est, te volecere velibus tibearum qui consequo ipidernate voluptam aliquid quis dellam ra aut is accusciet arciis is ut vid evelia quam, quae comnihiciist que ad explaboris dolupta temporesto eicit occust es et pliti quiatioriae siti berferum re nihil mo berumquation explabor mi, nestrum recest, aut venet ut omnis minvele ctetus dent.

Ecat. Ommodisquae volupta quo tem et evendel is et vid eumet arcimin ctiostiatis apit, sunto to volorum, occusap iciatibus etum imus maiost, tempos exerfer atquiate ni in rectem exceat issit alistem quiatqui remque occus neculpa

圍繞物件形狀

文本绕排

□ 反转

8点 — 繞排間距
8点
8点 — 繞排方式

绕排选项:

绕排至: 左侧和右侧 — 繞排方式

轮廓选项:

类型:

□ 包含内边缘

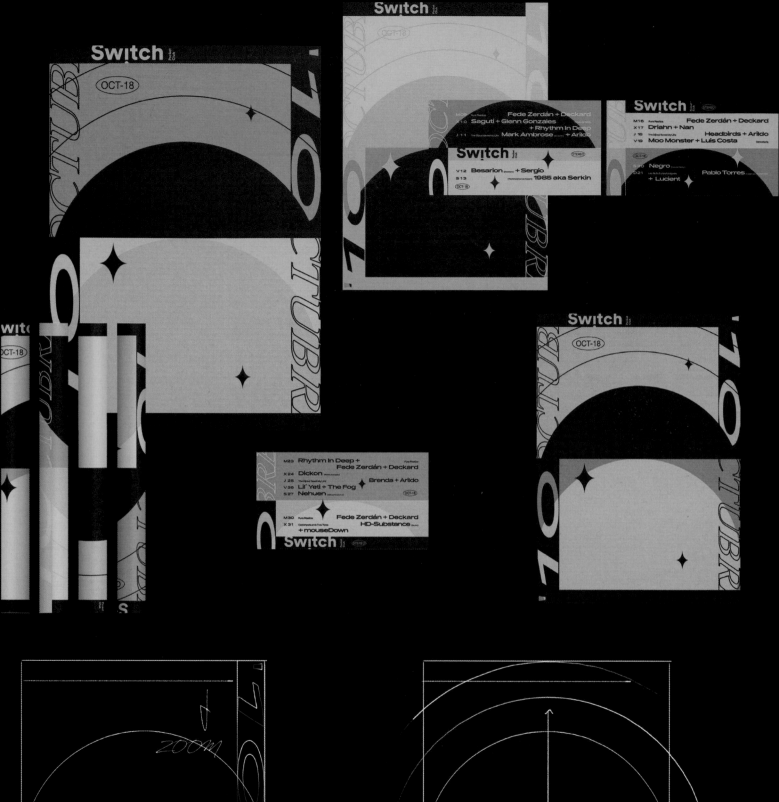

Switch 地下音樂海報

創意總監：David Jacob
設計師：David Jacob
國家：西班牙
客戶：Switch Pocket 俱樂部

巴塞羅那的Switch Pocket俱樂部對於地下音樂愛好者來說，它是真正的天堂。

該項目每月的動態海報和數字媒體周邊都由我來設計，以日常活動的推廣提升 Switch Pocket 俱樂部的知名度。

設計理念來自DJ台周圍的模擬設備和數位設備的外觀和動態展示，在這裏，字體動畫在螢幕上滾動，唱片在封套間穿梭，揚聲器輻射著音樂。這個項目使用Illustrator、Photoshop和After Effects執行。

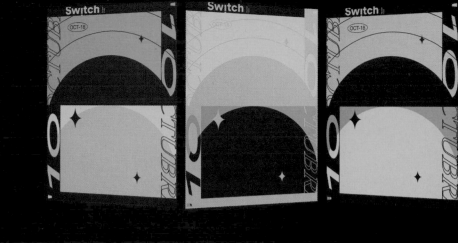

Rhythm in Deep

02 名片使用字體：Pano - Bold。

03 利用After Effects實現海報旋轉，文字、圖形滾動和縮放等動態效果。

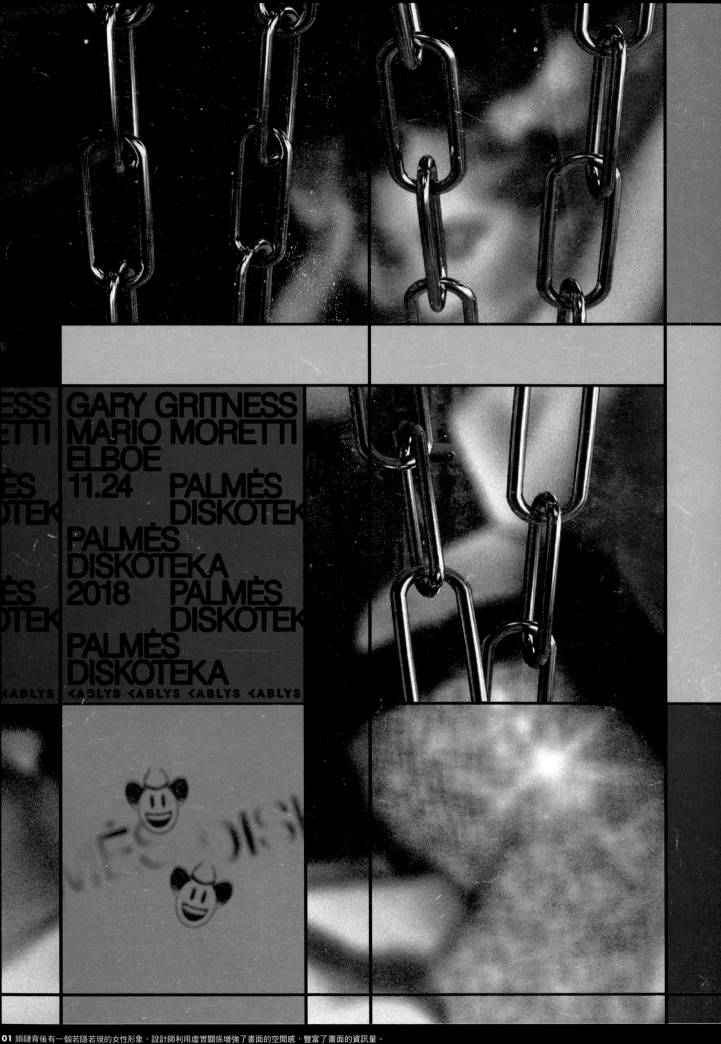

GARY GRITNESS
MARIO MORETTI
ELBOE
11.24 PALMÉS
 DISKOTEK
PALMÉS
DISKOTEKA
2018 PALMÉS
 DISKOTEK
PALMÉS
DISKOTEKA
ᏦABLYS ᏦABLYS ᏦABLYS ᏦABLYS

Palmes Diskoteka 海報系列

創意總監：Studio Cryo
設計師：Studio Cryo
國家：立陶宛
客戶：Palmes Diskoteka

這組海報是 Palmes Diskoteka 音樂俱樂部
的系列活動海報，分別為 Mario Moretti &
Elboe 兩位歌手在不同時間舉辦的音樂活動
而設計。

在我的理解中，設計應該是基於主體去傳遞
某種真實的情感，而不是依賴視覺趨勢。所
以，對於這個項目，我的重點是將夢幻、情
色和活力的音樂體驗與暗黑系的俱樂部氛圍
相融合。

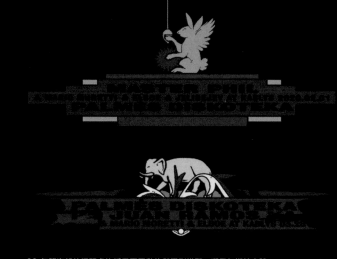

02 每張海報的標題處均採用不同動物與圖形搭配；選用無襯線字體GrotesqueNo9T，
並在此基礎上對字體變形。

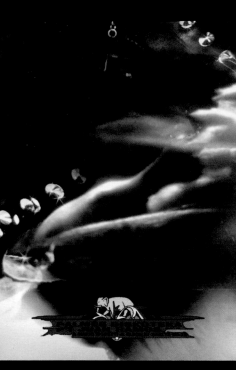
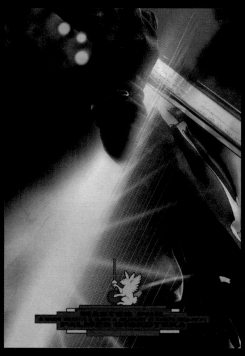

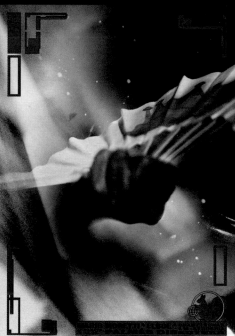
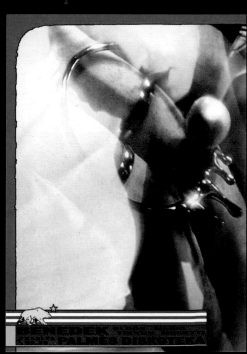

03 海報沒有採用完整、清晰的圖片去展現具體形象，而是截取圖片的某部分細節，以一種抽象的方式去傳達主題或歌曲給人的感受。

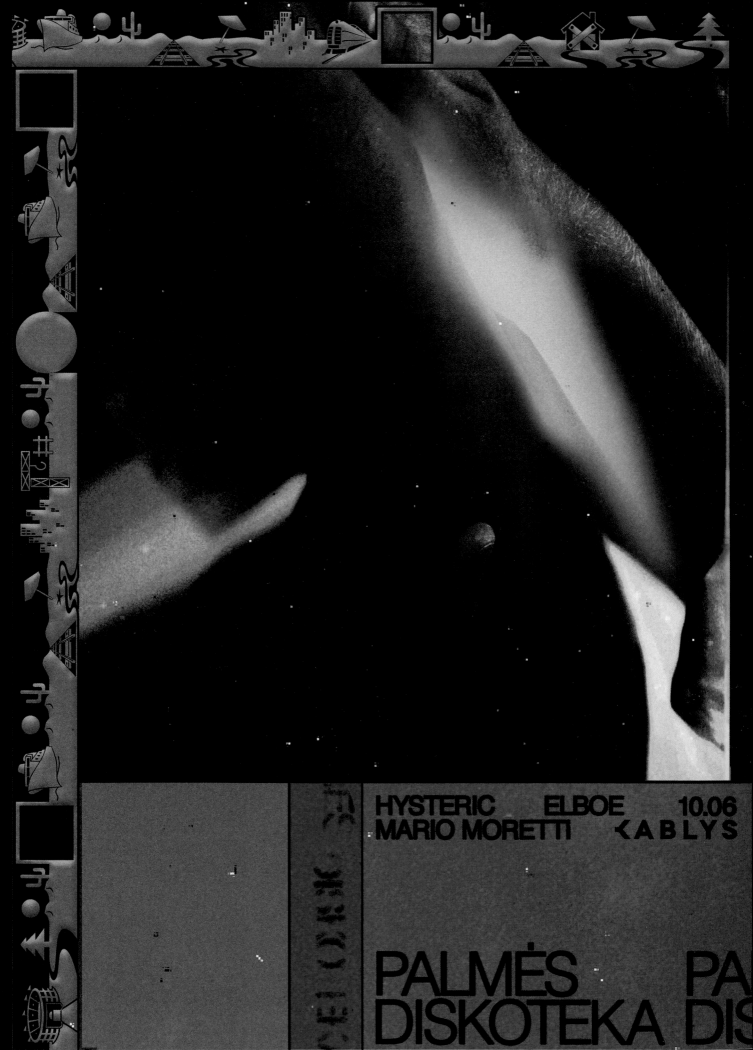

HYSTERIC ELBOE 10.06
MARIO MORETTI KABLYS

PALMĖS PA
DISKOTEKA DI

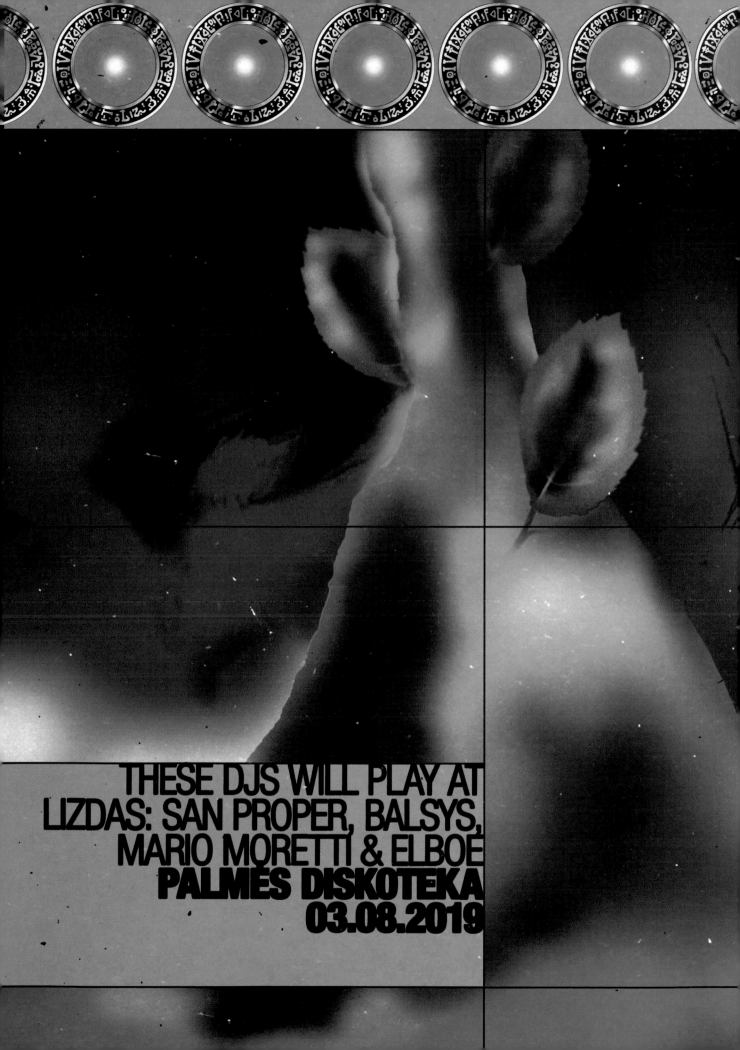

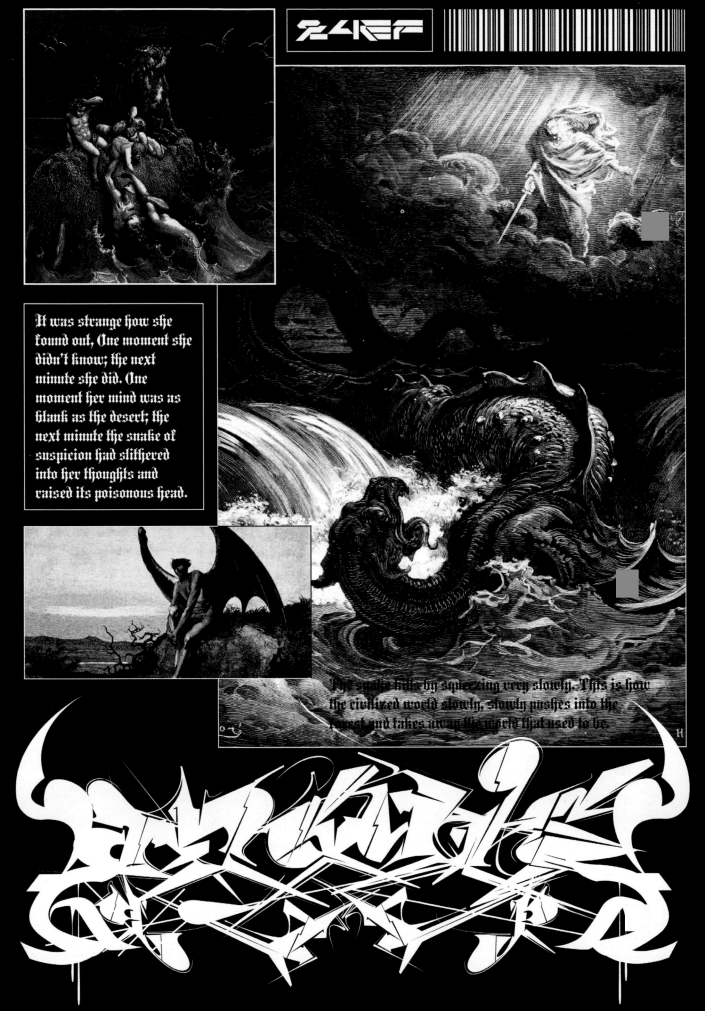

It was strange how she found out. One moment she didn't know; the next minute she did. One moment her mind was as blank as the desert; the next minute the snake of suspicion had slithered into her thoughts and raised its poisonous head.

The snake kills by squeezing very slowly. This is how the civilized world slowly, slowly passes into the forest and takes away the world that used to be.

Anguis & Orcus 海報

設計師：Sheida Assa
國家：德國

這個作品由定制字體、HUD 元素和古典插畫製作而成。

在義大利，人們的生活與過去緊密相連。作為一名年輕的設計師，我的設計介於現在、過去和未來之間。我的大多數項目都會把不同的元素和風格混搭在一起形成新的感覺。

為古典插畫加上賽博龐克塗鴉的元素，這就是設計的構思。當人們看到它的時候，很快就會注意到它不常見的形式和元素，這就是這個作品的特點，它將很多故事集合在一起變成一個新的作品。

02 HUD 為 Head Up Display 的縮寫，可以翻譯為平視／抬頭顯示器。HUD 最早出現在軍用飛機上，目的是降低飛行員低頭查看儀錶的頻率；而後廣泛應用於汽車、科幻電影、遊戲操作界面等領域。

It was strange how she found out, One moment she didn't know; the next minute she did. One moment her mind was as blank as the desert; the next minute the snake of suspicion had slithered into her thoughts and raised its poisonous head.

01 海報中的古典插畫均來自19世紀法國藝術家古斯塔夫·多雷（Gustave Doré）的版畫作品。上圖主圖為《白馬上的死神》（Death on the Pale Horse）。

03 海報在字體的選擇上採用了塗鴉字體、哥德體和斜切角的無襯線體，與古典插畫搭配 HUD 元素的混搭風格形成視覺上的統一。

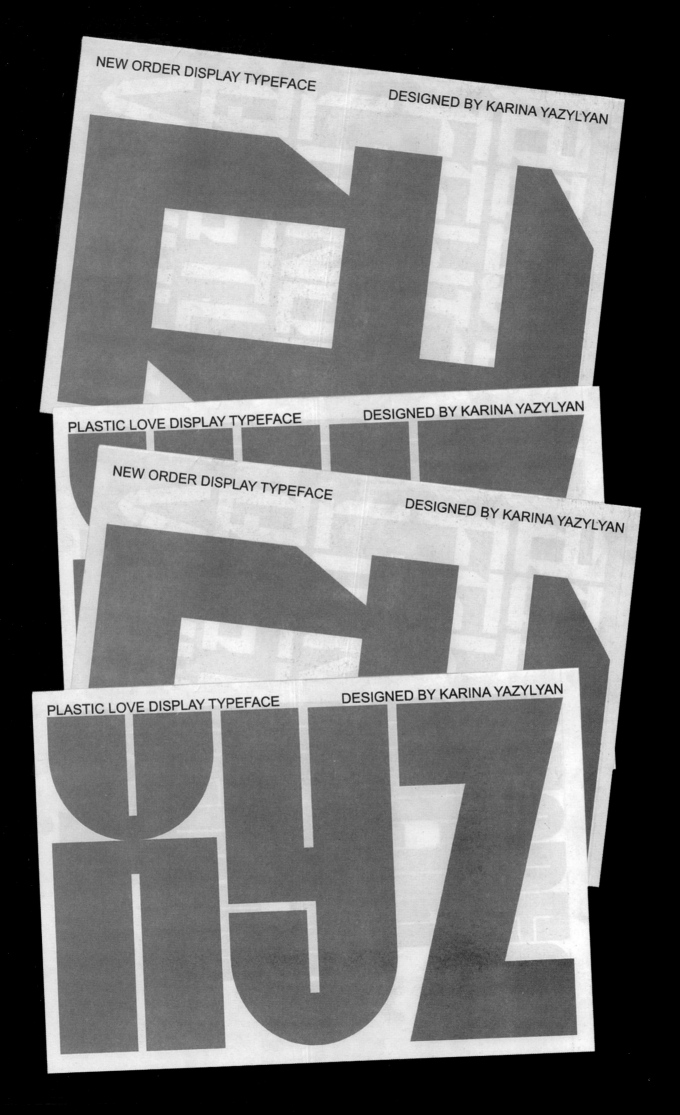

NEW ORDER DISPLAY TYPEFACE

DESIGNED BY KARINA YAZYLYAN

PLASTIC LOVE DISPLAY TYPEFACE

DESIGNED BY KARINA YAZYLYAN

NEW ORDER DISPLAY TYPEFACE

DESIGNED BY KARINA YAZYLYAN

PLASTIC LOVE DISPLAY TYPEFACE

DESIGNED BY KARINA YAZYLYAN

「New Order」。在研究這些字體時，我將目光轉向20世紀（例如20世紀60年代和80年代），我認為我捕捉到了這種氛圍。我決定做一本字體樣書，而不只是關於字體的枯燥介紹訊息，而且還要採用獨立雜誌的形式。這樣的書是有趣的，它不是僅僅針對那些瞭解字體設計的人。於是我試著用不同的技巧，把整本書的每一頁都做成海報一樣。書籍採用 Riso 印刷螢光粉色，顏色看起來非常鮮豔飽滿。

Riso 印刷機的外觀與大型打印機相似，其工作原理接近絲網印刷，但操作上更加簡易。Riso 印刷機使用環保的乳劑水基大豆油墨，一般有 20 多種常規顏色可選，且油墨均為專色，印刷的發色飽和鮮豔。由於 Riso 印刷機的操作簡單便捷，因此與絲網印刷相比，它在套色時精度不高。但正是因為這種不完美，印刷出品時常有意外驚喜，這也是 Riso 印刷深受廣大藝術家與設計師喜愛的原因。

套色不精準產生的漏白。這種不完美帶來了獨特的復古質感。

02 黑色文字與螢光粉底色存在套不準的漏白，這種「缺陷美」是 Riso 印刷的獨特魅力。

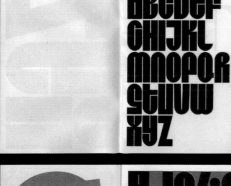

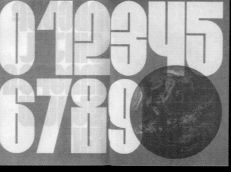

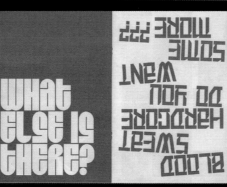

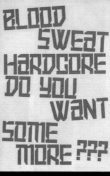

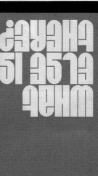

Blue Note Reimagined

Alfa Mist, Blue Lab Beats, Emma Jean-Thackray, Ezra Collective, Fiah, Ishmael Ensemble, Jordan Rakei Jorja Smith, Melt Yourself Down, Mr Jukes, Nubya Garcia, Poppy Ajudha, Steam Down, Shabaka Hutchings, Skinny Pelembe, Yazmin Lacey.

2020

BLUE NOTE

by Jay Vaz

「藍色音符」系列唱片海報

設計機構：The Mannequin Collective
創意總監：Jay Vaz
設計師：Jay Vaz
國家：英國

Blue Note Re:imagined Poster 這件作品（左圖）是受迪卡唱片公司委托，為他們的「藍色音符」系列唱片設計整體形象。整個項目由16位藝術家組成，涵蓋了16張古典爵士樂唱片。Jay Vaz 為「Blue Note Re:imagined 2020」設計了標識，製作了原曲和重新想像的歌曲抽象符號。這種視覺語言被應用到海報上，將16道音軌的抽象符號組合在一起，創造出了這幅整體作品。海報旨在反思當代爵士樂的聲音，保留了早期爵士樂以復古和古典音樂美學為代表的核心基礎。

Blue Note Re:imagined

01 Bluenote Re:imagined 2020 項目標識。

#b53718
C22 M89 Y100 K14

#b6401b
C22 M85 Y97 K13

#36314c
C79 M78 Y45 K41

#365027
C73 M46 Y91 K46

#b3b0ad
C35 M29 Y29 K0

#e6c5a3
C11 M26 Y36 K0

#365027
C31 M73 Y66 K0

#3f7a6d
C78 M44 Y61 K0

02 海報使用了低飽和度、高級灰的配色來呈現復古感。

FRIDAY 4TH MAY
2018

Rhythm Section

£6 ADVANCE

ESTABLISHED 2009

PECKHAM STRONG

Yu Su
Hidden Spheres
Bradley Zero

wearerhythmsection.com

10PM TIL
LATE

OSCAR JEROME
AT VILLAGE UNDERGROUND

SEPTEMBER 25TH 2018

KWALU
LOUIS VI
ALEX RITA

54 HOLYWELL LANE, EC2A 3PQ LONDON · UNITED KINGDOM | (7:30 – LATE)

O'Flynn (Ninja Tune)

Jordan (Turbo Recordings)

Red Verse (Loose Fit)

Romy Mats

XJB

LIFE OF CODE

51.5074° N, 0.1278° ——— 130-9_L"S619-022097" V(A)Z

VOL1

001

300

∞ the
droplet
with me

energy
colour
chapter, a new

life.

hyara

CHAPTER VI: HE OPENED HIS EYES.

KAMAAL WILLIAMS

THE RETURN TOUR

FEBRUARY 22ND | Los Angeles | MORROCAN LOUNGE
MARCH 1ST | Oakland | STARLINE SOCIAL CLUB
MARCH 3RD | Toronto | VELVET UNDERGROUND
MARCH 5TH | Montreal | CENTRE PHI
MARCH 7TH | Miami | FLOID
MARCH 9TH | New York City | LE POISSON ROUGE
MARCH 19TH | Atlanta | AISLE 5

LANDED

MANNEQUIN/01

KURUS
& ADUNA ○——————— WHAT IT SEEMS

PHARDAH PEPI II

MEYERKARE
HEZEKKYKE

ANKHESENPEPI III · NEITH · IPUT II

94

MONH (VINEGAR*)

GEORGE RILEY
HERSTORY

Bill Evans Trio
"I Should Care"

1964

ja z

ZZ

Z]]]
ZZZZ
ZZ

ZZz z

SUBPHONICS

8PM - FREE ENTRY

LIVE SOUND SESSION

Li Song + Adam Paroussos + Erin Robinson + Jamie Turner
Giulio Dal Lago + Yinan Ji + Toby Edwards + Ava Halloran

18.12 THE BEEHIVE PUB

Stoneleigh Rd, Tottenham, London N17 9BQ

「副音」音樂活動形象識別

設計機構：Supernulla Creative Studio
創意總監：Supernulla Creative Studio
設計師：Supernulla Creative Studio
國家：義大利
客戶：Subphonics Collective

Subphonics Collective 位於倫敦，專門從事實驗性電子音樂活動的舉辦，我們為其設計活動形象。

這次活動使用粗糙的聲音和電子音樂混合在一起，所以這個平面構思反映了這種集體的實驗性情緒。大標題文字使用像素來指代電子樂，圖像則來自微觀世界，由細菌組成，想要表達的是沒有什麼東西是純淨的，所有東西都被感染了，就像嘶啞的、混合的聲音一樣。

我們的靈感來自過去用來宣傳狂歡或龐克演出的傳單，渾濁的外觀很快成為這種特定音樂場景的標誌。

01 標題使用像素字體來指代電子樂。

02 用於 Facebook 的活動 Banner 設計。

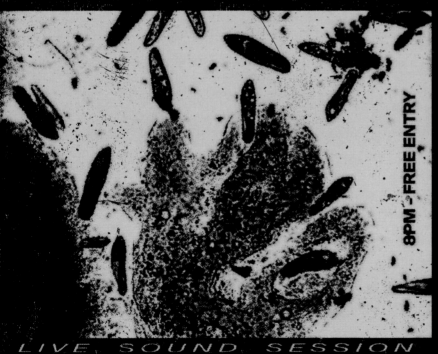

O ZEBRAS

OPEN MIC NIGHT

13th March @9pm
Stand-up Comedy
in English

TICKETS 5€

BAR CARGO 111 – BAIRRO ALTO BAR CARGO 111 – BA

AIRRO ALTO

-WINSTON-

O Zebras

設計機構：Beco Creative Studio
創意總監：Beatriz Ramos and
Constança Soromenho
設計師：Beatriz Ramos and
Constança Soromenho
國家：葡萄牙
客戶：Maria Dominguez and
Joana Sousa Lara

O Zebras 是一個活動組織機構。該機構的目標是通過參與互動性高的活動把人們聚集在一起。無論是單口喜劇之夜，還是舞蹈、音樂、電影、餐飲和交際等活動，他們組織的活動都是一扇敞開的大門，可以進行討論、對話、娛樂，並具有可持續性。作為設計師，我們的工作就是讓這些斑馬和它們所代表的人類「活」起來。我們的方法是創造一個豐富多彩和有趣的品牌形象。與黑白條紋不同的是，這種斑馬身上有著不同的圖案，使Z字母具有不斷變化的個性。這個品牌的標誌是字母Z，它為了突顯自身而不斷改變形式，這給品牌帶來了一個有趣和可識別的元素。

01 字母「Z」根據不同主題變換樣式。

OPEN MIC NIGHT

02 使用字體 Bentonsanswide - Black。

13th March @ 9pm

03 使用字體 Bentonsanswide - Bold。

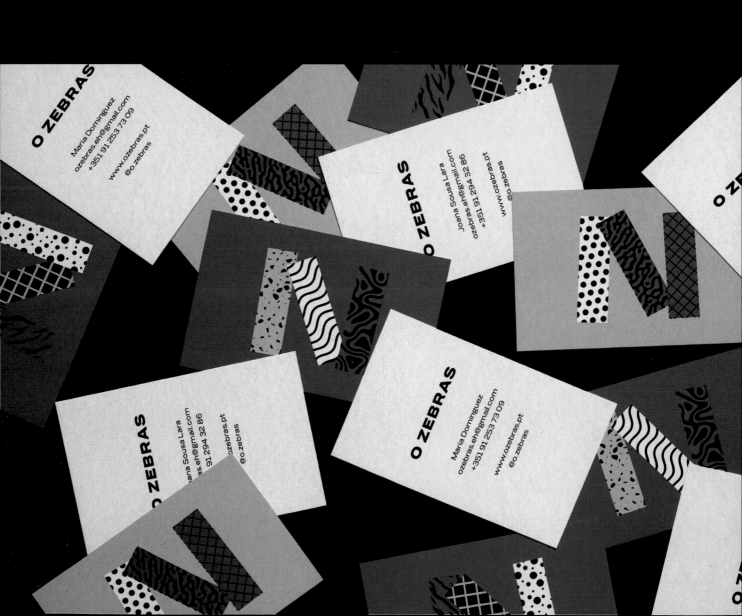

PIXEL

像素風格設計案例 >

像素畫原本是一種以「像素」（Pixel）為基本單位來製作的電腦繪圖，其特點是通過像素點用距陣排列的方式拼合成圖像，你可以看到裏面的像素顆粒。而如今的像素藝術（Pixel Art）已從電腦最原始的圖像表現演變成一種獨立的藝術創作方式，它強調的是一種具有清晰的輪廓、明快的色彩、不受約束的風格。在一味追求清晰、極致美感的今天，像素元素的加入無疑具有強烈的衝擊力，它粗糙拙樸的方格，模糊的鋸齒邊緣帶來極不和諧的懷舊感，卻常常成為整個畫面的點睛之筆。

GOODBOIS

Goodbois - Ss 19 時尚手冊

設計機構：Simbayu Studios
創意總監：Julian Schröpel
設計師：Brando Corradini
國家：義大利
攝影師：Nepomuk Bösker

在這個街頭時尚設計項目中，Goodbois工作室和II bravo graphic design工作室的設計師Julian Schropel使用了我製作的字體「MITHROGLA」，創造性地再現了電腦的像素，與穿著T恤的街頭時尚模特圖像完美結合。

SOMMER

2019

GOODBOIS

zwei
tausend
neunzehn

GOODBOIS ®

01 系列海報以上方版式為基礎，畫面中心淡藍色區域置入不同的攝影圖，畫面背景與元素根據攝影圖搭配顏色。

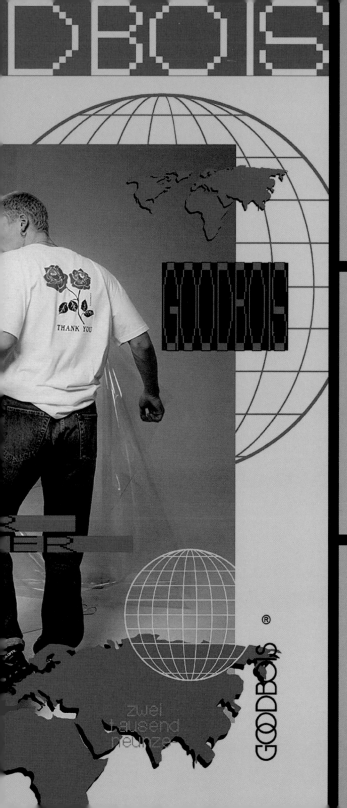

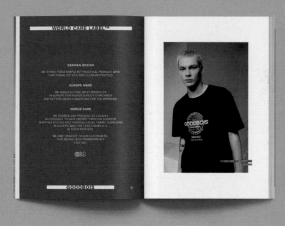
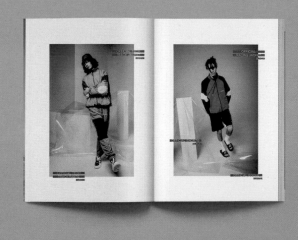

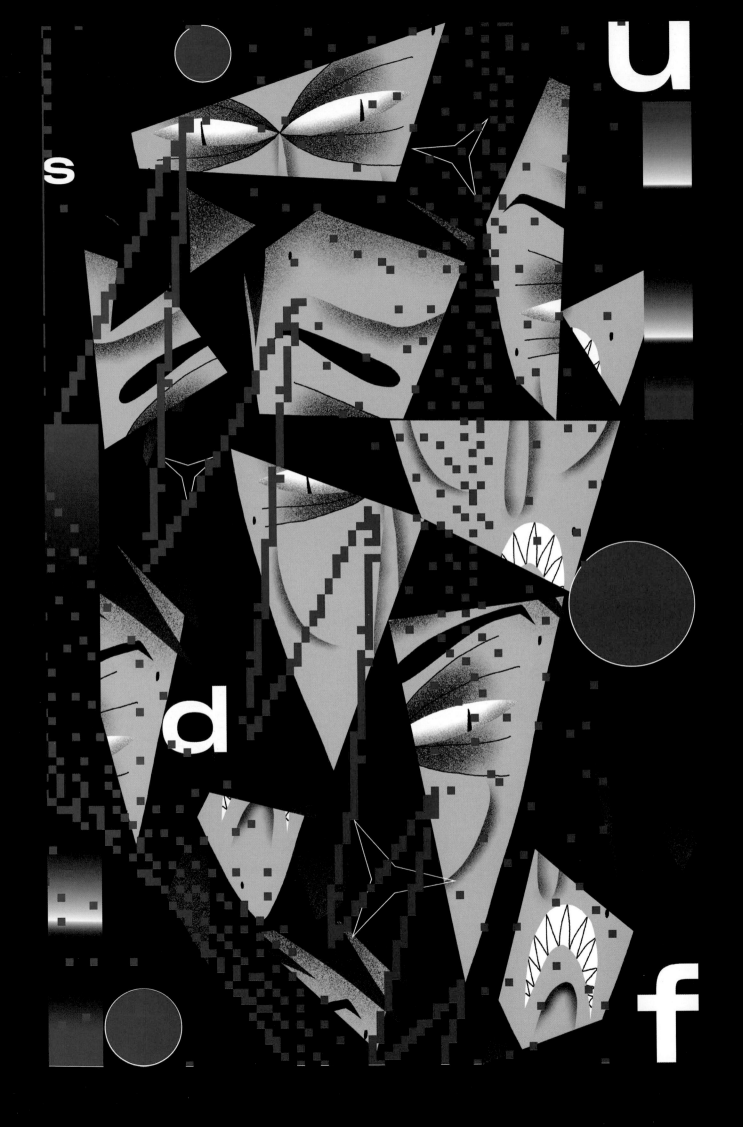

Tutta Brava Gente「非展覽」

設計機構：Supernulla Creative Studio
創意總監：Supernulla Creative Studio
設計師：Marcello Raffo - Nicolò Tromben
國家：義大利
客戶：Galeria Ocupa
攝影師：Jorge Almeida

「Tutta Brava Gente」是在波爾圖Galeria
Ocupa畫廊舉辦的一次「非展覽」。這個畫
廊的獨特之處在於空間，兩位老闆回收了一
家肉店，直接改成畫廊，像陳列肉塊一樣陳
列藝術品、平面設計和插圖。畫廊內允許開
展任何類型的活動，唯一的要求是要與畫廊
的空間氛圍相融合。

我們不想將這次展覽策劃成一個藝術展，而
是進行一次創造性的視覺實驗。插圖與平面
設計兩者相輔相成。

插圖畫家NicolòTromben繪製了插畫的每
個角色，Marcello Raffo則用這些畫作來創
作另一幅與角色相對應的解構圖形。

所有的圖片都在像紙一樣的畫布上進行數字
印刷。藝術品的擺放位置與空間和觀察者的
位置相呼應。牆壁上還覆蓋著我們標誌性的
紅色像素點，與展出畫面中使用的圖形元素
一致。

這個設計在視覺上最顯著的特徵是插畫、平
面藝術與空間的線性交流，創造了充滿活力
的藝術空間。

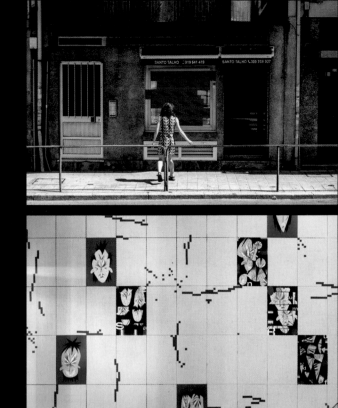

01 在肉店中的展覽（將海報擺放在放置肉類的冰櫃裏）。

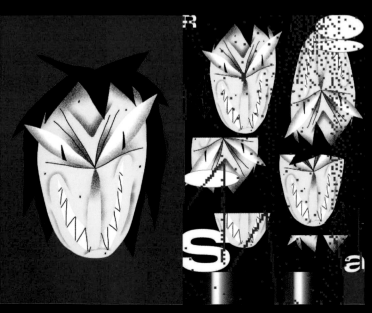

02 Marcello Raffo 根據插畫家 NicolòTromben 的作品進行解構重組。

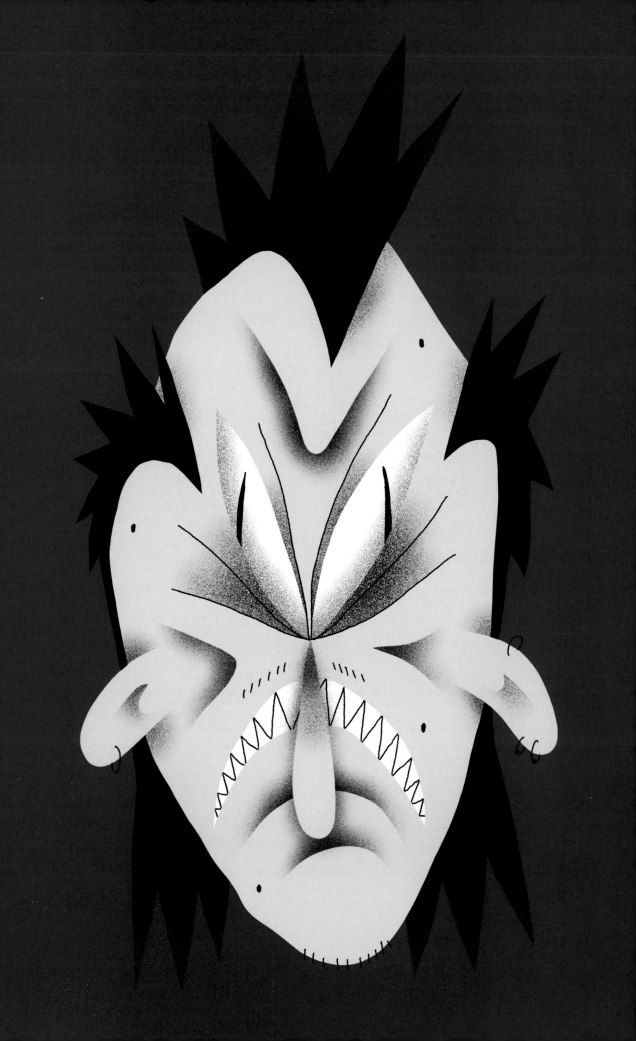

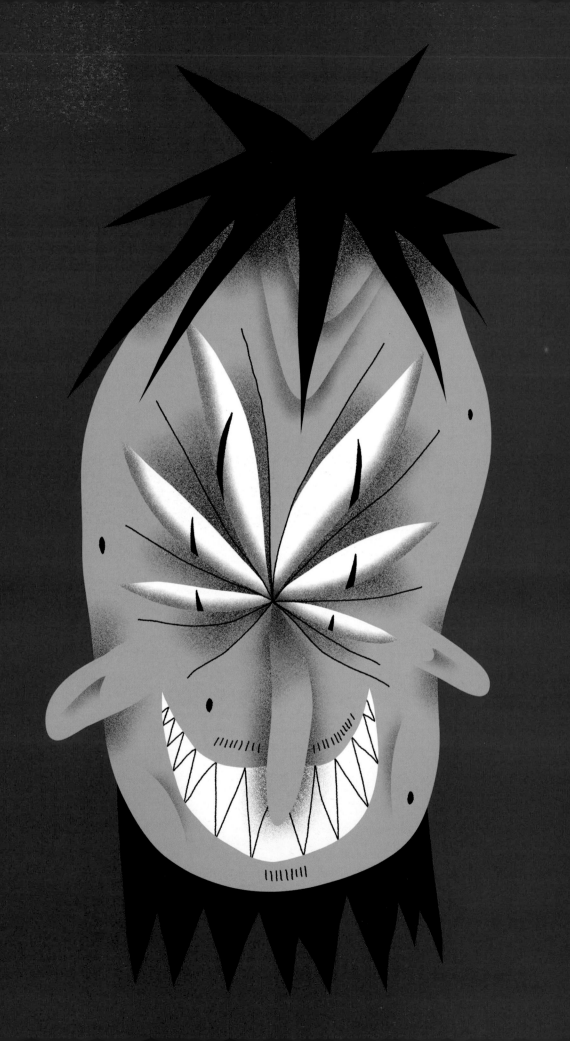

國家：葡萄牙
客戶：Hackathon 100％ In
攝影師：Afonso Lourenço, Bruno Boiça,
Filipa Combo, Luis Lopes

Hackathon 100％ In是一場大學24小時
耐力競賽，比賽的主旨是通過參賽者們研發
的技術解決方案，通過創造新的方式幫助有
特殊教育需要的學生適應社會。

我們的任務是創造這次比賽的品牌形象。我
們通過失真變形的像素美學，來呈現社會的
不確定性和擁抱這種不確定性的需要。

首先要確定項目的顏色。使用閃爍的像素藝
術，需要帶技術感的顏色 —— 螢光綠和螢
光粉，能呈現良好的視覺對比效果。接下
來，我們創建了比賽的視覺代碼 —— 綠色
代表參賽隊伍，粉色代表工作人員。之後，
我們為每個團隊創建了專屬的綠色符號。
最後階段是創造市場傳播的介質 —— 主海
報，它可以被分成4張更小的且同樣能獨立
使用的海報。

項目最大的視覺亮點是色彩的使用，廣告海
報的可分割性以及故障像素概念的獨特性，
使這個提案成為一個特別的方案。

hackathon

使用字體：GoshaSans - Regular

01 帆布袋設計。

02 貼紙設計。

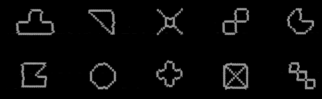

03 活動Icon設計。

04 App與網頁端設計。

Spamzine 由設計師 Jutta Babak 創作

GLITCH

故障美學設計案例

故障藝術不是作為一個風格門類而是作為一種美學態度
（故障美學 Glitch Aesthetics）出現的，它把科技硬體
或軟體的運行錯誤作為畫面元素加入創作。設計師們從
故障中發現了美，在他們眼裏每一次故障都像是打破常
規的再創造。

故障藝術打破了唯美流暢的和諧畫面，它比故障本身能
傳達更為豐富的內容，是對審美的一次再顛覆。本章中
的作品並非只是簡單地利用故障藝術製造一種畫面的感
覺或情緒的渲染，而是真正從設計主題出發，使用故障
失真的手段來達成各自的目的。

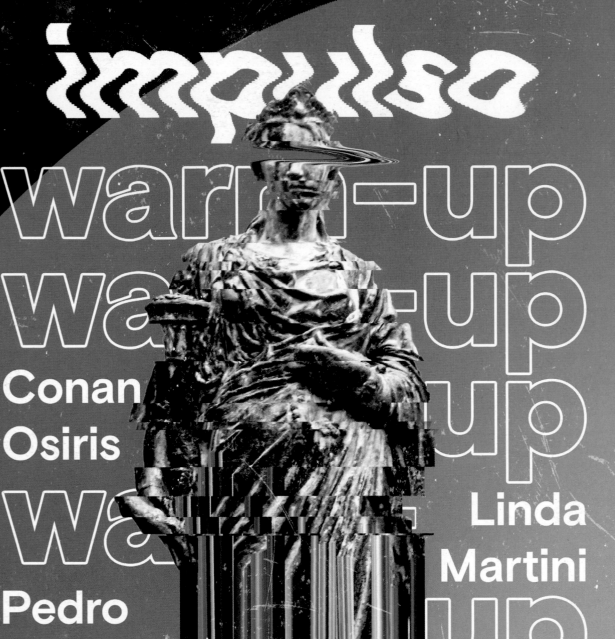

impulso

warm-up
warm-up

Conan Osiris

warm-up

Linda Martini

Pedro Geraldes

warm up

Caldas da Rainha

17.05 - 23:00h
Déjà-vu bar

Impulso 音樂節

創意總監：Gonçalo Silva, Maria Rosa
設計師：Carolina Domingues,
Gonçalo Silva, Maria Rosa
國家：葡萄牙
客戶：Festival Impulso
攝影師：Gonçalo Silva

這個項目是為葡萄牙 Impulso 音樂節創造一個新的視覺形象，這是一個聲音、視覺、影像交叉的綜合性文化節日，也是一個藝術展覽平台，通過聲音和視覺的藝術展示在葡萄牙製作的「另類音樂」的最佳作品。而我們的目標是為它創造視覺形象，以及用不同的素材來宣傳節日。

我們的理念是將電影節的周邊環境與視覺形象協調起來。在這一點上，靈感來源於公園周圍的雕像，因為公園是這個活動舉行的主要場地。

Impulso 指衝動、動力、運動、節拍。因此，我們所創建的標識在顏色和形狀上是可變的，以聯結運動的概念和節日的多元性。因此，我們應用切割和故障來給出運動的概念。

由於 Impulso 是一個綜合性的文化節，展示另類的音樂和藝術，我們決定融入色彩，還添加紋理和拼貼元素，使其成為一個有趣的圖像。

我們對照片素材進行了修改和處理，以適應我們試圖描繪的氛圍，同時考慮了如何使紋理和拼貼與整個創意協調。最突出的特點是極具個性的圖形圖像，我們在不同的圖像中融入節日氛圍，以有趣和特別的方式表達節日本質的感覺。此外，公園是這座城市的主要景點之一，每個人都知道這些雕像，有些雕像還是葡萄牙著名雕塑家製作的，因此將它們整合在遍布全城的平面海報中，讓人感覺到共鳴以吸引人們的注意力。

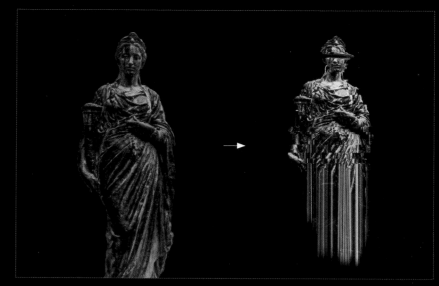

01 左圖為公園中的雕塑原型，右圖為作者製作後的效果，以上效果可以在 Photoshop 中實現。

02 雕塑的頭部使用了 Photoshop 中的「液化」功能。在導航欄中打開「濾鏡 - 液化」，進入調整面板後選擇左側工具欄的第一個工具「向前彎曲工具（W）」，筆刷工具選項如圖「大小根據繪製需求調整；濃度：50；壓力：100」。然後按住滑鼠左鍵，從雕像頭部左側向右側橫向拖動幾次以達到圖片效果，點擊「確定」保存。

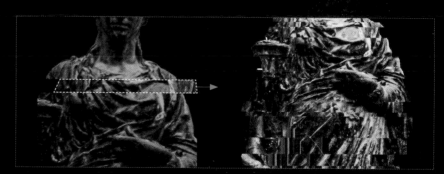

03 身體的上半部分可以通過矩形選取畫面工具（M）先框選出目標範圍，然後在選取狀態下切換至移動工具（V），並按左右方向鍵來獲得錯位效果。

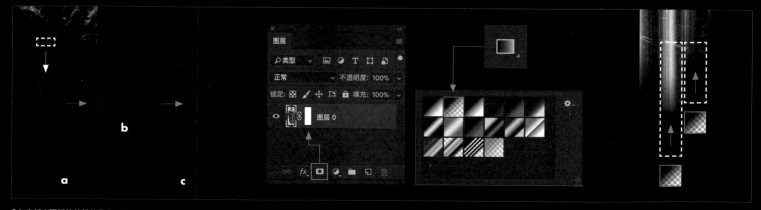

04 底部向下延伸的線條是利用矩形選取畫面工具（M）框選目標區域，再利用任意變形工具（Ctrl / Command + T）拉伸目標以實現該效果的。值得注意的是，如果直接選中一塊區域用任意變形工具向下拉伸，會出現 a 的情況，即無法形成規則的豎條紋理。因此，要在拉伸後的基礎上，從中截取一個片段（b），並再次進行拉伸，即可獲得平滑的效果（c）。

雕像最末端的「漸隱」效果是利用漸層工具與圖層遮色片實現的。首先在圖層面板點擊下方第三個按鈕創建遮色片，然後根據需求框選不同寬度的區域，使用漸層工具（G），將前景色更改為黑色，並選擇「前景色到透明漸層」的效果，按住 Shift 在選取內從上往下添加漸層效果。在遮色片中，黑色代表不顯示，白色代表顯示，「前景色到透明漸層」中的透明度為0％，代表不產生影響。因此，對一張顯示的圖片添加「從黑色到0％透明度漸層」代表「從消失到逐漸不產生影響」，即「漸隱」的效果。

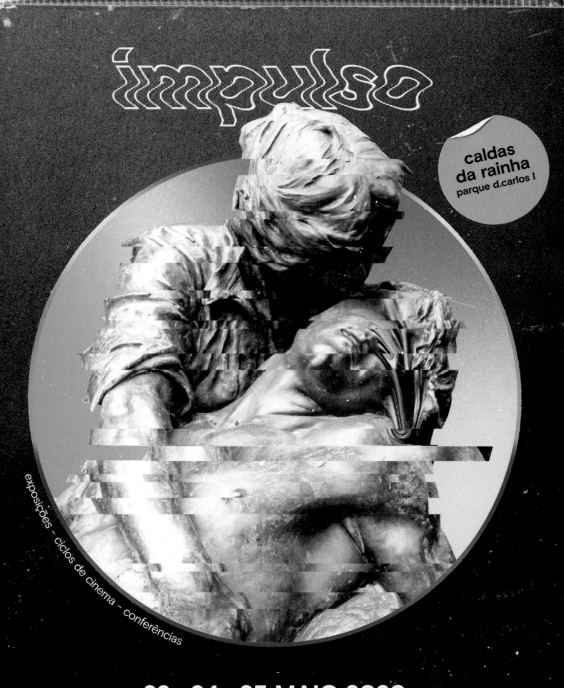

impulso

caldas
da rainha
parque d.carlos I

exposições · ciclos de cinema · conferências

23—24—25 MAIO 2020

BRUNO PERNARDAS - HHY THE MACUMBAS - LAVOISIER - MONDAY - ZA! - VIOLET B2B - MARUM - AURORA PINHO - MELQUIADES- MAZARIN - JOAO PAIS FILIPE - DAKOI - SURMARA, TOMARA, TIAGO BETTENCOURT - FRED FERREIRA, IGOR JESUS, JOAO PIMENTA E PEDRO GERALDES BRUNO PER-NARDAS - HHY THE MACUMBAS - LAVOISIER - MONDAY - ZA! - VIOLET B2B - MARUM - AURORA PINHO - MELQUIADES- MAZARIN - JOAO PAIS FILIPE - DAKOI - SURMARA, TOMARA, TIAGO BETTEN-COURT - FRED FERREIRA, IGOR JESUS, JOAO PIMENTA E PEDRO GERALDES
BRUNO PERNARDAS - HHY THE MACUMBAS - LAVOISIER - MONDAY - ZA! - VIOLET B2B - MARUM - AURORA PINHO - MELQUIADES- MAZARIN - JOAO PAIS FILIPE - DAKOI - SURMARA, TOMARA, TIAGO BETTENCOURT - FRED FERREIRA, IGOR JESUS, JOAO PIMENTA E PEDRO GERALDES

ìmpulso

caldas
da rainha
parque d.carlos I

exposições - ciclos de cinema - conferências

23—24—25 MAIO 2020

BRUNO PERNARDAS - HHY THE MACUMBAS - LAVOISIER - MONDAY - ZA! - VIOLET B2B - MARUM -
AURORA PINHO - MELQUIADES- MAZARIN - JOAO PAIS FILIPE - DAKOI - SURMARA, TOMARA, TIAGO
BETTENCOURT - FRED FERREIRA, IGOR JESUS, JOAO PIMENTA E PEDRO GERALDES BRUNO PER-
NARDAS - HHY THE MACUMBAS - LAVOISIER - MONDAY - ZA! - VIOLET B2B - MARUM - AURORA
PINHO - MELQUIADES- MAZARIN - JOAO PAIS FILIPE - DAKOI - SURMARA, TOMARA, TIAGO BETTEN-
COURT - FRED FERREIRA, IGOR JESUS, JOAO PIMENTA E PEDRO GERALDES
BRUNO PERNARDAS - HHY THE MACUMBAS - LAVOISIER - MONDAY - ZA! - VIOLET B2B - MARUM -
AURORA PINHO - MELQUIADES- MAZARIN - JOAO PAIS FILIPE - DAKOI - SURMARA, TOMARA, TIAGO
BETTENCOURT - FRED FERREIRA, IGOR JESUS, JOAO PIMENTA E PEDRO GERALDES

KØBENHAVM
KØBENHAVM
KØBENHAVM
KØBENHAVM
KØBENHAVM
KØBENHAVM
KØBENHAVM
KØBENHAVM
KØBENHAVM

2020

FAST STATIC
MOVEMENT

Fast Static Movement

設計師：Cristiano Cola
國家：義大利
尺寸：14.5cmx22.6cm

這個作品的概念是關於「時間」和「運動」的，靈感來自一次丹麥哥本哈根的旅行。所有的照片都是我在沿途遊走時用iPhone拍的，大多是在夜裏。我之前從來沒有去過哥本哈根，我很驚訝地發現這樣一個豐富多彩的城市和充滿生活氣息的美妙夜晚。在我的旅行中，我發現了時間的重要性，我在這個地方只待了3天，但是卻做了許多工作，這些工作我在家可能要花費一兩周才能完成。所以我做了這個關於「時間」的項目。有了這些意象，就有了一些詩歌，我把我的思想寫成了一個故事。

所有的圖像都是自然模糊的，以代表時間的流動和持續的運動，影響著我們的生活。

為什麼叫快速靜態運動？ 因為攝影是唯一能夠阻止時間無限流動的方式，捕捉一個瞬間，捕捉一個生命，讓它永遠存在。

01 在Photoshop中，可以利用「重複任意變形」功能實現左圖封面的故障效果。首先在Photoshop中打開一張原圖，然後按Ctrl / Command + J複製圖層。

02 對複製的圖層執行 Ctrl / Command + T 進入任意變形工具，並向右、向下移動該層圖片（注：這裏必須在任意變形的狀態下移動圖片）。

03 執行完上一步操作後，按住 Ctrl / Command + Shift + Alt ，並點擊按鍵 T，圖片將會根據點擊 T 的次數執行重複任意變形，直至達到您需要的效果。

19.06

11AM—3PM +
7PM—11PM
30—45€

GENRES

DRAWING
MY PER-
CEPTIONS
DRAWING
THEIR PER-
CEPTIONS

WEEKLY BUTOH TRAININGS WITH
WEEKLY BUTOH TRAININGS W
WEEKLY BUTOH TRAININGS WITH VALENTIN TEE
WEEKLY BUTOH TRAININGS WITH VALENTIN

01 海報的視覺亮點是用故障手法處理的人體，混合了手寫文字和「嚴肅」的無襯線字體。

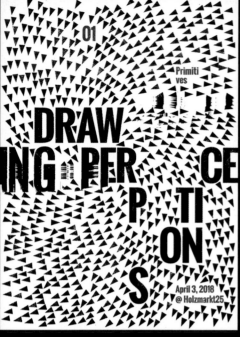

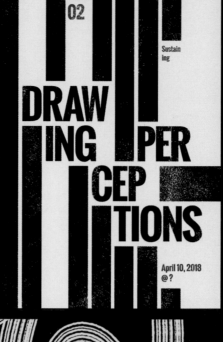

設計師：Sergey Skip
國家：德國
客戶：Valentin Tszin butoh workshops
攝影師：Dasha Yastrebova

這個項目是為柏林藝術家和舞蹈研究人員Valentin Tszin主持的每周一次的布托舞（Butoh）課程繪製的系列海報作品。這個課程主要是為表演藝術家、舞者、演員以及經常自我發問「什麼是現實」或「哪些現實有可能發生」的人們提供培訓。

該課程的節目包含12個主題，每個主題都有自己的海報。設計師選擇了統一的布局來傳達必要的訊息，例如講習班的日期和名稱。但是，為了創建一個視覺上有趣的系列，每張新海報都以怪異的方式為Valentin Tszin拍攝一張照片，並使用故障效果和失真手法進行了不同的處理，同時在視覺上與布托舞保持一致。為了強調視覺多樣性，並增加布托舞的不完美和困擾感，每張海報上還使用了粗糙的手繪塗鴉。

攝影修飾有一部分通過iPhone的色彩處理應用程序完成，然後在Photoshop中完成包括特效以及海報的其他部分。

17.04

11AM—3PM +
7PM—11PM
30—45€

PARADISE

DRAWING
MY PER-
CEPTIONS
DRAWING
THEIR PER-
CEPTIONS

WEEKLY BUTOH TRAININGS WITH VALENTIN TSZIN

12.06

11AM—3PM +
7PM—11PM
30—45€

BODY TYPE

WEEKLY BUTOH TRAINING WEEKLY BUTOH TRAININGS WITH VALENTIN TSZIN WEEKLY BUTOH TRAININGS WITH VALENTIN TSZIN WEEKLY BUTOH TRAININGS WITH VALI WEEKLY BUTOH TRAININGS WITH VALI

DRAWING MY PER-CEPTIONS DRAWING THEIR PER-CEPTIONS

ZINE
ZINE
ZINE
ZINE
ZINE
SPAM
SPAM
SPAM
SPAM
SPAM

Der Mensch und
sein Spam

SPAM ME

Spam · 2018

Spamzine 垃圾郵件雜誌

創意總監：Jutta Babak
設計師：Jutta Babak
國家：德國

在攻讀學士學位期間，我收集了 5 年的垃圾郵件，並分析這些郵件的內容。我試圖研究垃圾郵件的內容，以及我們和垃圾郵件在網上互動的方式：這些郵件是誰給我寫的？他們想要表達什麼？他們將如何說服我？

這是一個多媒介項目，包括雜誌、展覽和一系列海報。「反設計」是該項目的核心理念，我想利用那些人人都避之不及的電子垃圾作為材料，來創建一個亮眼的視覺作品。該項目的挑戰是通過不同尋常的方式，將垃圾郵件轉變為可視化的訊息，從而吸引觀眾。目的是讓人們思考這個消費社會如何塑造我們的欲望，其他人又打算如何利用這些欲望。

該設計受到垃圾郵件視覺的啟發，傳統的插圖和排版，結合 AI 技術進行圖像失真的處理。設計的一大視覺亮點是加粗字體和經典的視覺元素之間形成鮮明對比。在圖形設計規則之上有所改變，體現我自己重新構建的視覺秩序。

02 雜誌封底設計。

na HawliczekFrom: Anna Hawliczek From: Anna

BUY HERE

26:02

**SPAM ME
Project**

SexKampf bi
ur Erschöpfung

„*TOTALLY LEGIT*"

 plsspamme@aol.de

ORPHEUS

even stones with his music, his attempt to retrieve his wife, Eurydice, from the underworld, and his death at the hands of those who could not bear his divine music. As an archetype of the inspired singer, Orpheus is one of the most significant figures in the reception of classical mythology in Western culture, portrayed or alluded to in countless forms of art and popular culture in_____ : film, opera, music, and painting. Orpheus is a legendary musician, p_____' in ancient Greek religion and myth. The major stories about him are c_____ bility to charm all living things and even stones with his music, his at_____ m his wife, Eurydice, from the underworld, and his death at the hands of t_____ o hear his divine music. As an archetype of the inspired singer, Orphe_____ s most significant figures in the reception of classical mythology in Wes_____ ortrayed or alluded to in countless form_____ popular culture including poetry, film, opera, music, and painting. Orph_____ ndary musician, poet, and prophet in ancient Greek religion and myth. The_____ es about him are centered on his ability to charm all living things and even_____ his music, his attempt to retrieve his wife, Eurydice, from the underworld_____ ath at the hands of those who could not hear his divine music. As an archetype_____ ired singer, Orpheus is one of the most significant figures in the reception of classical mythology in Western culture, portrayed or alluded to in countless forms of art and popular culture including poetry, film, opera, music, and

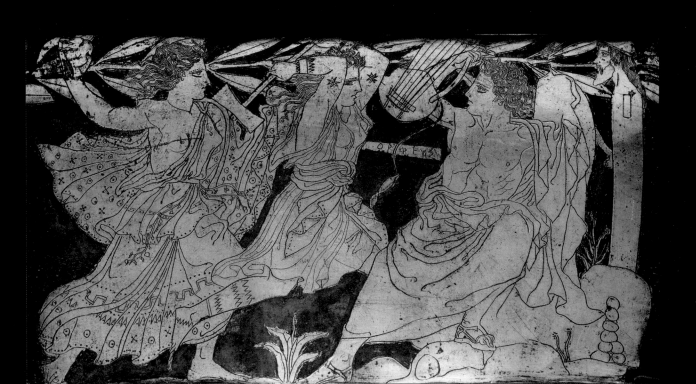

甫斯之死的概念化為一個字母，並用印刷作
為媒介來想像他所經歷的痛苦，會發生什
麼？這就是它能帶給你的。

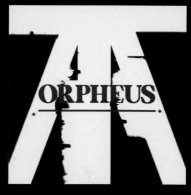
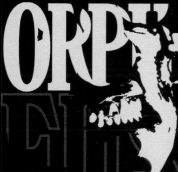

致　謝

該書得以順利出版，全靠所有參與本書製作
的設計公司與設計師的支持與配合。gaatii
光體由衷地感謝各位，並希望日後能有更多
機會合作。

gaatii光体

TITLE

歐洲平面設計新浪潮

STAFF

出版	瑞昇文化事業股份有限公司
編著	gaatii光体
總編輯	郭湘齡
文字編輯	張聿雯
美術編輯	許菩真
排版	執筆者設計工作室
製版	明宏彩色照相製版有限公司
印刷	桂林彩色印刷股份有限公司
法律顧問	立勤國際法律事務所　黃沛聲律師
戶名	瑞昇文化事業股份有限公司
劃撥帳號	19598343
地址	新北市中和區景平路464巷2弄1-4號
電話	(02)2945-3191
傳真	(02)2945-3190
網址	www.rising-books.com.tw
Mail	deepblue@rising-books.com.tw
初版日期	2022年9月
定價	1800元

ORIGINAL EDITION STAFF

策劃編輯	段園園	林詩健
責任編輯	段園園	柴靖君
編輯總監	柴靖君	
設計總監	陳 挺	
責任監印	陳 挺	

國家圖書館出版品預行編目資料

歐洲平面設計新浪潮 = New waves of
European graphic design/gaatii光体編
著. -- 初版. -- 新北市：瑞昇文化事業股
份有限公司, 2022.05
208面 ; 22.5 x 30公分
ISBN 978-986-401-554-2(精裝)

1.CST: 平面設計 2.CST: 作品集 3.CST:
歐洲

964　　　　　　　　　111004650